UNIVERSITY OF
SOUTH
CAROLINA

A Portrait

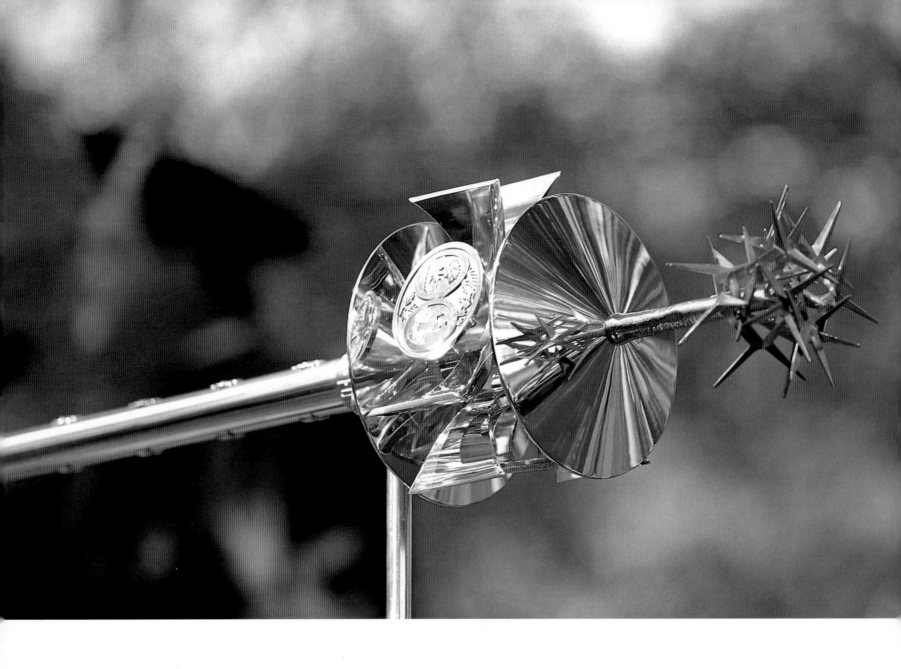

We hail thee, Carolina, and sing thy high praise
With loyal devotion, remembering the days
When proudly we sought thee, thy children to be:
Here's a health, Carolina, forever to thee!

UNIVERSITY OF
SOUTH CAROLINA

A Portrait

PHOTOGRAPHS BY *Robert C. Clark*

TEXT BY *Chris Horn*

FOREWORD BY *John M. Palms*

UNIVERSITY OF SOUTH CAROLINA PRESS

Text © 2001 University of South Carolina
Photographs © 2001 Robert C. Clark

UNIVERSITY OF SOUTH CAROLINA *BICENTENNIAL*

Published in Columbia, South Carolina, by the
University of South Carolina Press

Manufactured in Korea

05 04 03 02 01 5 4 3 2 1

Library of Congress Cataloging-in-Publication Data

Clark, Robert C., 1954–
 University of South Carolina : a portrait / photographs by Robert C. Clark ; text by
 Chris Horn ; foreword by John M. Palms.
 p. cm.
 Includes index.
 ISBN 1-57003-408-7
 1. University of South Carolina. 2. University of South Carolina—Pictorial works.
 I. Horn, Chris. II. Title.
 LD5034.5 .C53 2001
 378.757'71—dc21 00-011151

Overleaf

The gleaming four-foot-long University Mace, placed on its stand during commence-
ment ceremonies, features the seals and symbols of the University, the State of South
Carolina, and the United States. USC officially adopted the mace in 1967.

FOREWORD

On clear Monday nights, when the Melton Observatory on USC's main campus in Columbia opens to the public, it is possible to stare up into the universe through a telescope and chart your place among the stars. Or, you could step outside the observatory, take seven paces, look down, and, with nothing but your unaided eyes, know precisely your location on one of America's most historic campuses. There at your feet would be the image of a compass embedded into the walkway, and it would tell you that you stand facing south by southeast.

The existence of this compass, handcrafted from blue, yellow, orange, and green tiles, might come as news to most USC students, faculty, staff, alumni, and visitors. But that is not surprising. Places and people often hold delights that fade with familiarity. If we grow so accustomed, however, we find other rewards. We have the chance to discover again the inspirations that our world offers us every day. It is wonderful to know, then, that a unique photograph of that compass is but one among hundreds in this book reintroducing our University to us.

Here, familiar horizons assume fresh magic in images that demonstrate as never before the aesthetic pleasures, vibrant life, and special world of this great institution. Here, thanks to Robert Clark's stunning photographs, Chris Horn's informative observations, and our own USC Press's publishing craftsmanship, we have a gift to treasure. Their artistry helps us see an old University through new eyes. In essence, this book finds a way to express in visual terms a founding purpose of Carolina. Since its inception, USC has been devoted to enlivening minds with the richness of experience and the power to see the world clearly.

Just as this mission endures, so does the natural and architectural beauty that seems always to have been part of USC. Legacies, though, are never easy to preserve. Once, in fact (surely during a spell of profound Columbia midsummer heat), administrators in the 1970s debated whether to wipe out much of this legacy. Specifically, they considered razing the Horseshoe, where USC began as South Carolina College in 1801. Maintaining the age-old facilities in which the University was born had proven increasingly problematic. Perhaps, they suggested, the time had come to start over. Thankfully, wiser minds prevailed. Instead of opting for irreversible destruction, the University invested in a major renovation project.

That work, it could be argued, preserved the campus of the first truly public university in the United States. Some historians describe USC in precisely such language. One scholar of higher education, Donald G. Tewksbury, writes, "It was in South Carolina that

the first 'revolutionary' type of state university . . . was established on a permanent basis."[†] Another, USC's own historian emeritus, Daniel Hollis, likewise observes, "Here was the genesis of a fully state-controlled, adequately state-supported college, and such an institution did not exist in the United States at that time."[‡] These views find their basis in ideas that since have become models for the very concept of a state university. In addition to creating South Carolina College, our legislative charter promised the school annual state appropriations, a radical idea. The state also required that the legislature elect the Board of Trustees. Until then, the few other colleges in the nation had only self-perpetuating boards. Finally, the state granted an unheard-of sum—$50,000, as well as the land for the original campus—to propel the college forward from the beginning. South Carolina had reason to declare from the outset that this college would "promote the instruction, the good order and the harmony" of the entire state, as the charter proposed. The charter, the board, the funding, and that declaration itself joined a college and a state in an alliance like no other before it.

In light of this history, USC stands either as the first public university in our country, or, by virtue of its founding date, as one of the first five. The distinction is not worth much quibbling. Of far greater interest is Carolina's remarkable evolution and the exciting future ahead. These pages capture this momentum. They offer us an expressive view of USC's growing campuses throughout the state. They show us some of the 7,500 new alumni who graduate every year, adding to the 190,000 alumni already active around the world. We also see examples of the 36,000 full-time students pursuing their dreams at USC. These students represent America and the world, for they come not only from every county in South Carolina but also from every state and some 120 countries. Within these pages, Robert Clark's unerring lens has caught their intelligence, talent, diversity, and drive. He has also managed to convey the vitality of USC's 2,000 faculty and 3,200 staff. Their work ethic, their devotion to their students and communities, and their contributions to the University's mission prove as evident in these images as they do to those of us who witness it every day.

USC's human impact obviously has flourished since that December 19, 1801, when we were chartered so uniquely. Back then, people could marvel at a new kind of institution, preparing to welcome the nine students who first enrolled. Today, we likewise can marvel at the material advances that have strengthened our home in the landscape. Modern academic buildings and residence halls, cutting-edge teaching and research equipment, expansive new gardens and green spaces, and one of the most competitive athletics programs in the nation now enrich the University of South Carolina. This book illustrates these changes beautifully.

[†]Tewksbury, *The Founding of American Colleges and Universities before the Civil War* (New York: Columbia University Press, 1932), 177.
[‡]Hollis, *University of South Carolina: South Carolina College* (Columbia: University of South Carolina Press, 1951), 1:18.

It is more difficult to capture an institution's spirit. It is a spirit reflected in our founding motto, which declares, "Learning humanizes character and does not permit it to be cruel." But *University of South Carolina: A Portrait* succeeds here as well. It conveys that spirit. It shows us the greatest part of the University. It helps us see again the people of Carolina, in which the University's ideals live. We see clearly that whether we are seeking a place on campus, or looking from this place into the heavens, here people learn, grow, and serve together. In this book, we are reminded that it is always a joy to discover Carolina anew.

John M. Palms

PRESIDENT
UNIVERSITY OF SOUTH CAROLINA

UNIVERSITY OF
SOUTH
CAROLINA
A Portrait

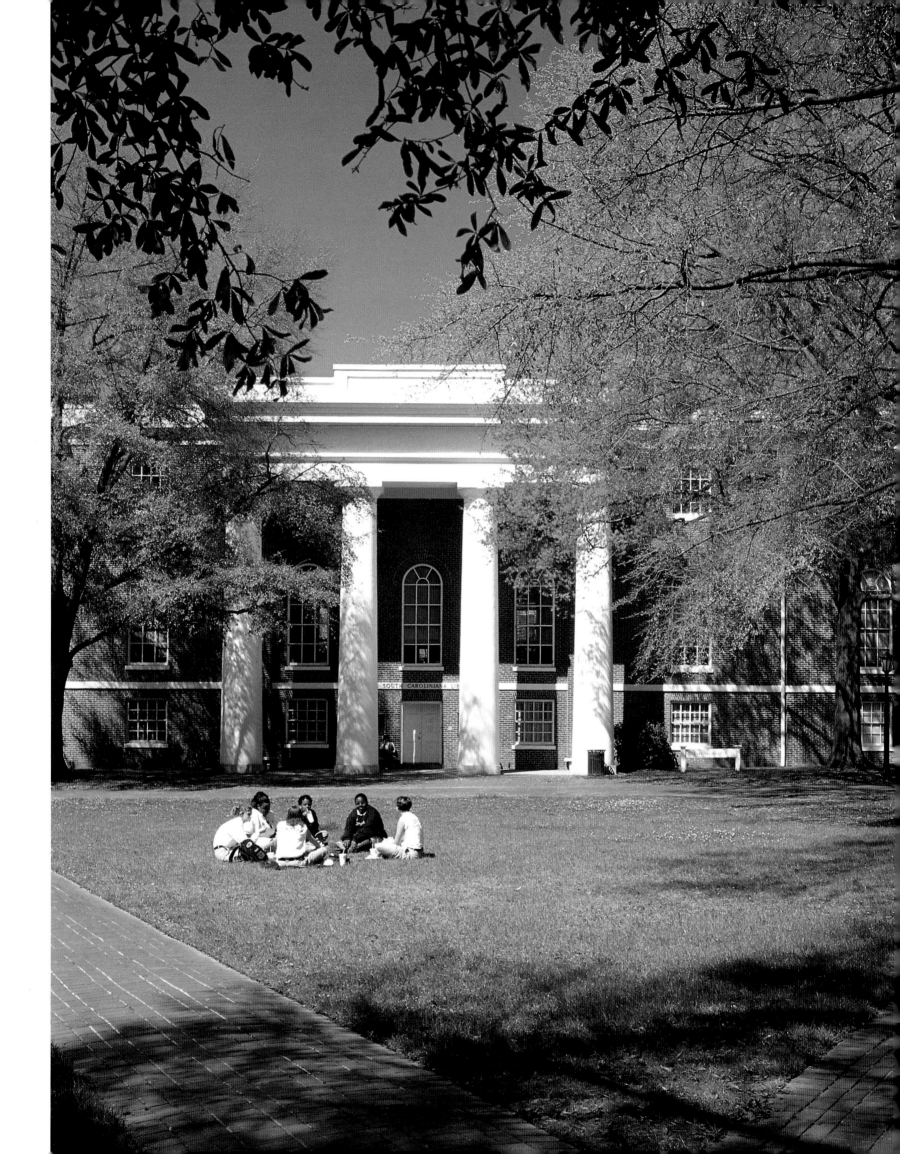

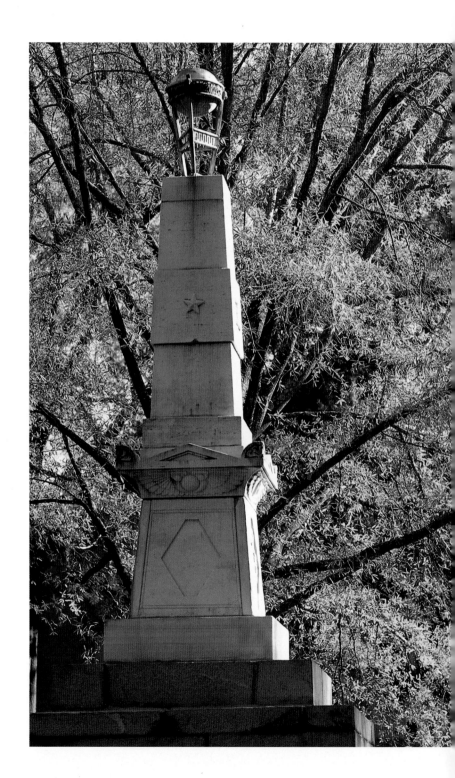

Previous Overleaf

A century ago, these students would likely have been studying inside the South Caroliniana Library instead of on the lawn in front of it. Built in 1840, it was the nation's first free-standing college library, predating libraries at Harvard, Yale, and Princeton.

Ivy decorates an entranceway to Maxcy College, a student residence hall built in 1937 with Public Works Administration funding and named for the Rev. Jonathan Maxcy, Carolina's first president.

Designed by Washington Monument architect Robert Mills, the Maxcy Monument honors President Maxcy, who served from 1804 to 1820. The monument, of the Egyptian Revival style, features a ball on top cradled within an inverted metal pyramid. A favorite campus legend from pre-World War II days jokingly suggests that the ball twirls whenever a virgin student walks past.

Right

The first hues of autumn color signal the approach of Homecoming and other traditional fall events.

Overleaf

Stately hardwood trees, manicured lawns, and criss-crossing brick walk-ways are hallmarks of the Horseshoe, the site of Carolina's historic 19th-century campus that continues to serve the modern University.

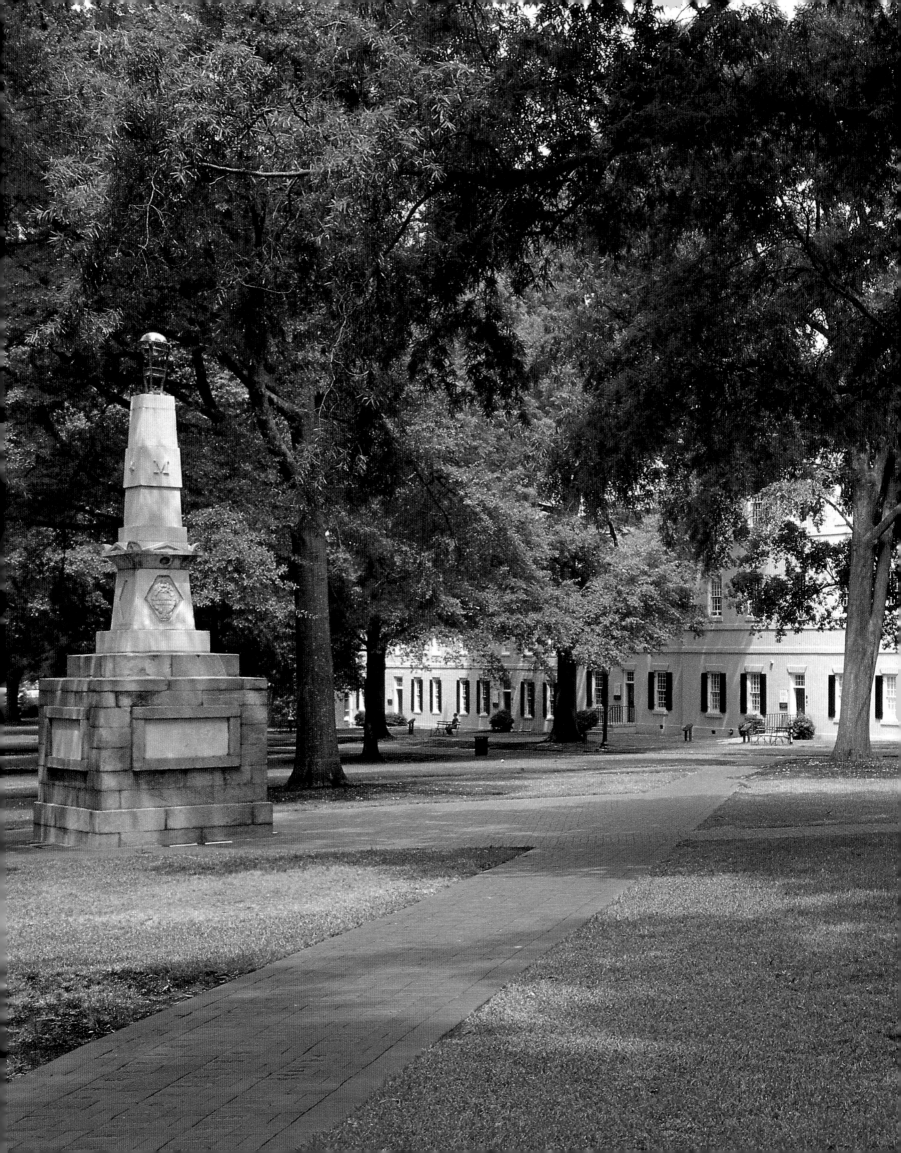

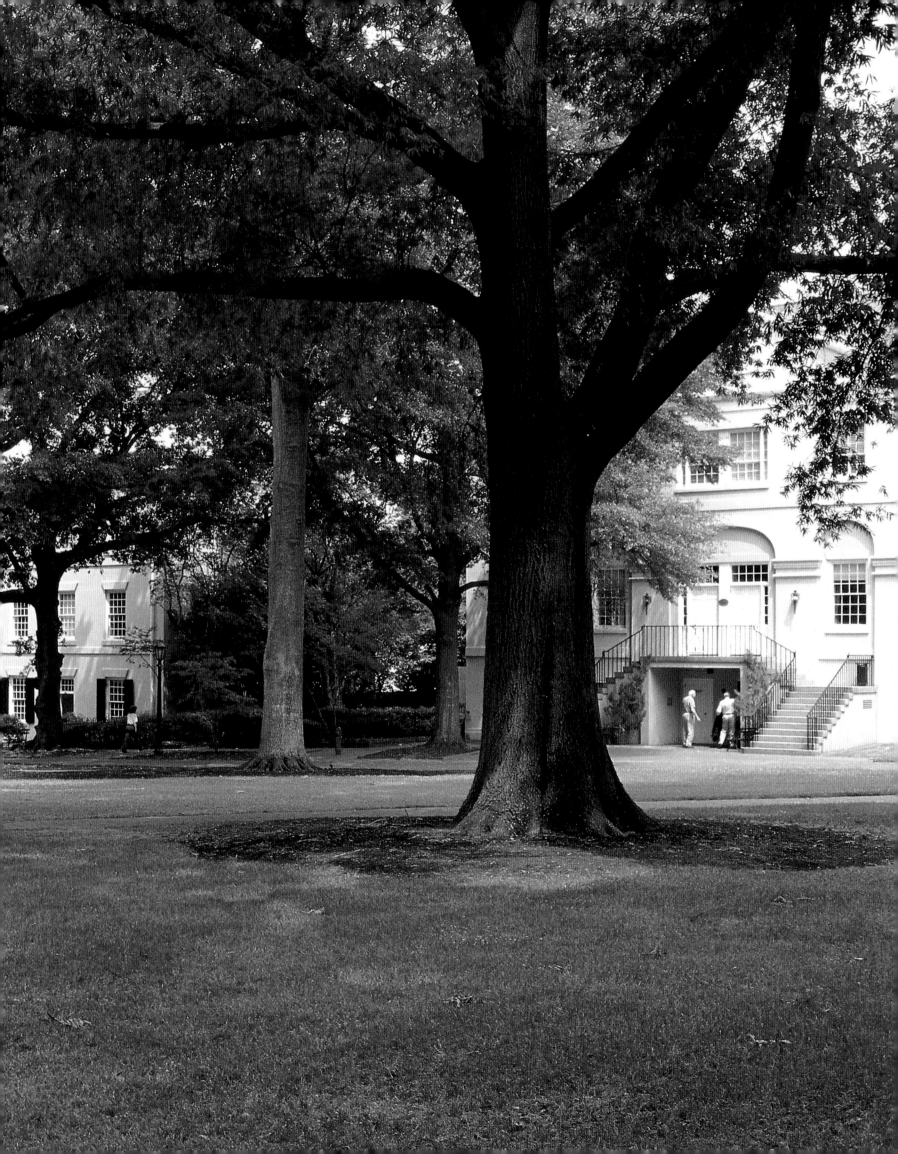

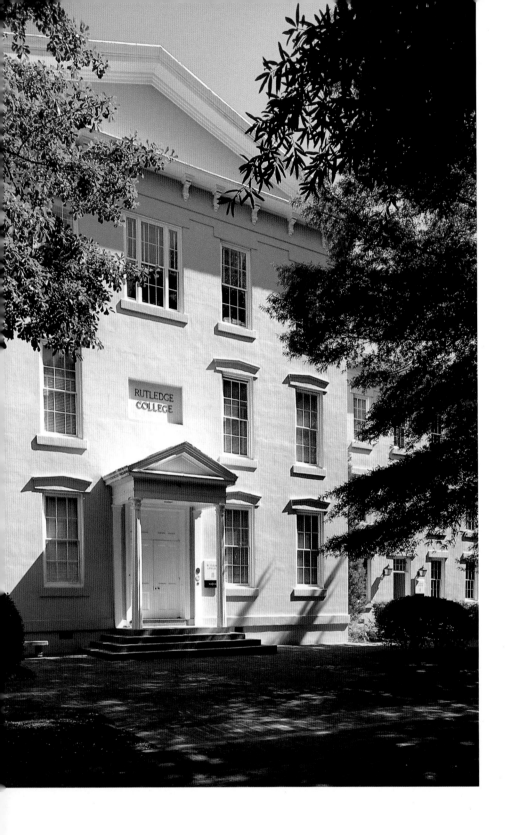

The first building on the Carolina campus, Rutledge was built in 1805 to accommodate about fifty students and faculty. The building was destroyed by fire in 1855 and rebuilt immediately. Named for 18th-century South Carolina statesmen and brothers John and Edward Rutledge, the building now houses the University chapel and Religious Studies department.

A tiny bird perches on the tail of a metal weathervane gamecock, catching the breeze atop DeSaussure, USC's second oldest building, situated on the Horseshoe. The 1809 structure, which accommodates academic space and student dorm rooms, is named for Henry William DeSaussure, a Revolutionary War veteran and South Carolina legislator who was active in establishing South Carolina College.

Right

Built in 1860, Flinn Hall began as a faculty residence and was nearly destroyed by fire when Columbia burned at the end of the Civil War. More than a century later, the building caught fire again and was afterward extensively restored to its former grandeur. Named in honor of former professor William Flinn in 1910, the building now houses Honors College classrooms and the Women's Studies and African-American Studies programs.

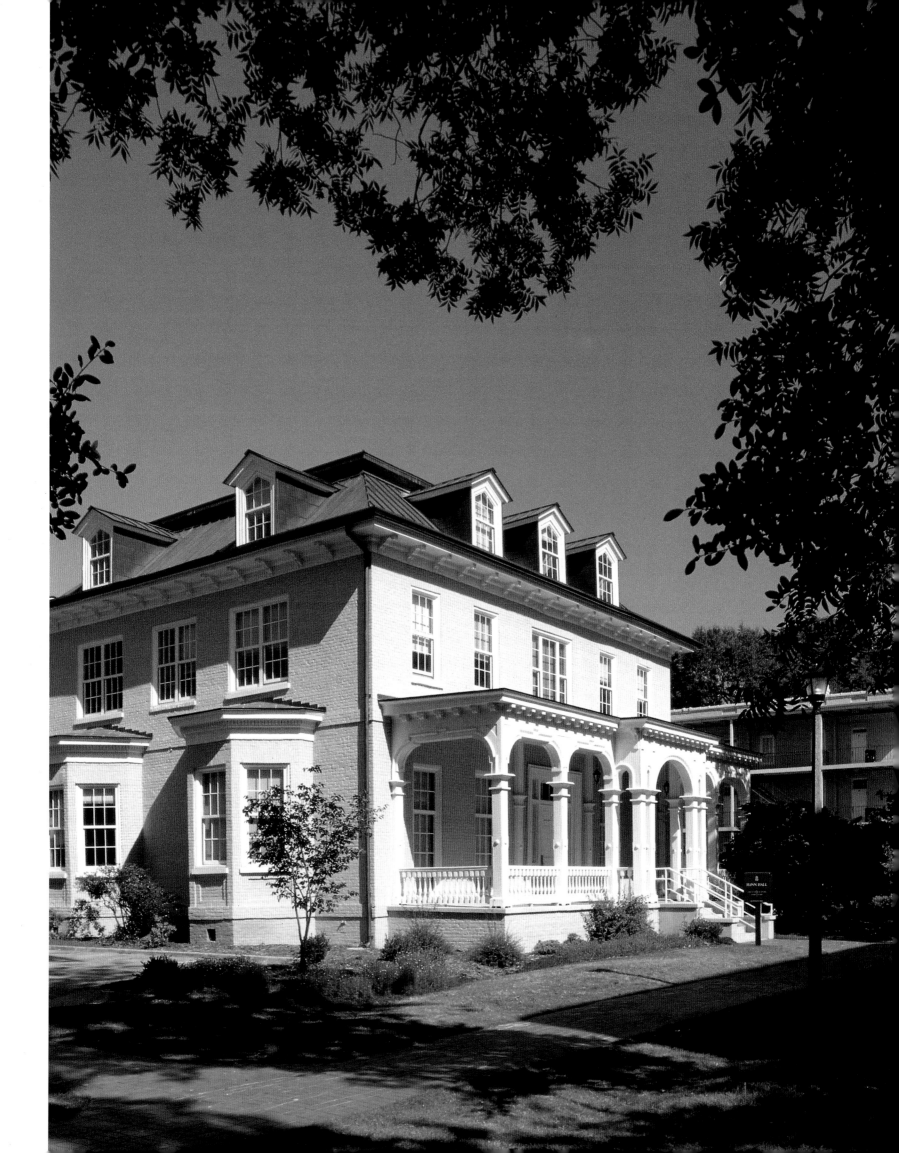

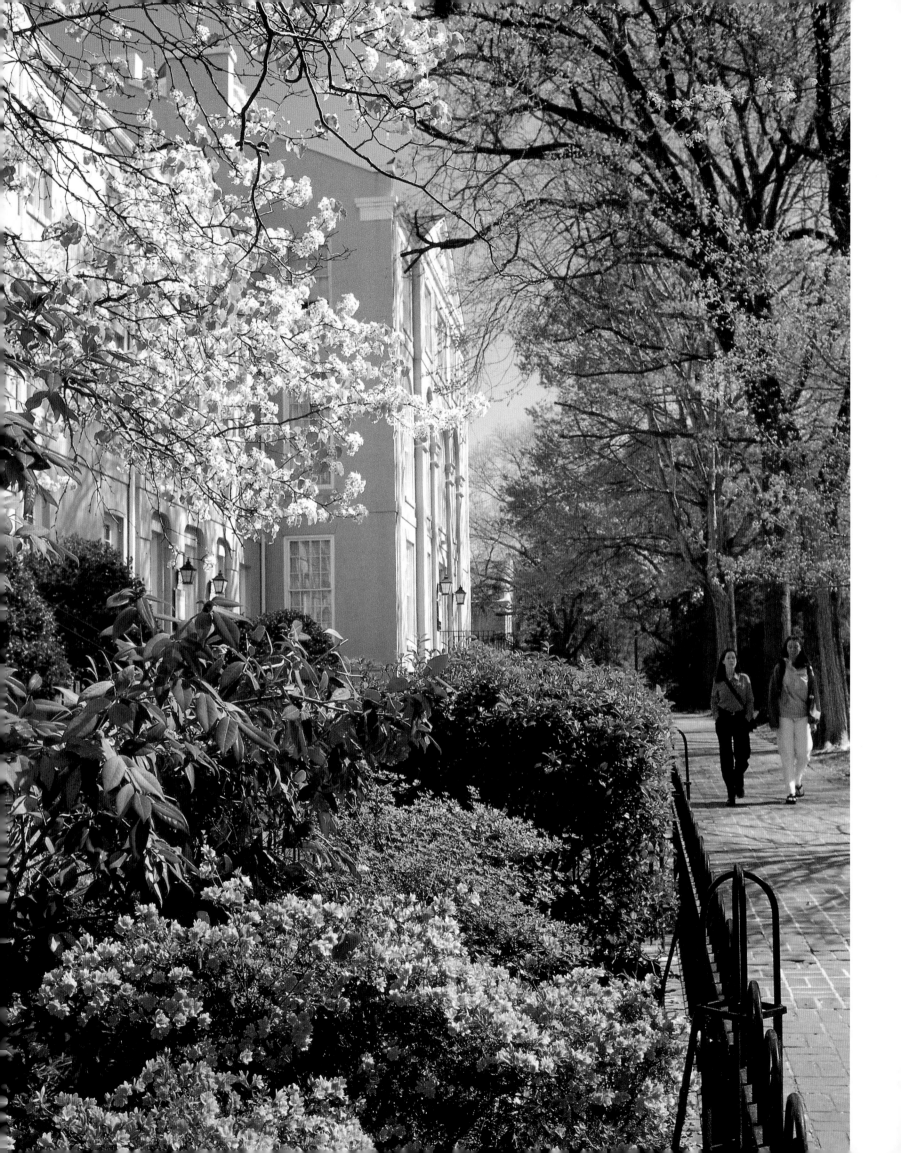

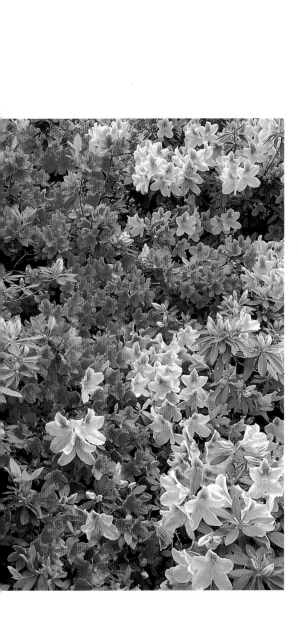

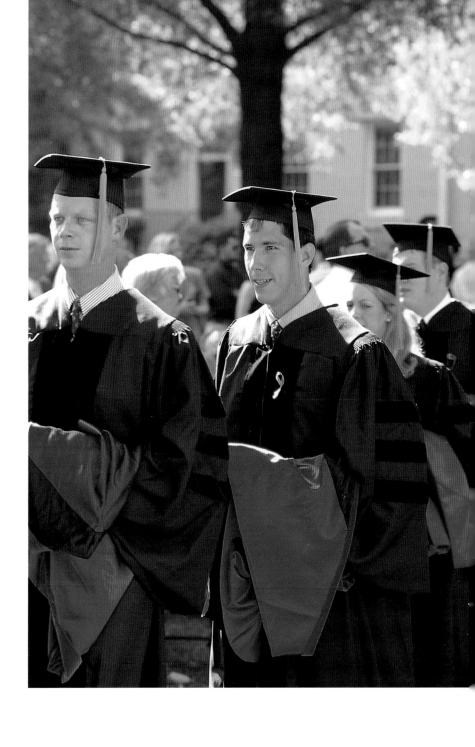

Azaleas, in all of their many hues, are a hallmark of Horseshoe gardens and other green spaces across the Columbia campus.

USC's School of Law, the state's only law school, is also the only major academic unit on campus to hold its commencement on the Horseshoe. The school was authorized in 1820 but did not begin operation until 1867.

Left
Azaleas and dogwoods are close companions on this scenic brick walkway near historic campus buildings.

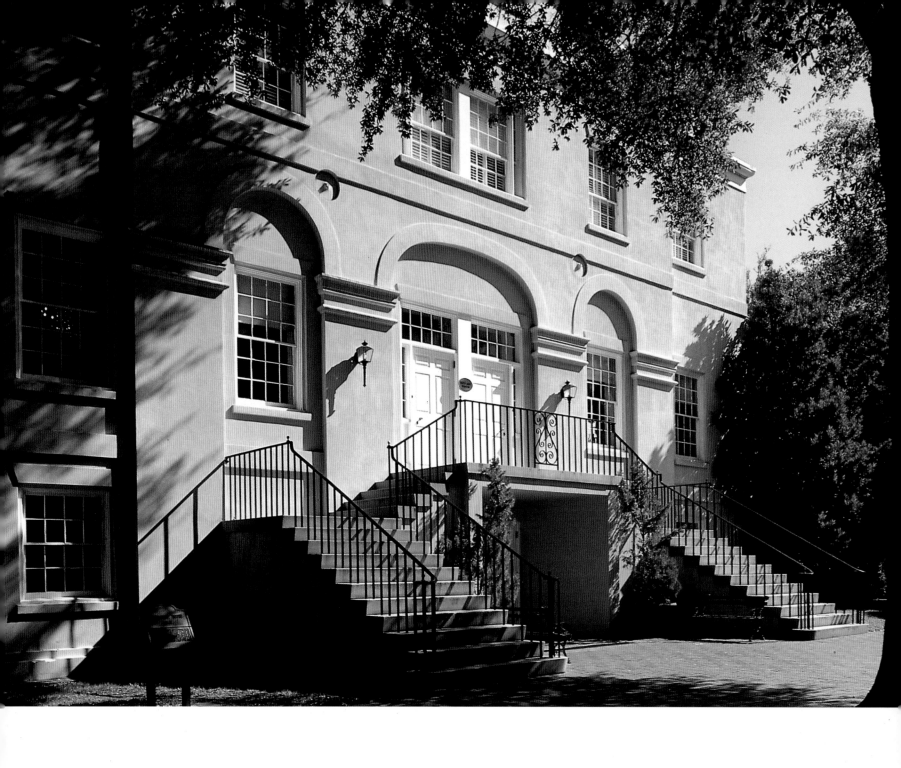

Right

A sundial marks the sunny hours in the Lieber College rose garden, one of several Horseshoe gardens.

A music student conducts a student orchestra concert on the Horseshoe, providing a soothing respite of sound among the giant trees.

Flower petals shed from nearby Bradford pear trees add a floral garnish to outdoor dining tables at the Faculty Club.

Originally a faculty residence, McCutchen House (so named in 1977) was erected in 1813 on the Horseshoe. Professor George McCutchen lived there with his family from 1915 until World War II, when USC stopped offering on-campus housing for faculty. The building, with its distinctive double stairway entrance, now houses the Faculty Club.

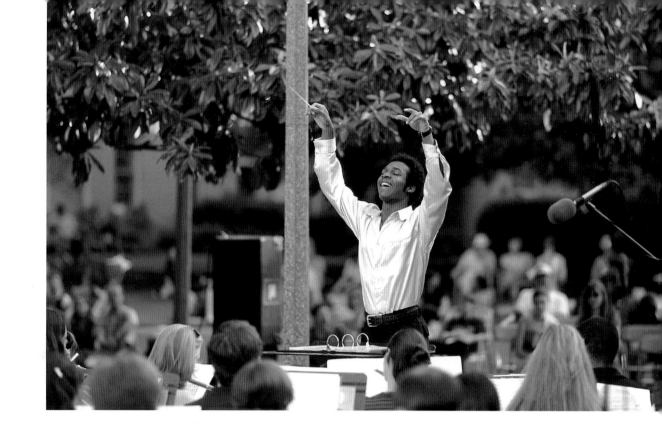

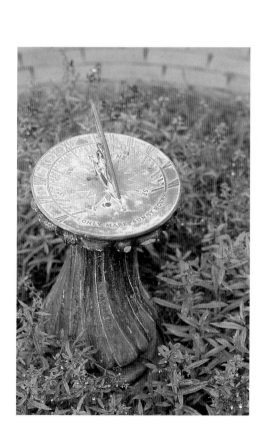

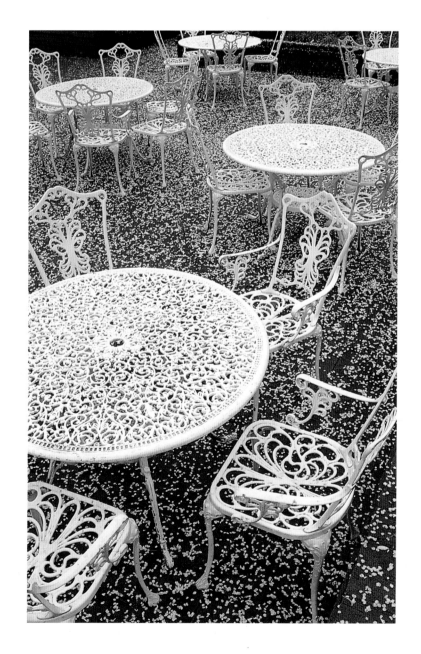

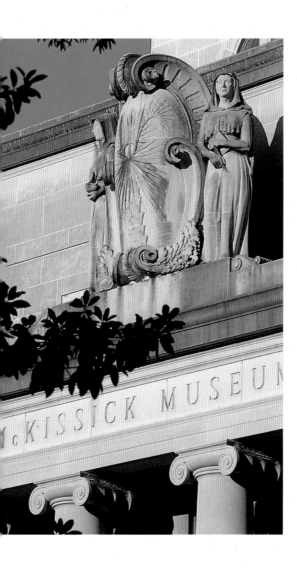

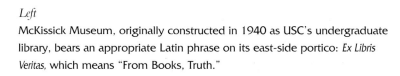

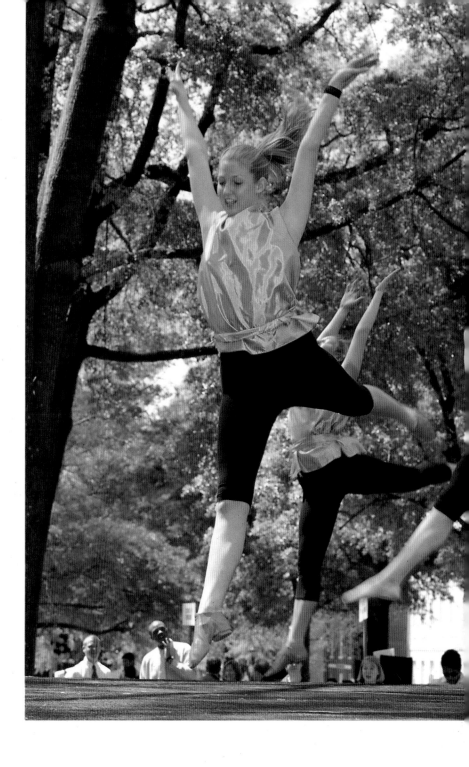

McKissick Museum, originally constructed in 1940 as USC's undergraduate library, bears an appropriate Latin phrase on its east-side portico: *Ex Libris Veritas*, which means "From Books, Truth."

Built as a New Deal project, McKissick was USC's main library until 1976, when Thomas Cooper Library was expanded. The figures of two muses standing on either side of a shield (a standard architectural design detail for Works Progress Administration buildings) are perched above the main entrance to the museum, which exhibits an ever-changing collection of cultural and natural history exhibits.

With a backdrop of live oak trees on the Horseshoe, student dancers give an energetic performance at Showcase, the annual spring fling event that draws thousands of visitors to campus.

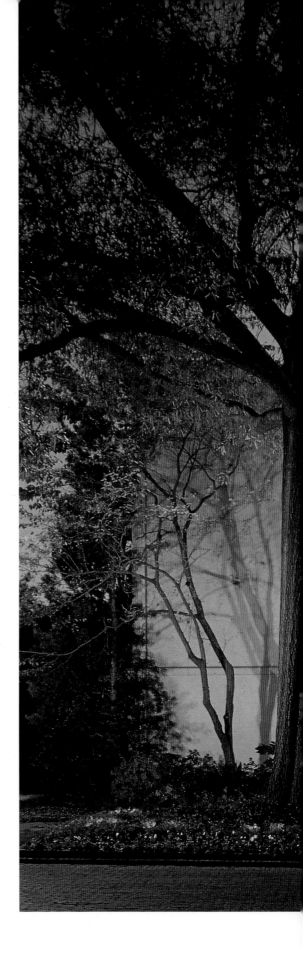

At the home of President and Mrs. John M. Palms, the Christmas tree is decorated almost exclusively with family ornaments, some of them hand-made years ago by their three now-grown children. John and Norma Palms still hang stockings for their children and grandchildren, each one cleverly tagged with a photograph of the intended recipient.

Wreathed in holiday lights and with candles in every window, the President's House glows with holiday spirit. Norma Palms oversees and assists in decorating the house, which is a gathering place for many holiday events.

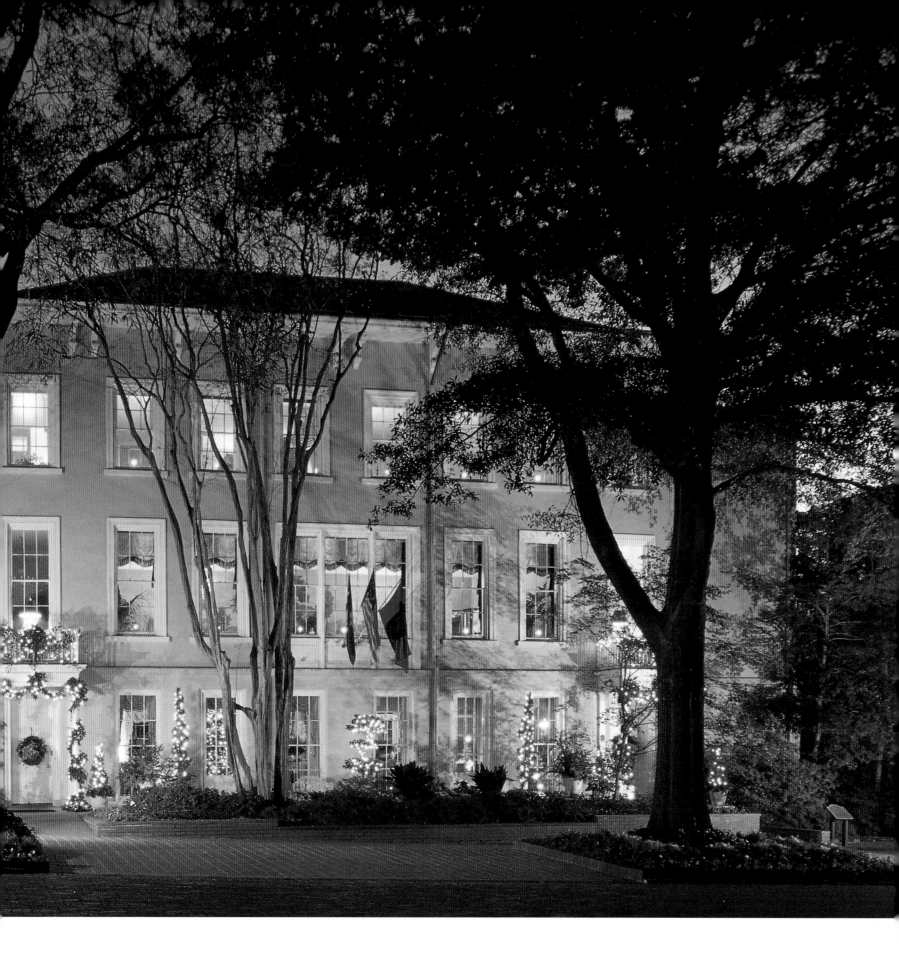

A Japanese maple offers a stunning display of autumn color beside the courtyard near Currell College, just beside the Horseshoe.

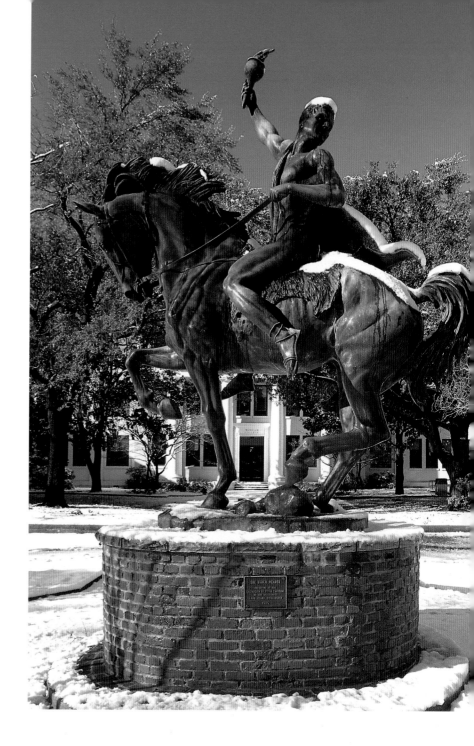

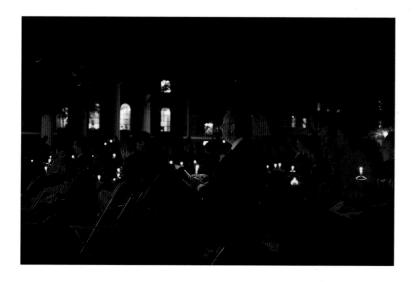

Built in 1956 as a private residence for Flora M. Barringer, this Georgian-style house was acquired by USC in 1972 and was home to the Alumni Association for many years.

Students, faculty, and staff hold candles, sing carols, and get in the holiday spirit during early December for the annual Christmas tree lighting service on the Horseshoe. Student organizations compete in an ornament decorating contest and gather toys and other items that are placed under the tree, then distributed to charities.

Following a rare snowfall in January 2000 that dumped several inches of powdery precipitation on the Midlands, snow gently decorates "The Torch Bearer," a bronze statue in front of Wardlaw College that was donated to the University in 1965 by its sculptor, Anna Hyatt Huntington.

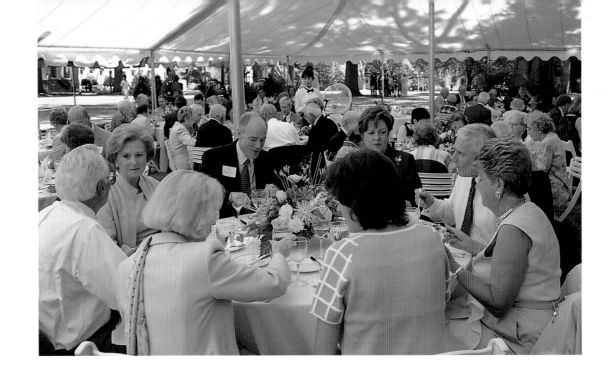

Members of the Horseshoe Society gather each spring to recognize new and continuing supporters of the University. All Horseshoe Society members have made cumulative gifts of $100,000 or more to the University.

A special social event hosted each spring by President and Mrs. Palms draws alumni from Richland and Lexington Counties to the President's House. About one-fourth of all USC alumni live in the two counties.

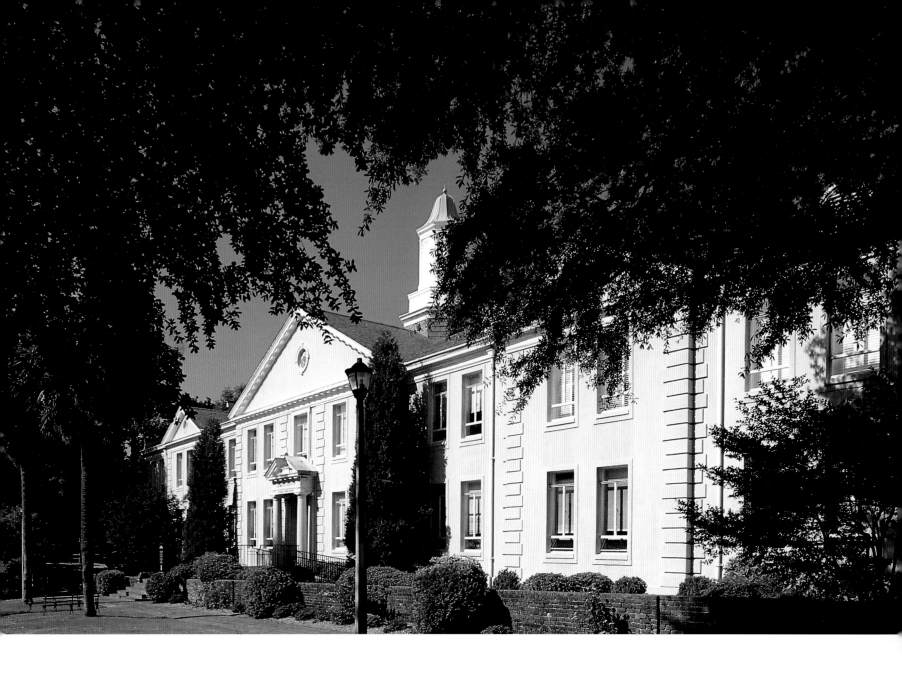

Home of the University's chief administrative offices, the Osborne
Administration Building was built in 1952 and is named for Rutledge
Osborne (1895–1984), a member of the Class of 1916 and chair of the
Board of Trustees from 1952 to 1970.

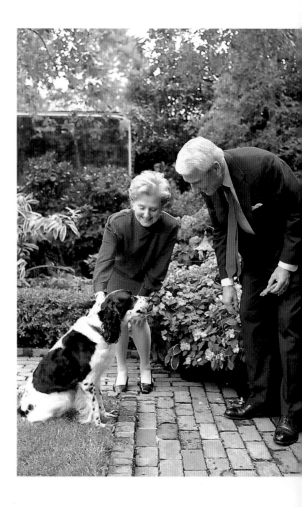

A Lady Banks climbing rose, profuse with yellow blooms, cascades over a corner of the President's House garden, with pansies and azaleas adding to the colorful palette.

Lady Carolina, John and Norma Palms's springer spaniel, enjoys attention from her masters and an occasional romp on the Horseshoe with Carolina students. The dog joined the Palms family as a puppy in December 1991, not long after their arrival at USC.

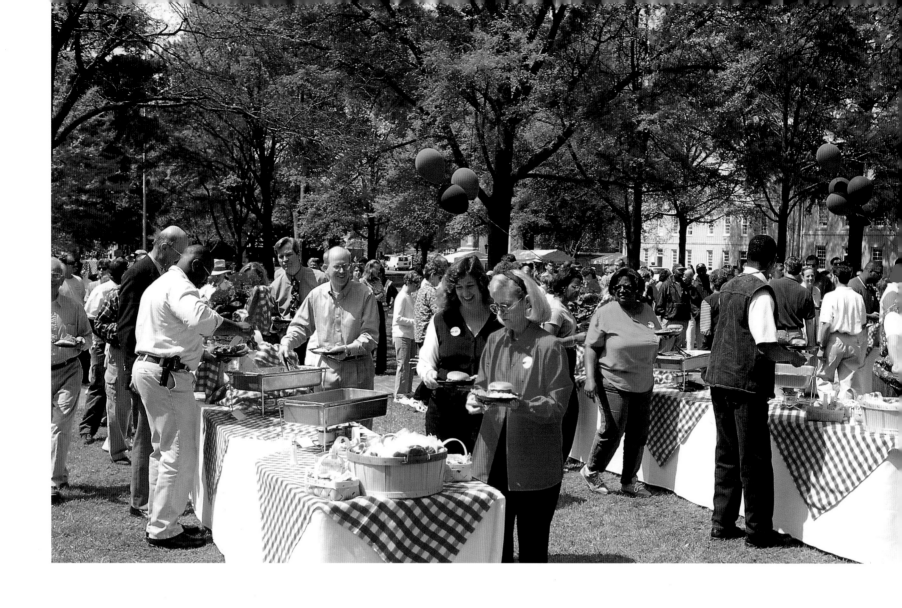

With an invitation from President and Mrs. Palms, faculty and staff congregate on the Horseshoe every year for an annual picnic that celebrates the efforts of every member of the Carolina community.

Flourishing in the Lieber College garden on the Horseshoe, these gorgeous rosebushes honor deceased members of the Columbia Garden Club. Club members supply the bushes and the meticulous care necessary to maintain the stunning blooms.

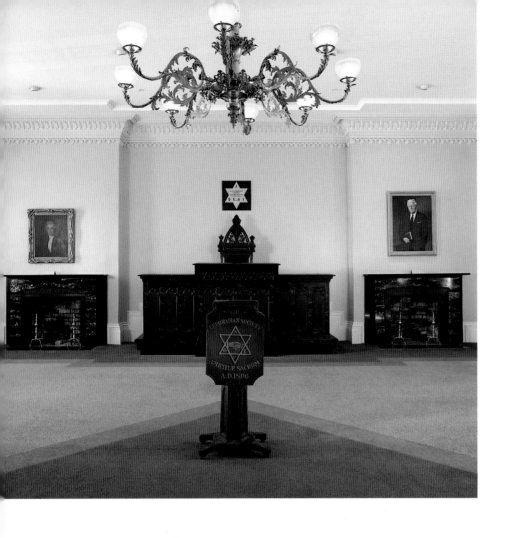

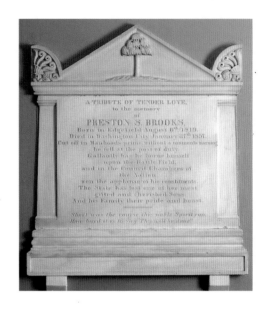

Maple leaves decorate a stretch of sidewalk on the Horseshoe—a sure sign of autumn and a new academic year.

The L. Marion Gressette Euphradian Society Hall, located on the third floor of Harper College, is the original home of the Euphradian Society, a student debating group that began shortly after South Carolina College opened its doors. Gressette, a 1924 graduate and vice president of the Euphradian Society, served more than fifty years in the South Carolina General Assembly before his death in 1984.

A memorial plaque to Preston Brooks, one of South Carolina's famous antebellum Congressmen, is on permanent display in the foyer of the South Caroliniana Library. Though Brooks was an accomplished scholar, his penchant for mischief resulted in his 1839 expulsion without a degree from South Carolina College.

Right
A wrought-iron gate in front of Lieber College opens to the University's admissions office, which fields applications from all fifty states and from around the world.

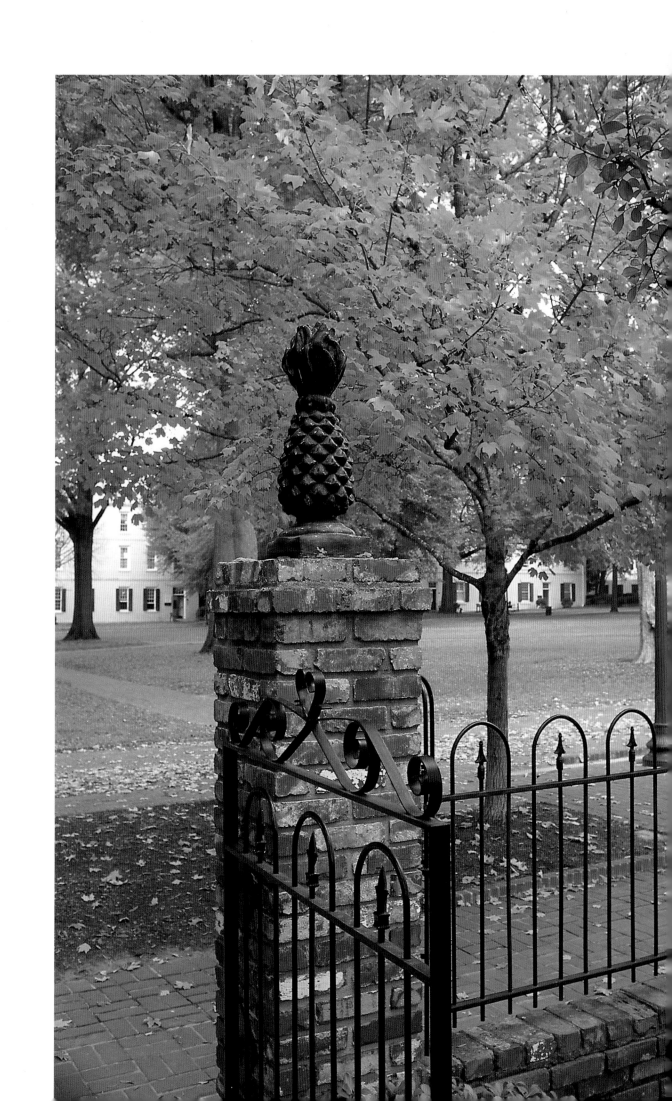

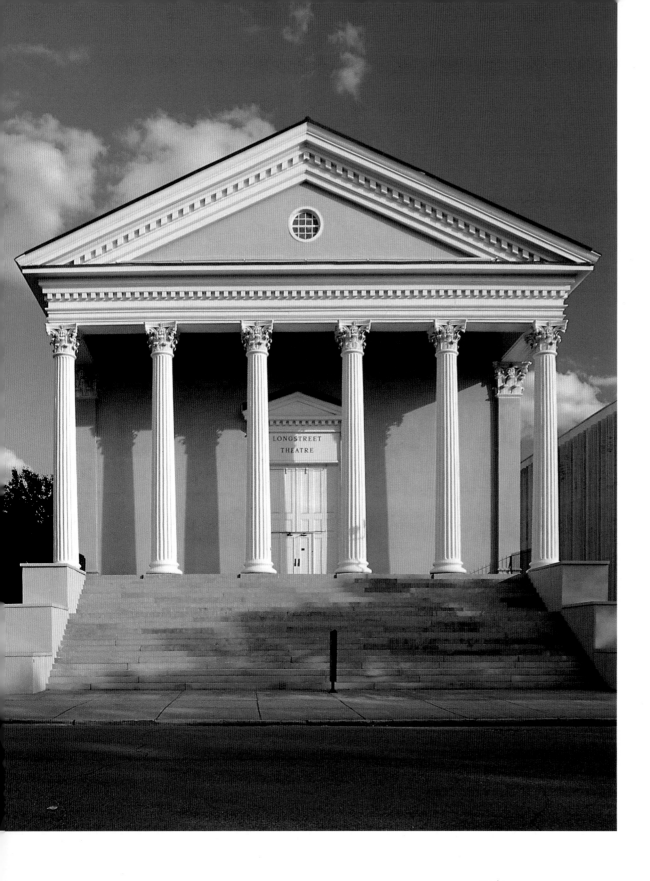

With its Roman temple features and signature Corinthian columns, Longstreet Theatre is a familiar landmark on Sumter Street and home to many USC theatre productions.

Built in 1930 as the home of USC's School of Education, Wardlaw College also housed University High School from 1932 to 1966. Wardlaw now is the classroom, office building, and museum site for the College of Education. The building is named for Patterson Wardlaw, a former USC education dean and professor.

For thirty-four years this clock mounted atop present-day Wardlaw marked the hours for students who attended University High School there. The school, jointly operated by USC and the Columbia public school system, provided practice teaching opportunities for USC education majors.

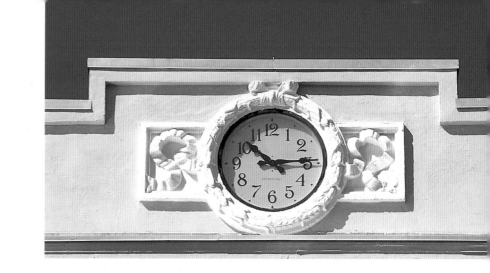

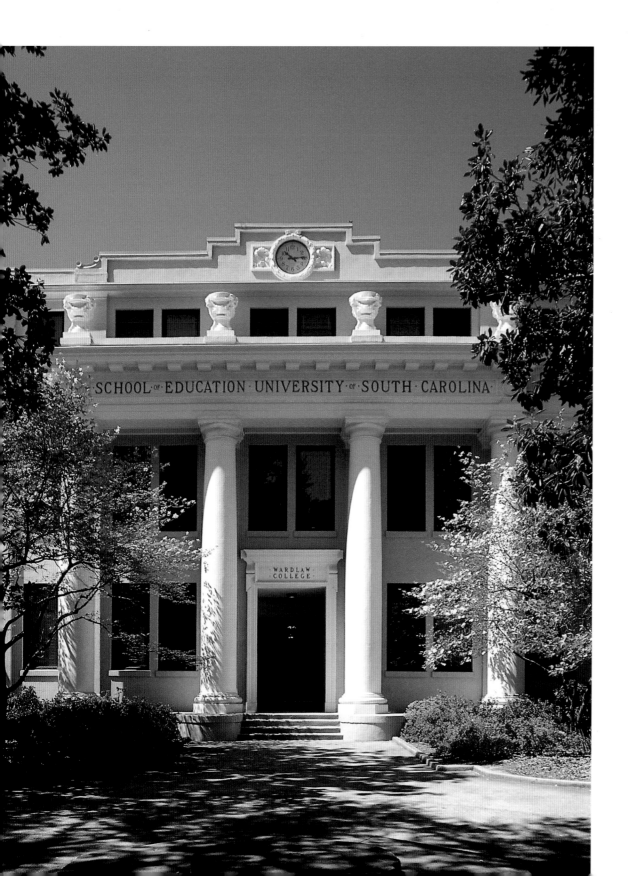

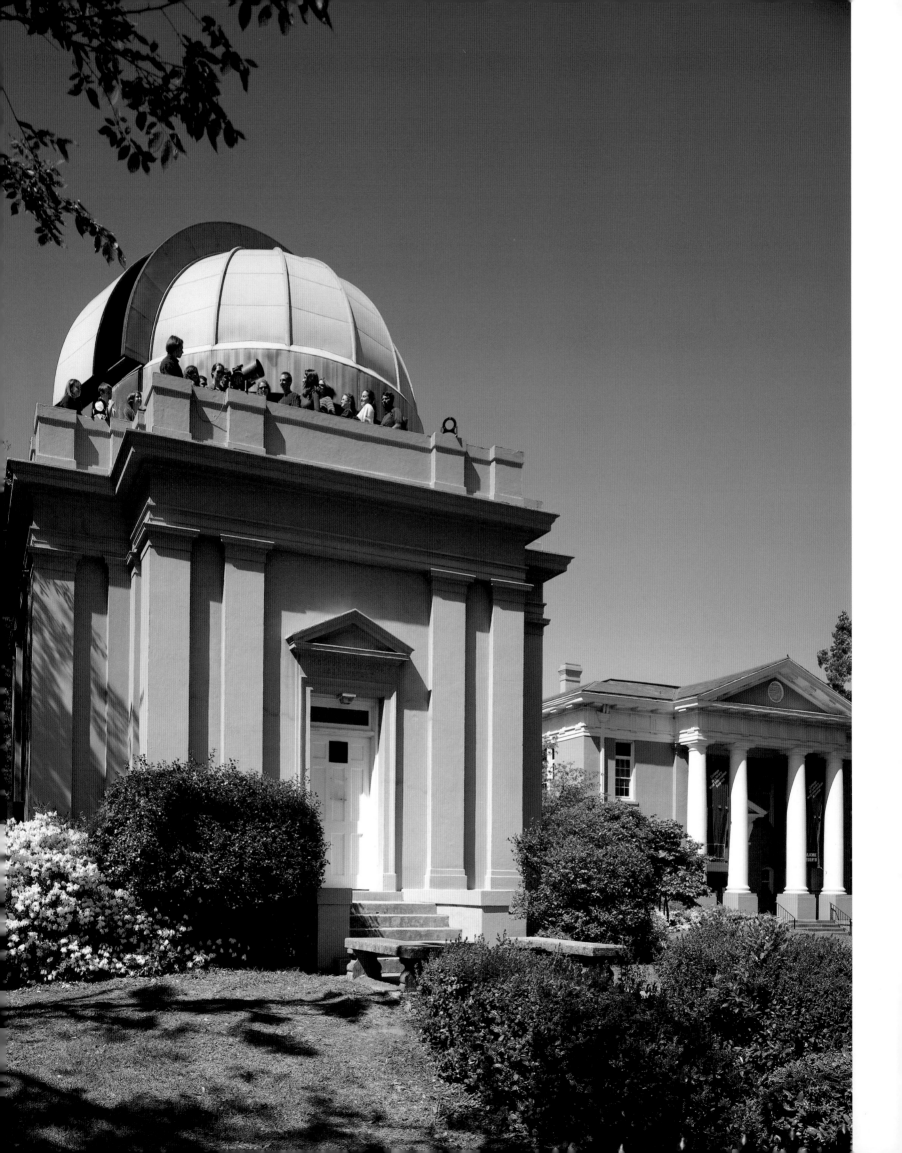

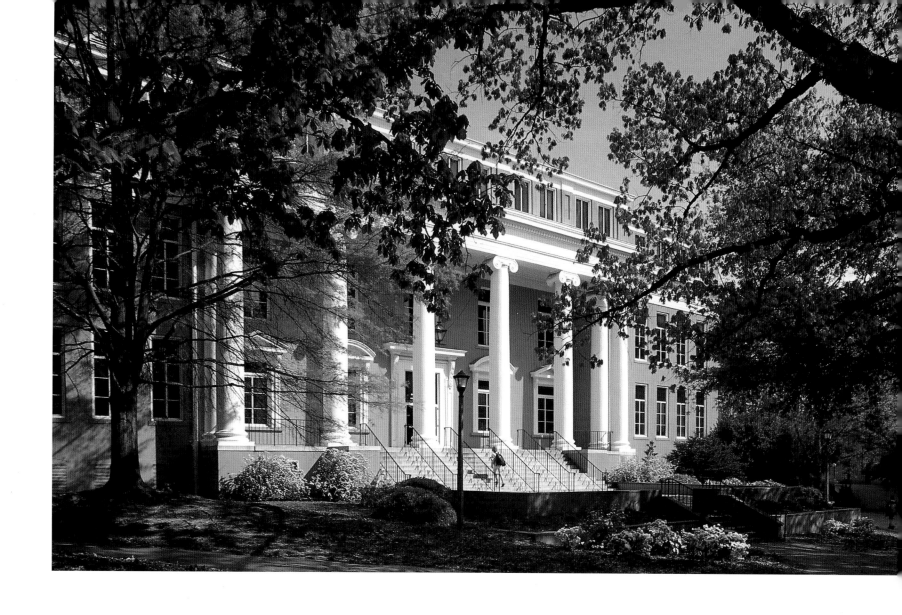

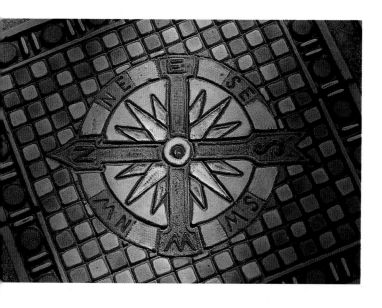

Left

The Melton Observatory's weathered copper dome is a familiar landmark near Davis College. The observatory, built in 1928, is named for William Davis Melton, USC's president from 1922 to 1926, and features a sixteen-inch diameter telescope. On clear Monday nights, the observatory opens its doors for the public to get an up-close look at the skies above Columbia.

Molded into the sidewalk on the south entrance to the Melton Observatory, this well-worn compass helps star-gazers maintain a celestial sense of direction.

The home of USC's psychology department, Barnwell College was built in 1910 as a science hall. The building is named for Robert W. Barnwell, South Carolina College's third president (1835–1841), who spearheaded construction of the South Caroliniana Library.

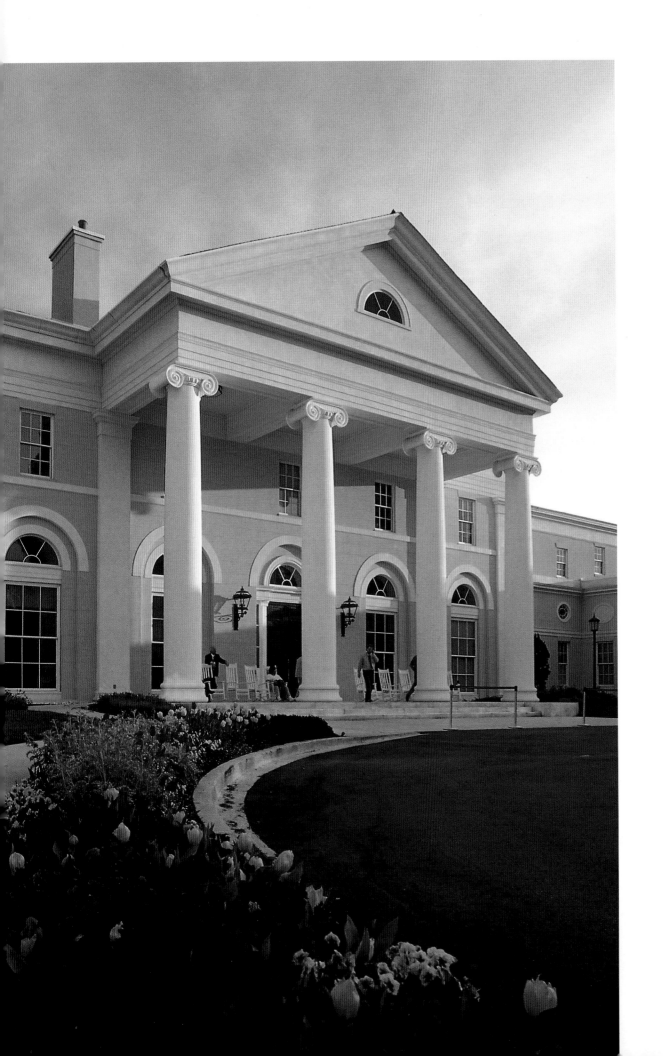

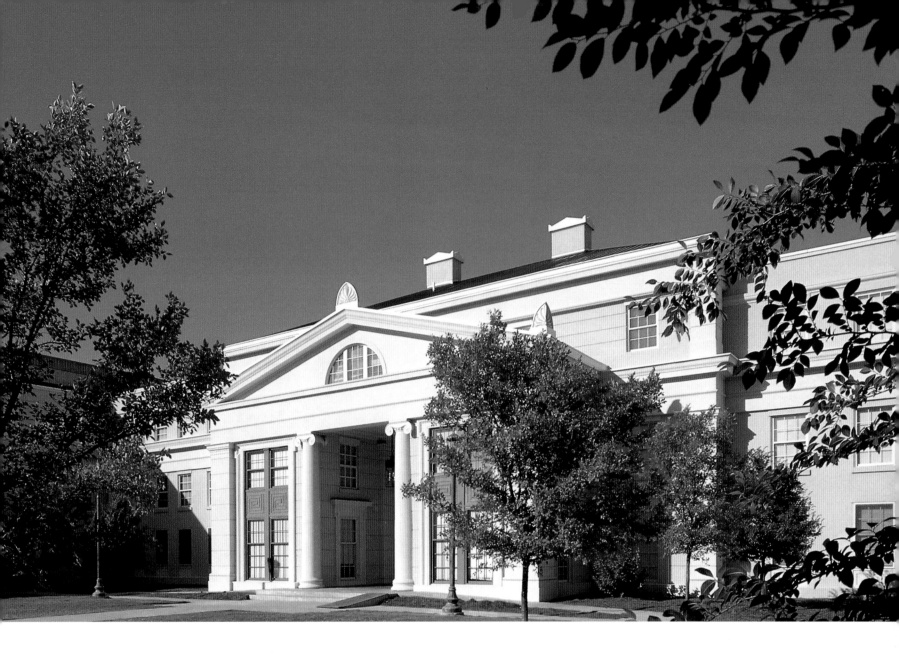

The United States Justice Department's National Advocacy Center relocated from Washington, D.C., to the USC campus in 1998 and serves as the training center for some 15,000 federal and state lawyers and prosecutors annually.

One of the newest and most popular residence halls, South Quad offers apartment-style living with on-campus convenience. The 400-bed dorm is located on Sumter Street beside the Blossom Street parking garage.

An acroterium adorns a roofline corner of South Quad. Featuring a stucco exterior and classic styling, South Quad's architecture mirrors that of 19th-century Horseshoe buildings.

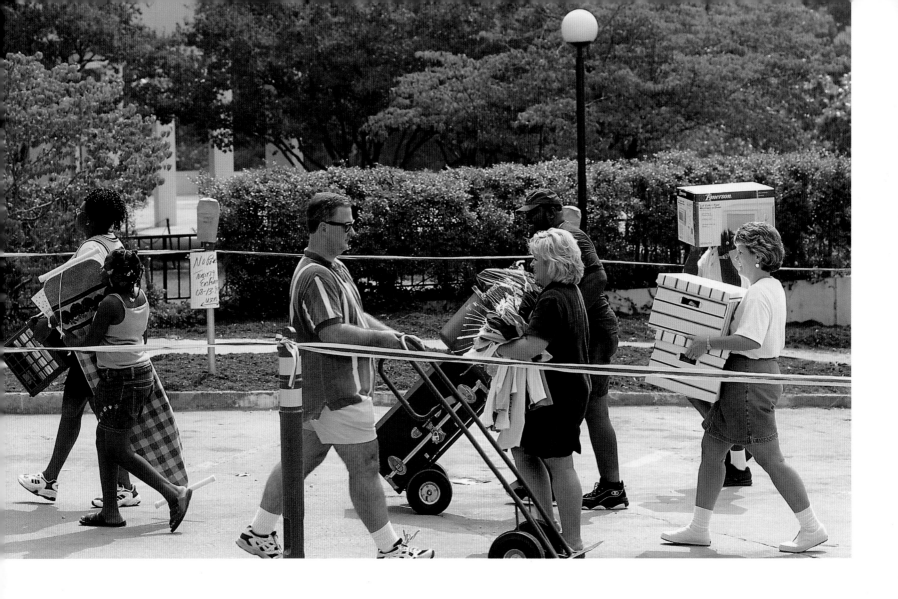

Arriving on campus during the heat of August, Carolina students, along with their friends and families, lug trunks, boxes, and other belongings to their residence hall rooms to begin the fall semester. Since 1994, faculty and staff volunteers have joined in the fray, helping first-year students and their families carry load after load from cars to dorm rooms.

Built in 1967, women's dormitory Patterson Hall was first called South Building but was renamed for William H. Patterson, USC's long-time administrator and its 24th president, from 1974 to 1977.

Right
Construction of Preston College in 1939 was among several campus building projects partly funded by the Public Works Administration during the Depression. The residence hall was extensively renovated in the mid-1990s and is now home of USC's popular residential college, where students live in an intellectually stimulating community.

A hand-painted banner attached to the historic campus wall invites alumni to remember their days at Carolina as part of Homecoming Weekend festivities.

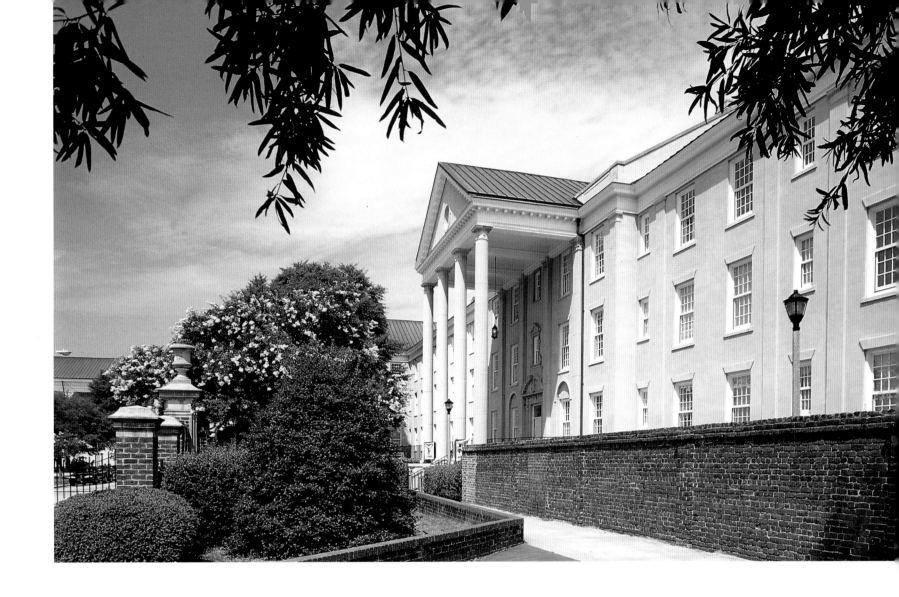

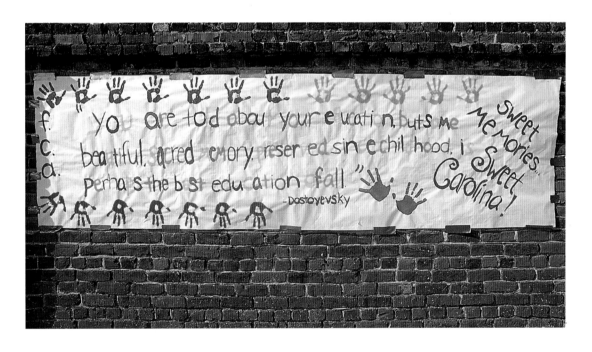

You are told about your education, but some beautiful, sacred memory, preserved since childhood, is perhaps the best education of all.

—Dostoyevsky

Sweet memories... Sweet Carolina!

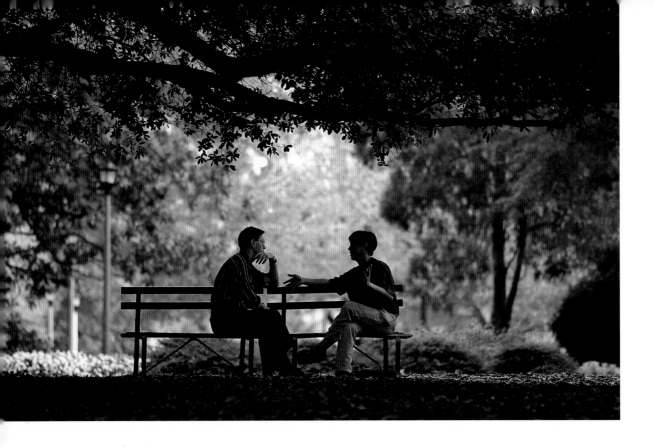

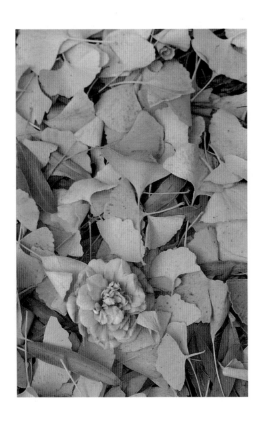

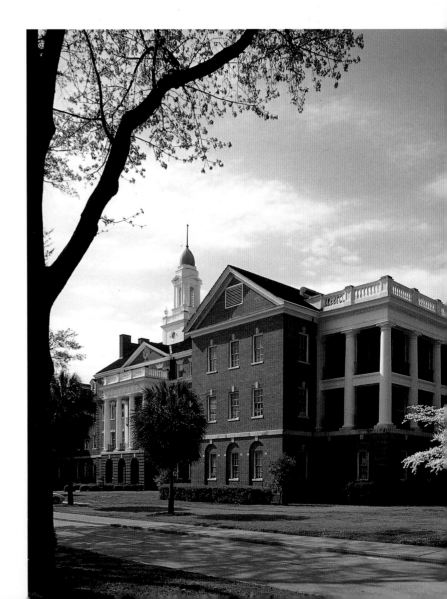

Overleaf
The midnight oil burns every night at Thomas Cooper Library, the heart of USC's academic life. USC libraries are ranked 47th in the country for overall quality among research libraries and 31st among libraries at public universities.

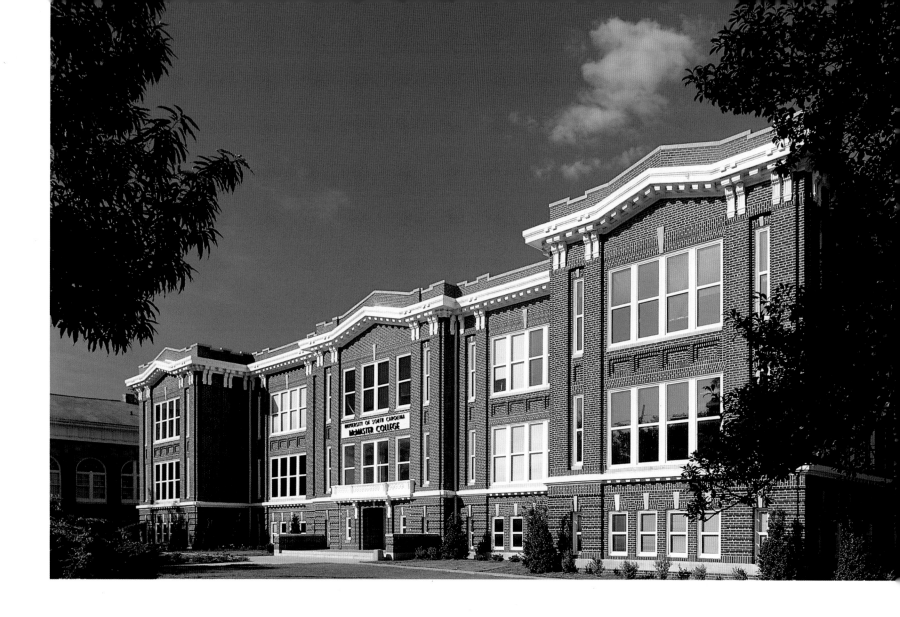

A bench near Gibbes Green offers a quiet, still place for conversation. An island of trees, hillocks, and manicured lawns on the east side of campus, Gibbes Green is named for Hampton Gibbes, whose land was purchased by the University in 1833.

A pink camellia blossom is nestled in a bed of yellow ginkgo leaves near the Horseshoe. USC's Havilah and Alice Babcock Memorial Camellia Garden features several camellia hybrids that the legendary English professor, Mr. Babcock, tended in their backyard. Years after Babcock's death, when his house was about to be demolished, the bushes were transplanted to campus.

The USC School of Medicine campus is located east of the Columbia campus beside the Dorn Veterans Administration Hospital. The school was chartered by the General Assembly in 1974 and graduated its first class in 1981.

The original section of McMaster was built in 1911 as Richland County's first public grammar school, then acquired by USC in 1960. The building was renovated, and a large addition with similar architectural style was completed in 1999 to become home of the Department of Art.

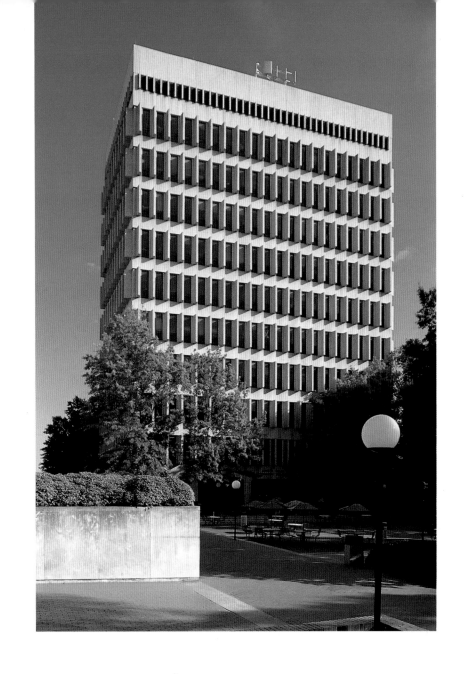

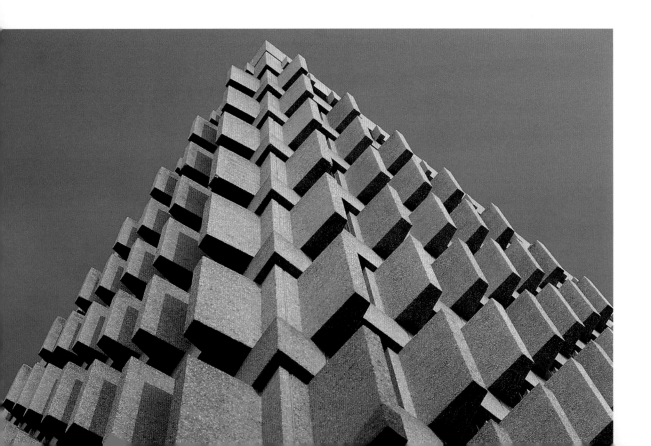

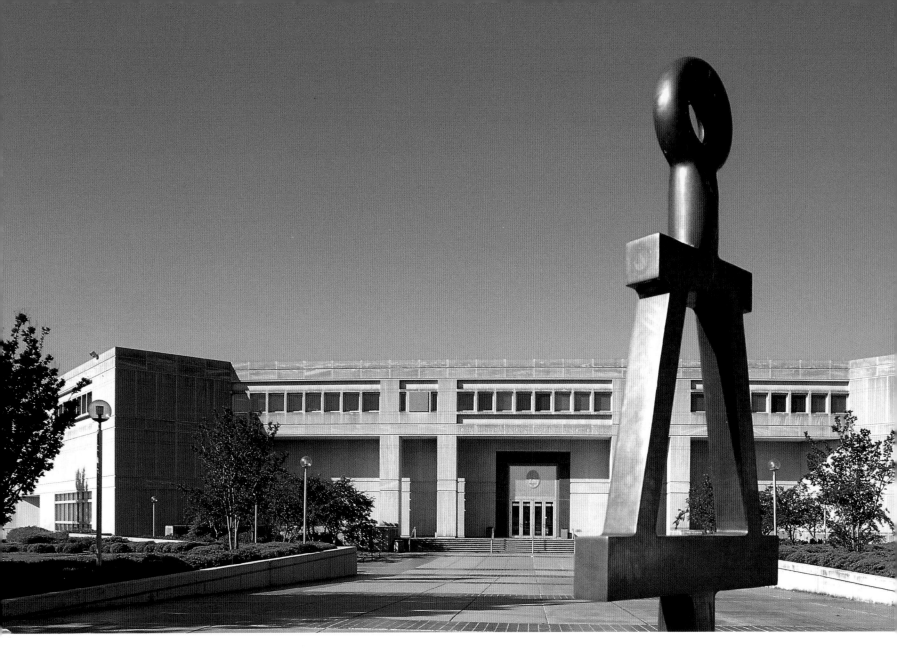

Left

The John R. Welsh Humanities Office Building provides office space for many faculty in USC's College of Liberal Arts and is adjacent to the Humanities Classroom Building. Both facilities were built in 1968 on the campus's east mall and were named for John R. Welsh, a University faculty member and administrator from 1949 until his death in 1974.

Stone fins projecting from the sides of the Welsh Humanities Office Building create eye-catching angles and shield the windows from summer's blistering sunlight.

With its facade of Alabama limestone and 210,000 square feet of labs, classrooms, and office space, the Swearingen Engineering Center is an imposing landmark on the southern side of the USC campus. The center is named for John E. Swearingen, a 1938 graduate and former chairman of Standard Oil Company of Indiana.

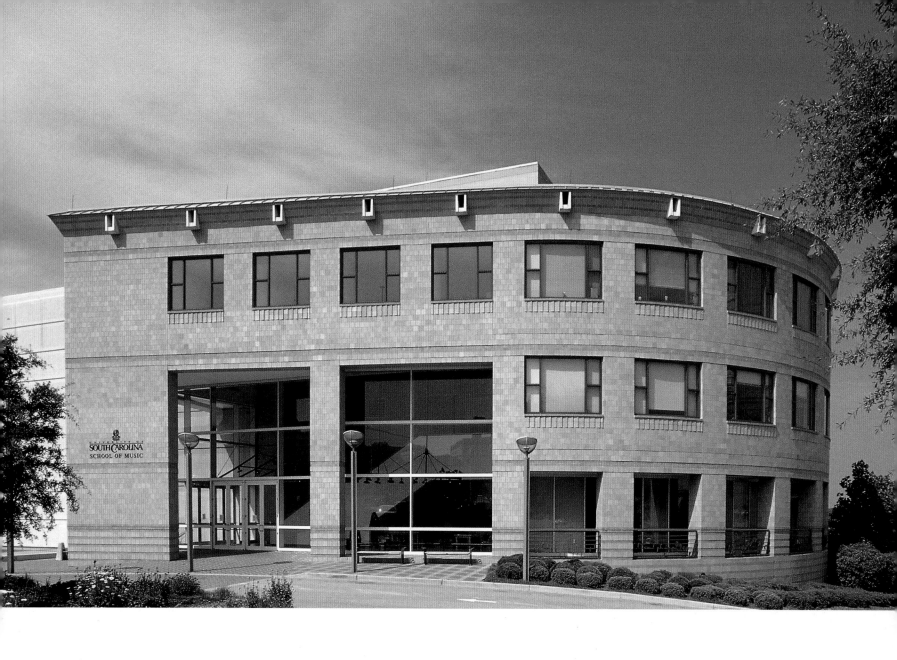

Completed in 1995, the School of Music Building features performance and recording studios, a recital hall, and special rehearsal rooms for chamber, opera, chorus, and instrumental ensembles. The 58,000-square-foot building adjoins the Koger Center for the Arts.

Right
Senior music performance students gather on the Horseshoe in the spring for a traditional senior concert. Each of the students takes a turn at conducting the mini-orchestra.

USC's Band Hall, located on Main Street a short distance from the marching band's practice field, has been used as a practice facility since the 1960s. The building, which sports six different musical notations on its outside walls, also houses the USC String Project, which offers string instruction for Columbia-area school children.

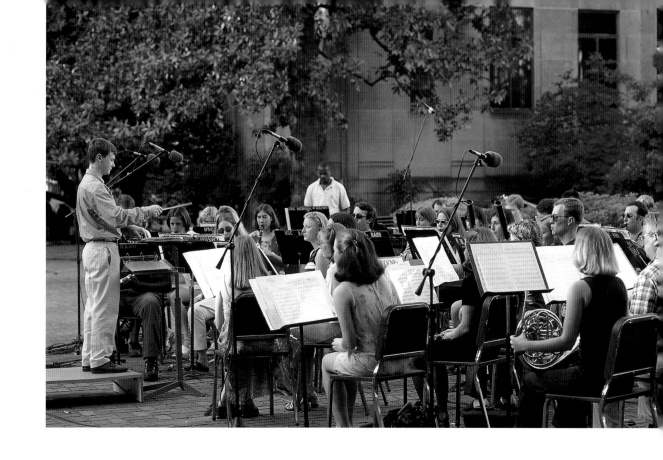
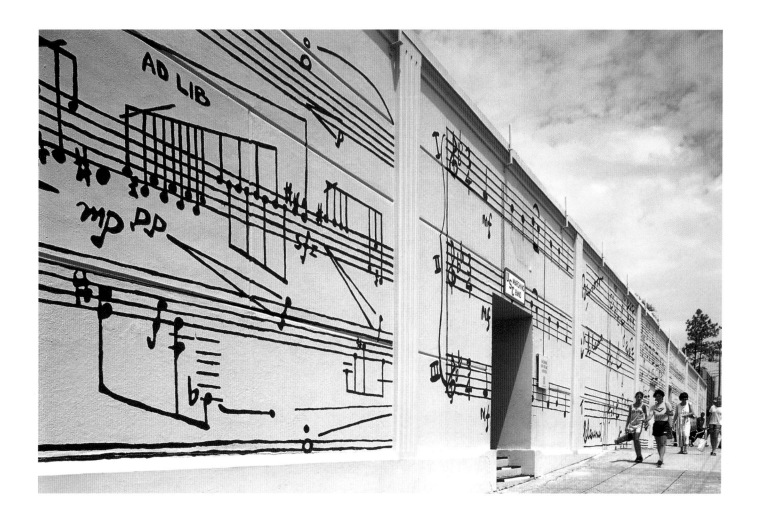

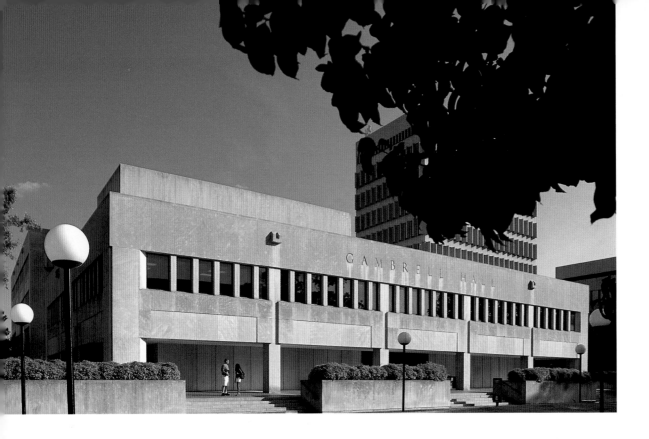

Built in 1976 on the east end of campus, Gambrell Hall provides class-room, office, and computer lab space for several departments in the College of Liberal Arts. The 140,000-square-foot building is named for Mary Latimer Gambrell, sister of E. Smythe Gambrell, Class of 1915, whose gift launched the building's construction.

The twin eight-story Close-Hipp Buildings house The Darla Moore School of Business, named for the Class of 1975 alumna who donated $25 million for academic enhancement of the business school.

Right
With late-summer blooms of a crape myrtle overhead and the soothing sounds of a fountain nearby, a student relaxes beside the reflecting pool in front of Thomas Cooper Library.

Overleaf
The eighteen-story Capstone House (below left) with its distinctive revolving top is an unmistakable landmark in any aerial view of campus. The circular top floor—whose rotating mechanism was acquired from the New York World's Fair—once served as an elegant public restaurant and is still used for private parties. Beyond Capstone to the south (upper center) rises the residential South Tower on Blossom Street. Diagonally across the spread is the dome of McKissick Museum, and toward the west (upper right), the square expanse of the Carolina Coliseum.

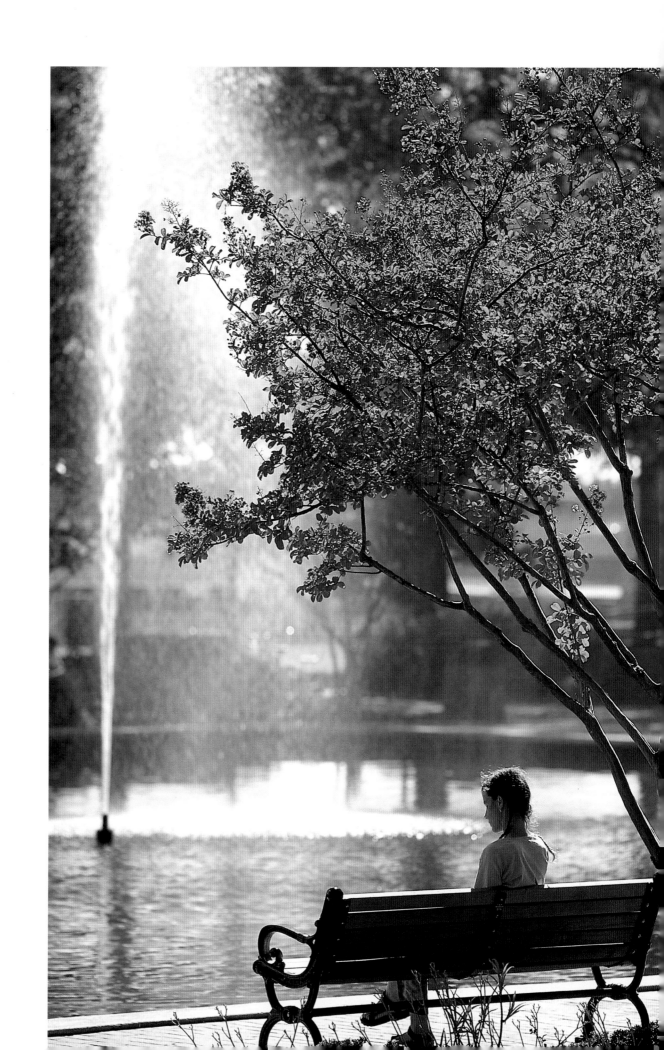

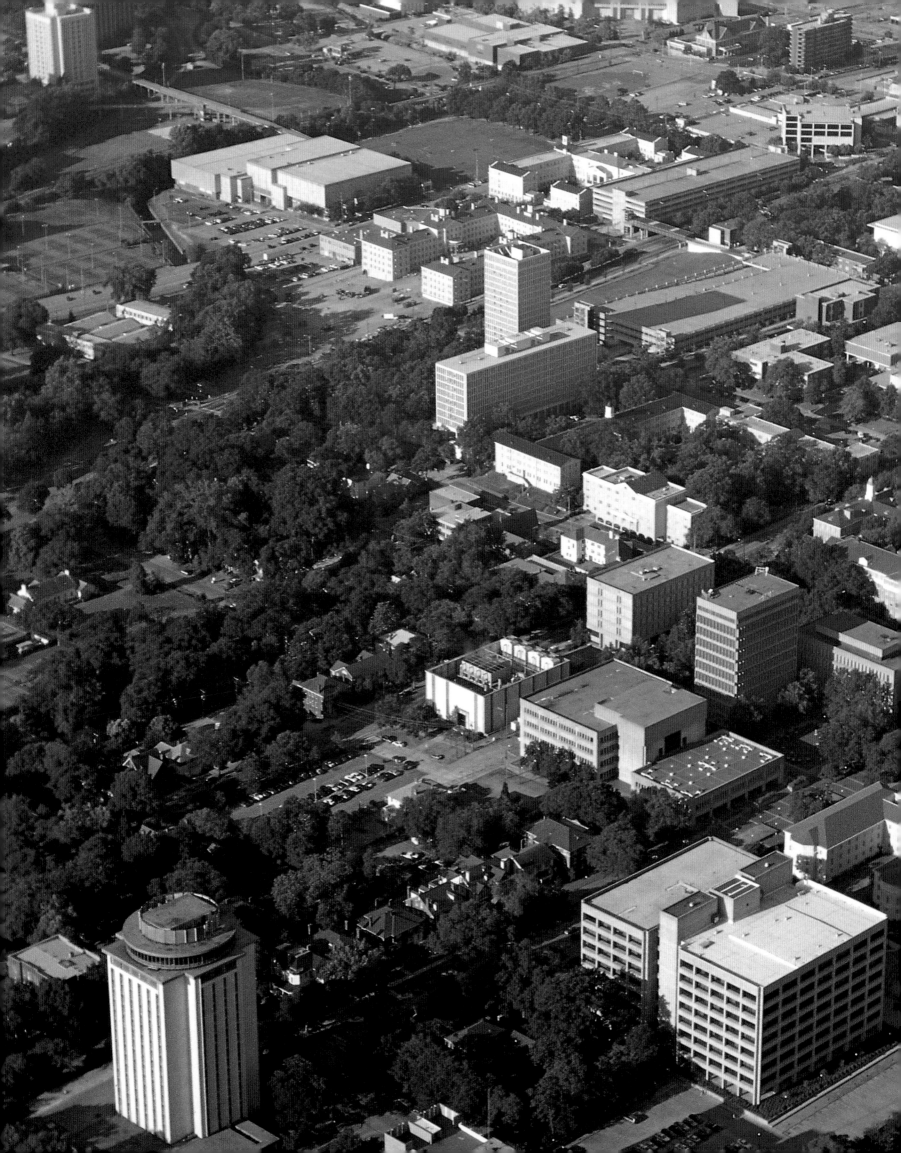

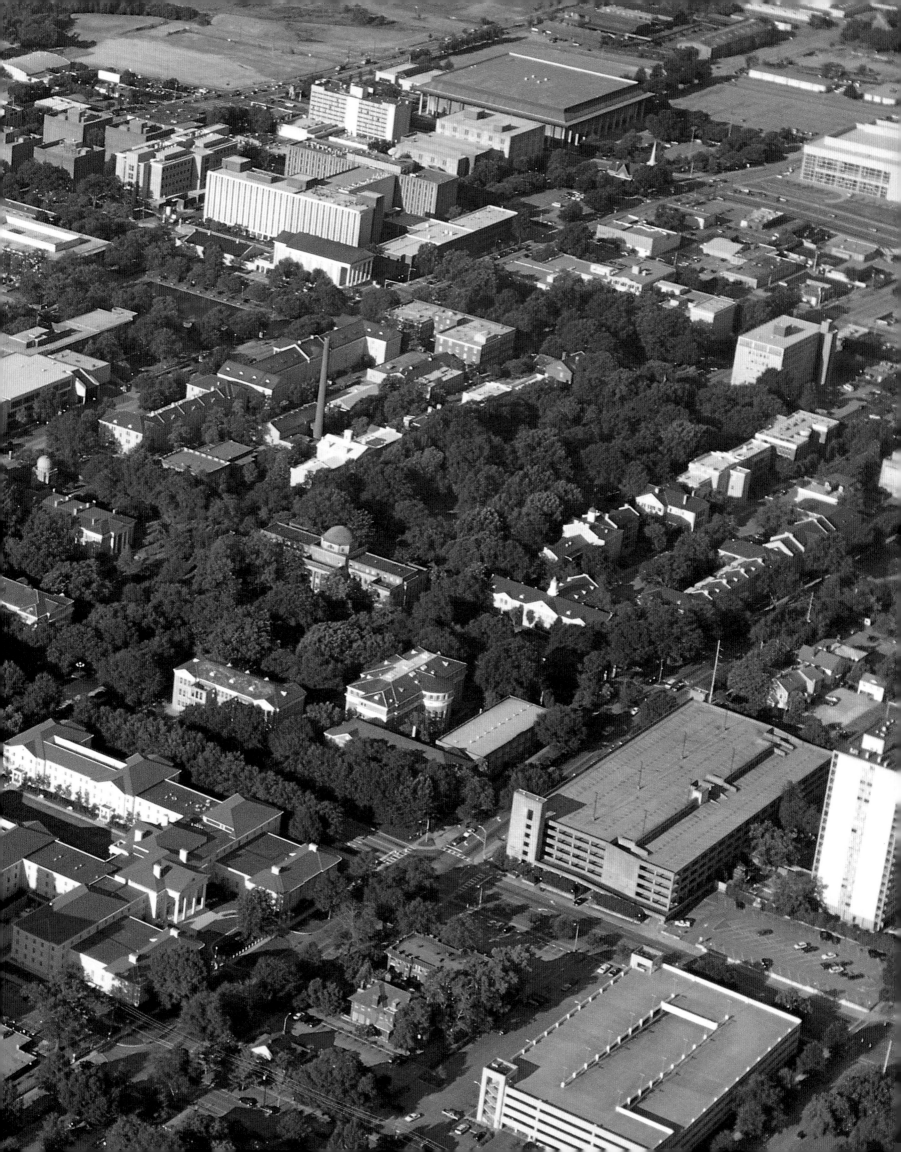

The six-story Williams-Brice College of Nursing Building was launched with a gift from the estate of Martha Williams Brice of Sumter. The building includes classrooms, labs, and a 300-seat auditorium.

With its gushing flow and underwater lights, the Law School fountain, built in the mid-1970s, provides a visual and auditory treat for students and visitors walking through the tunnel beneath Assembly Street.

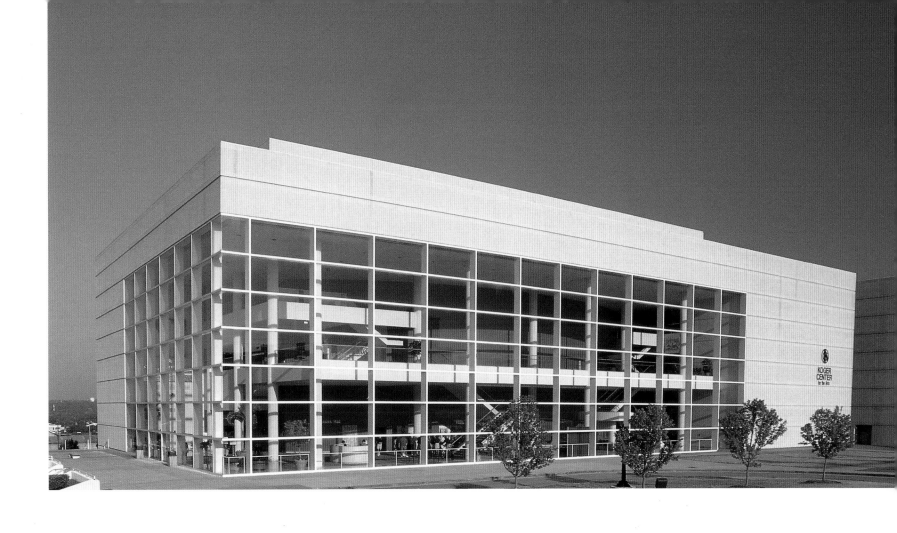

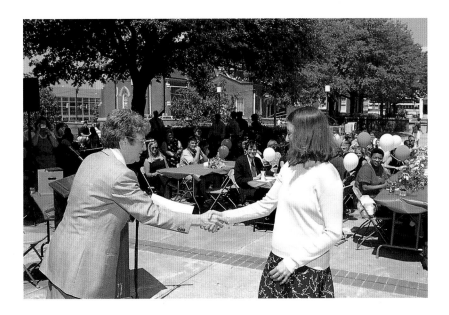

The premier venue for Columbia's performing arts scene, USC's Koger Center for the Arts features a state-of-the-art concert hall whose acoustical properties have been praised by renowned orchestras that have performed in the center since its opening in 1989.

South Carolina Supreme Court Chief Justice Jean Toal congratulates a student at a School of Law awards ceremony. When Toal graduated from USC's law school in 1968, only ten women were practicing law in South Carolina.

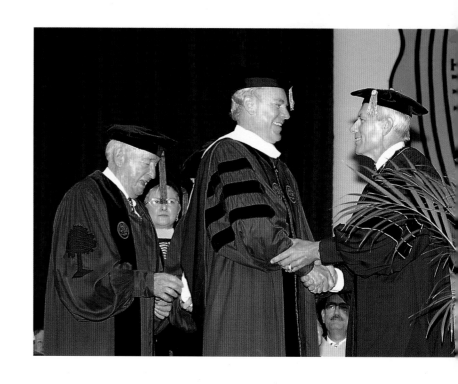

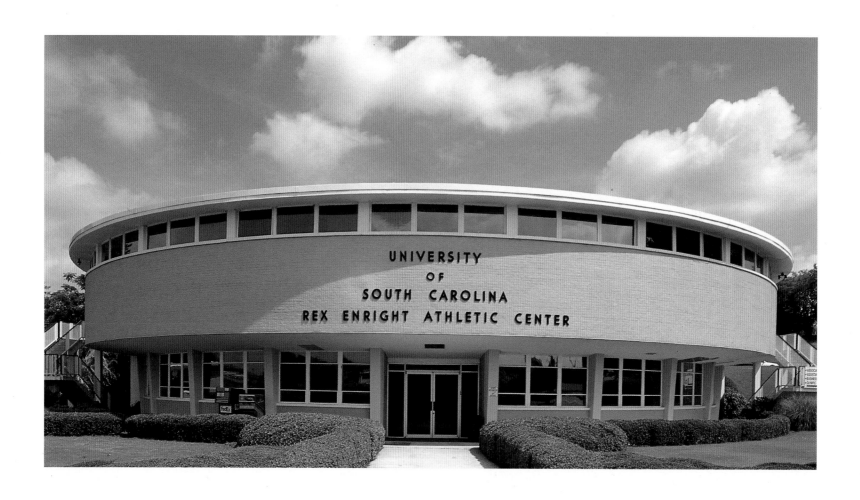

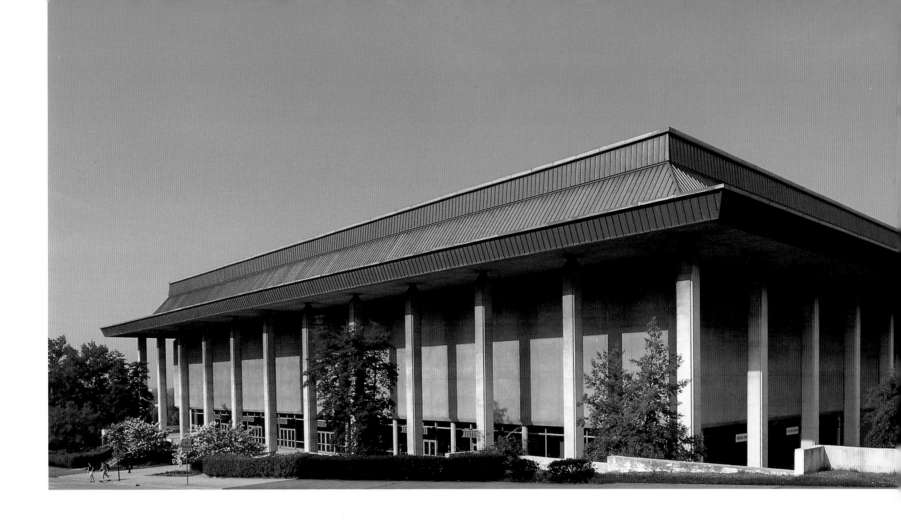

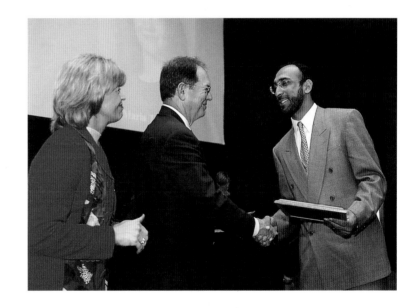

Left

Houston business leader and philanthropist Robert C. McNair receives an honorary Doctor of Humane Letters degree at commencement ceremonies in 1999. McNair, owner of Houston's new NFL franchise and a Thoroughbred-racing enthusiast, earned a bachelor's degree from USC in 1958. He donated $20 million to fund the McNair Scholars program, which attracts some of the nation's brightest out-of-state students to USC.

Better known as the Roundhouse, the Rex Enright Athletic Center houses athletics offices and is part of the University's athletics complex on the southern edge of campus. Rex Enright was USC's head football coach from 1938 until 1956 and also served as athletics director until his death in 1960.

With 315,000 square feet of space, including a 12,400-seat arena, Carolina Coliseum fulfills many needs for the University. The building, completed in November 1968, is home to University commencement ceremonies, basketball games, the College of Journalism and Mass Communications, and the College of Hospitality, Retail, and Sport Management.

Graduate School Dean Marcia G. Welsh and Provost Jerome D. Odom congratulate a student on Graduate Student Day, an annual awards event that recognizes the scholarly efforts of USC's sizeable body of master's and doctoral students.

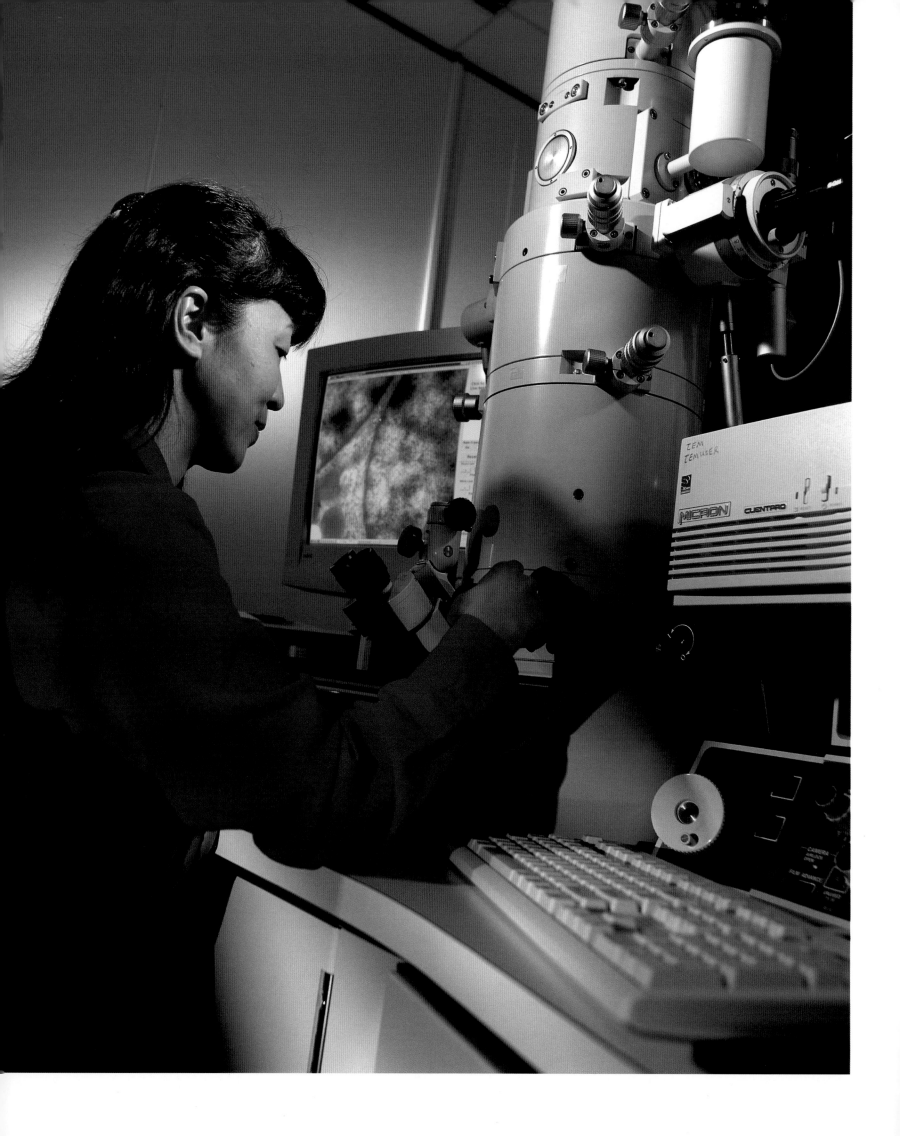

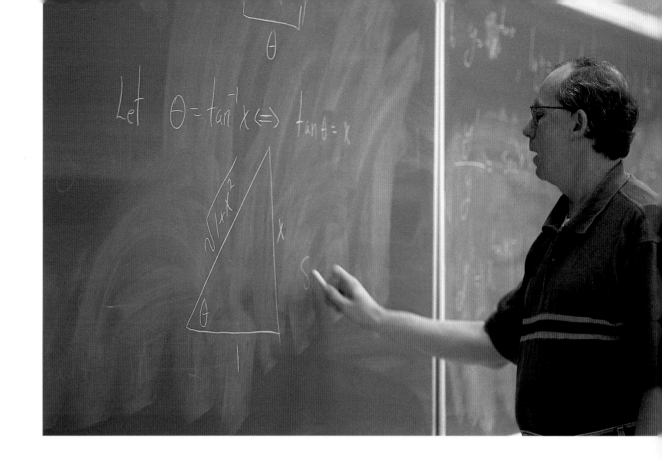

A technician in USC's Electron Microscopy Center prepares a sample for analysis. Established in 1970, the center has some of the most powerful microscopes available for research purposes, including the Southeast's first two-photon laser confocal microscope.

David Sumner, an associate mathematics professor, is one of forty full-time faculty members in the Department of Mathematics, which provides instruction to more than 8,000 students every year. More than 200 students on the Columbia campus pursue bachelor's and master's degrees in mathematics.

No amount of 21st-century technology can replace old-fashioned chalk, although many campus classrooms have made the switch to dry-erase boards—and to computer and multimedia instructional technology.

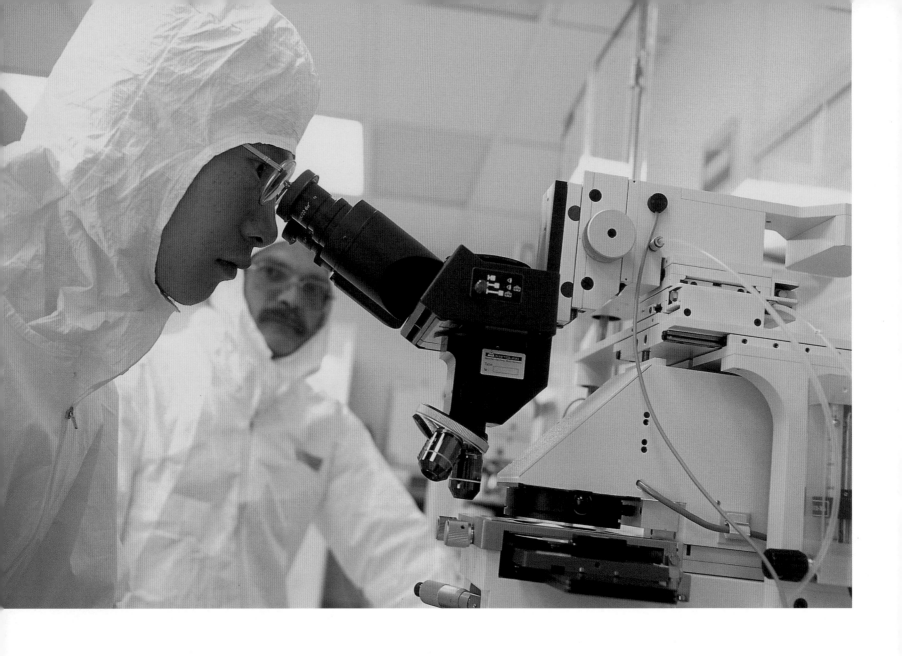

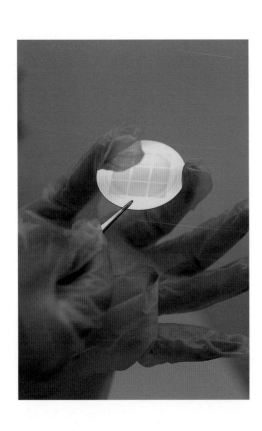

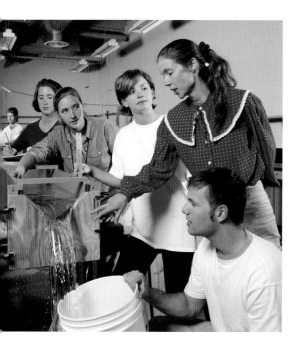

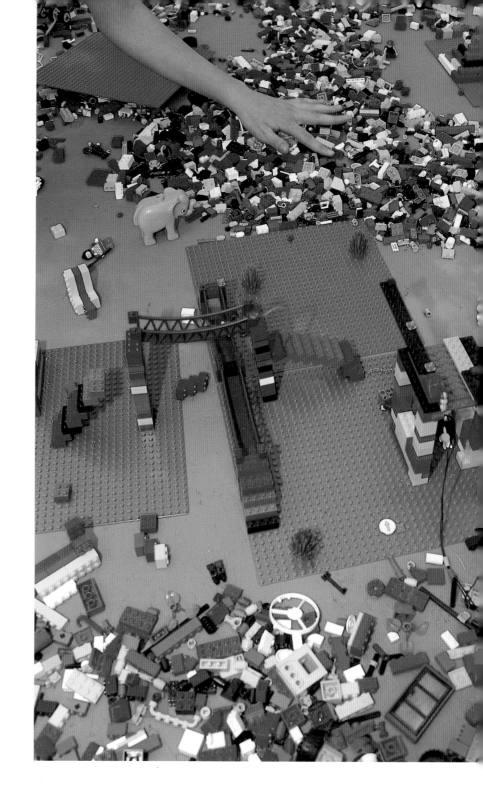

Electrical engineering faculty and staff wear special clothing to conduct research in a "clean room," where a new generation of silicon wafers is being developed.

A researcher in the College of Engineering and Information Technology holds a thin wafer of silicon carbide, from which semiconductors are made. Yellow light is used to examine the wafers because yellow wavelengths will not degrade the sensitive material.

Civil engineering students use a water flume in a laboratory to learn how water flow is measured in small streams and creeks.

Thousands of tiny Lego blocks lure industrious hands to the College of Engineering and Information Technology's display at USC's Showcase festivities on the Horseshoe. Children and adults assembled a lilliputian world with the blocks, using basic principles that guide real-world engineering problem-solving.

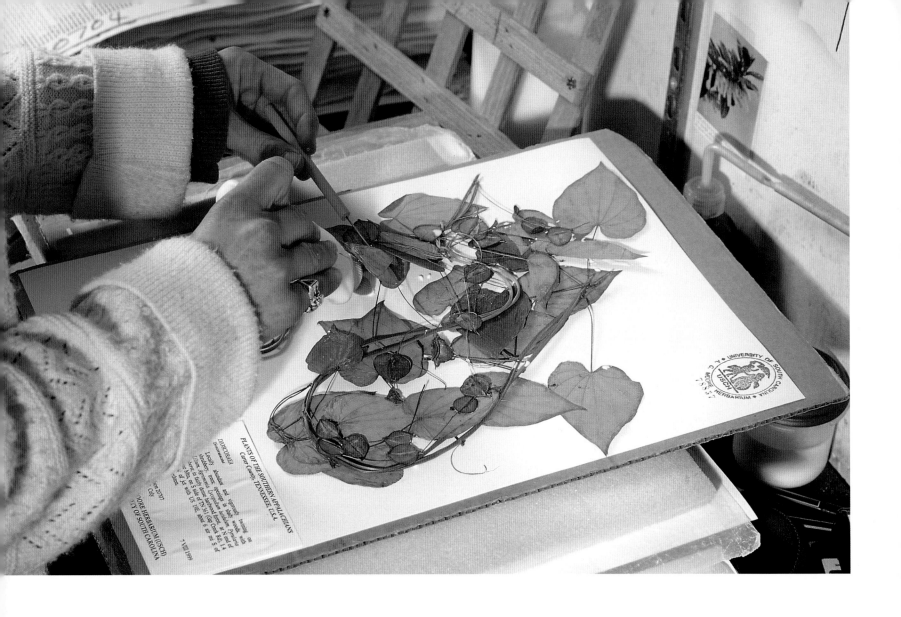

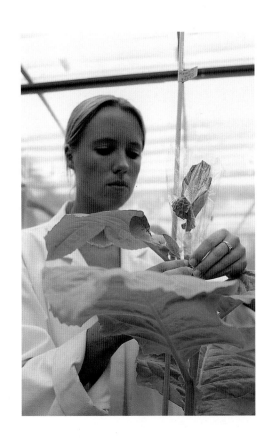

A pressed and dried plant specimen is prepared for storage at USC's A. C. Moore Herbarium, which takes its name from Carolina's first biology department chairman. The herbarium began in 1907 and today contains more than 80,000 dried plants, some of them rare species, from South Carolina and around the world.

USC plant molecular biologists are intrigued by the possibility that tobacco plants could be genetically altered to produce useful pharmaceutical products. Such genetic alterations might also produce higher-yielding food crops and landscaping plants with larger blooms.

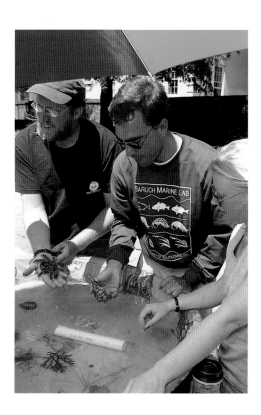

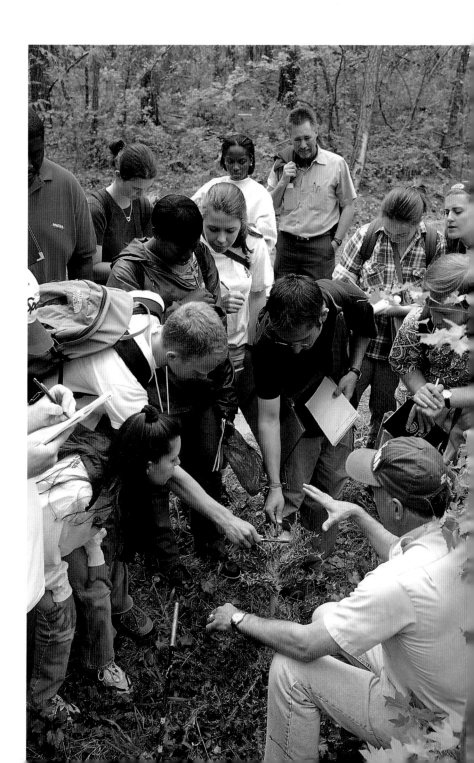

A marine touch tank attracts the ecologically curious on Earth Day, a day of observance celebrated at USC and around the world to promote awareness of environmental issues.

No leaf or bloom goes unnoticed in a botanical field trip through the Harbison State Forest. USC offers spring and fall flora classes, which teach students the taxonomy of plants in South Carolina.

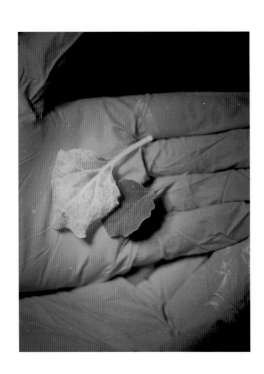

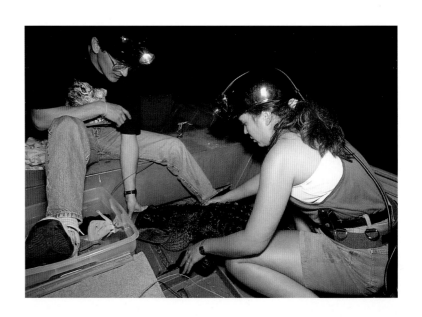

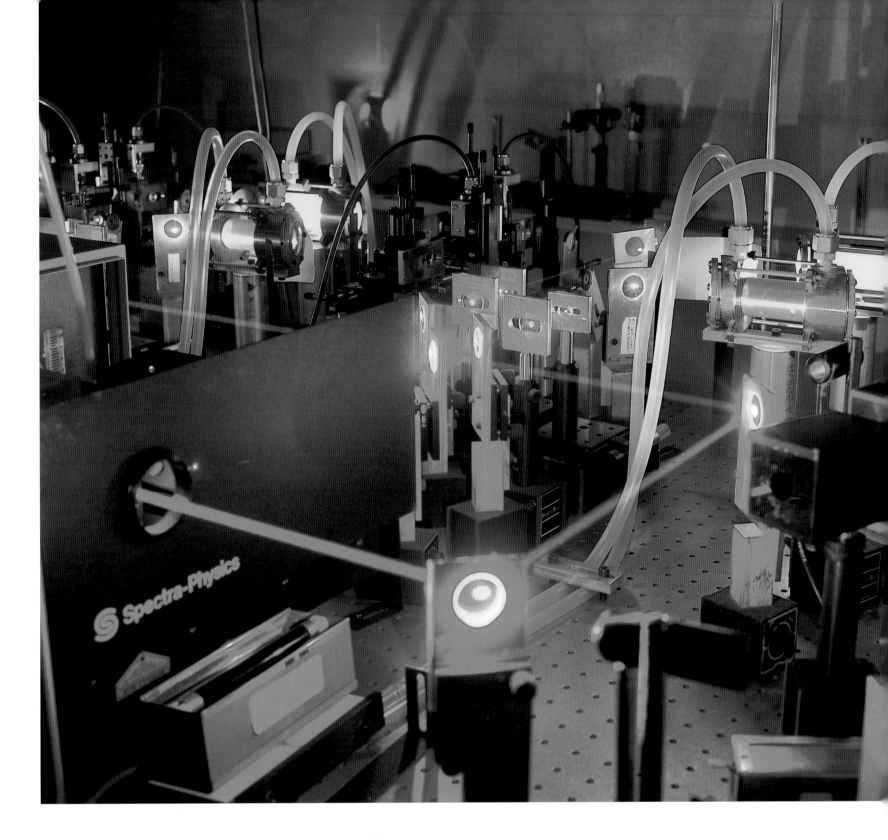

USC biologists used a computer to generate this gene-sequencing image of plant DNA. Several Carolina scientists are studying the effects of gene alteration on plant growth.

A USC plant molecular biologist holds a genetically altered leaf under ultraviolet light to look for evidence of changes in the plant. USC scientists are studying ways to develop plants that are more resistant to disease.

USC biology researchers carefully measure and remove a DNA sample from an alligator captured near the Savannah River Site, the former nuclear defense facility near Barnwell. University scientists, working with the Savannah River Ecology Lab, are studying the impact of contaminants on animal genetics.

Above

A laser system in a chemistry department lab measures the time elapsed in very fast reactions in liquid. USC scientists also use lasers for remote sensing and analytical applications.

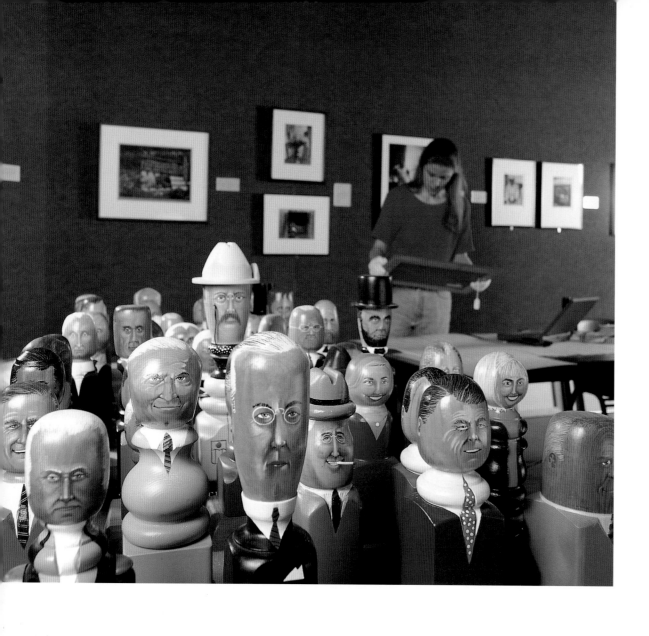

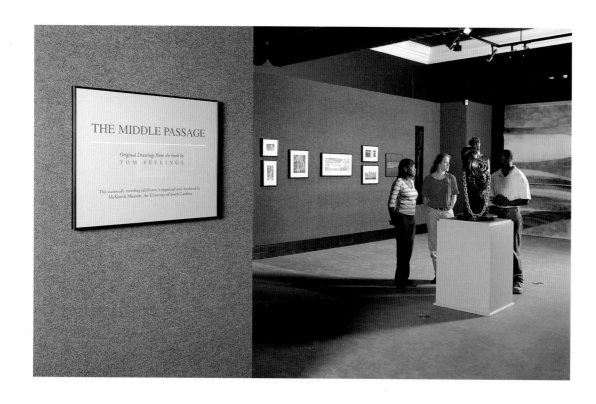

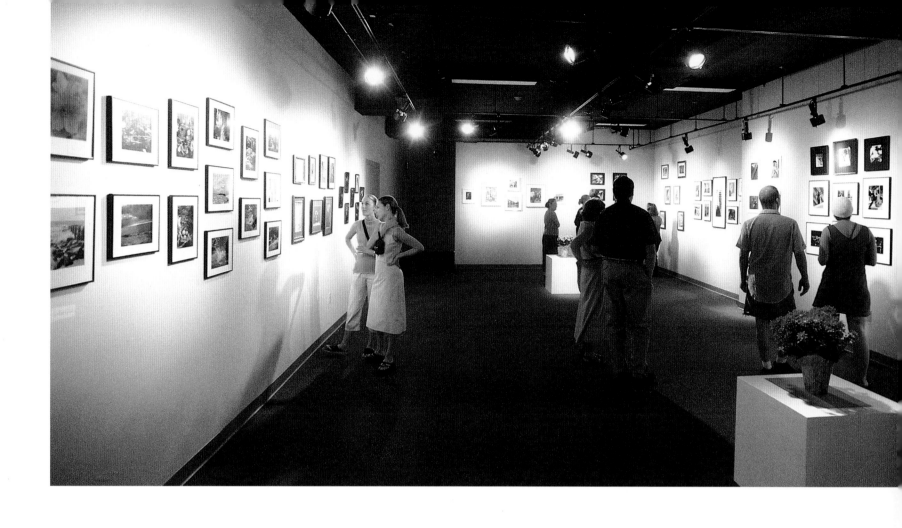

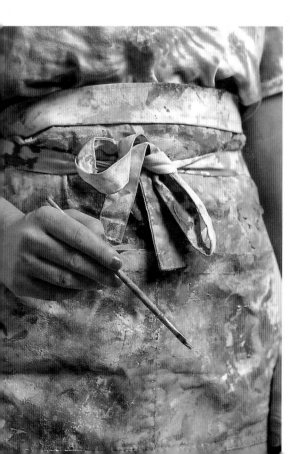

Left

These political caricatures, fashioned from antique bedposts by folk artist Bill Tait, make an eye-catching display at USC's McKissick Museum.

Drawings by retired USC art professor Tom Feelings from his book *The Middle Passage* are featured in an exhibition at McKissick. The museum, erected in 1940 as the University library, presents a constantly changing menu of art, cultural, and natural science exhibits.

Above

MediaFest, an annual exhibition of photography and video production by media arts division classes, is displayed in the McMaster Gallery, part of the recently renovated McMaster College.

With a paint-spattered apron and tie-dyed T-shirt as colorful as any artist's palette, an art student pauses with paintbrush in hand. Nearly 550 art majors practice their craft in McMaster College, an 85,000-square-foot facility of classrooms, studios, and office space.

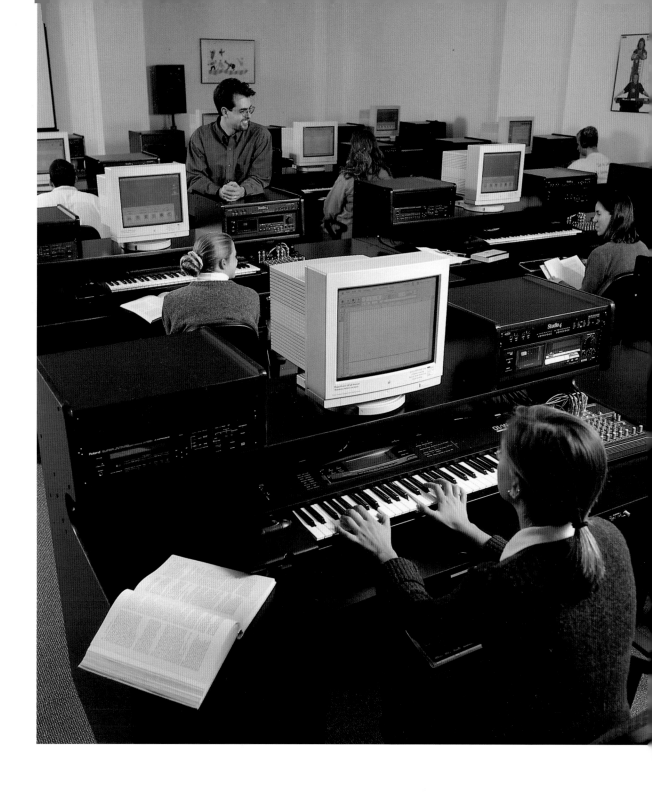

Students use the Music Technology Center to practice sight reading, to compose music and print it as a musical score, and to work on other class-related projects.

Overleaf

The annual spring concert of USC's String Project gives students in grades 3 through 12 from Columbia-area schools an opportunity to perform in the Koger Center. The String Project began in the mid-1970s and provides instruction to as many as 350 children each year, taught by USC music education undergraduates.

Left

French majors stage a play—speaking their lines in French, of course—as part of annual French Day festivities.

Native American author Marilou Awiakta, the keynote speaker at the annual Women's Studies conference, chats with participants following her address. The Women's Studies program began in 1973 and offers a bachelor's degree and a graduate certificate.

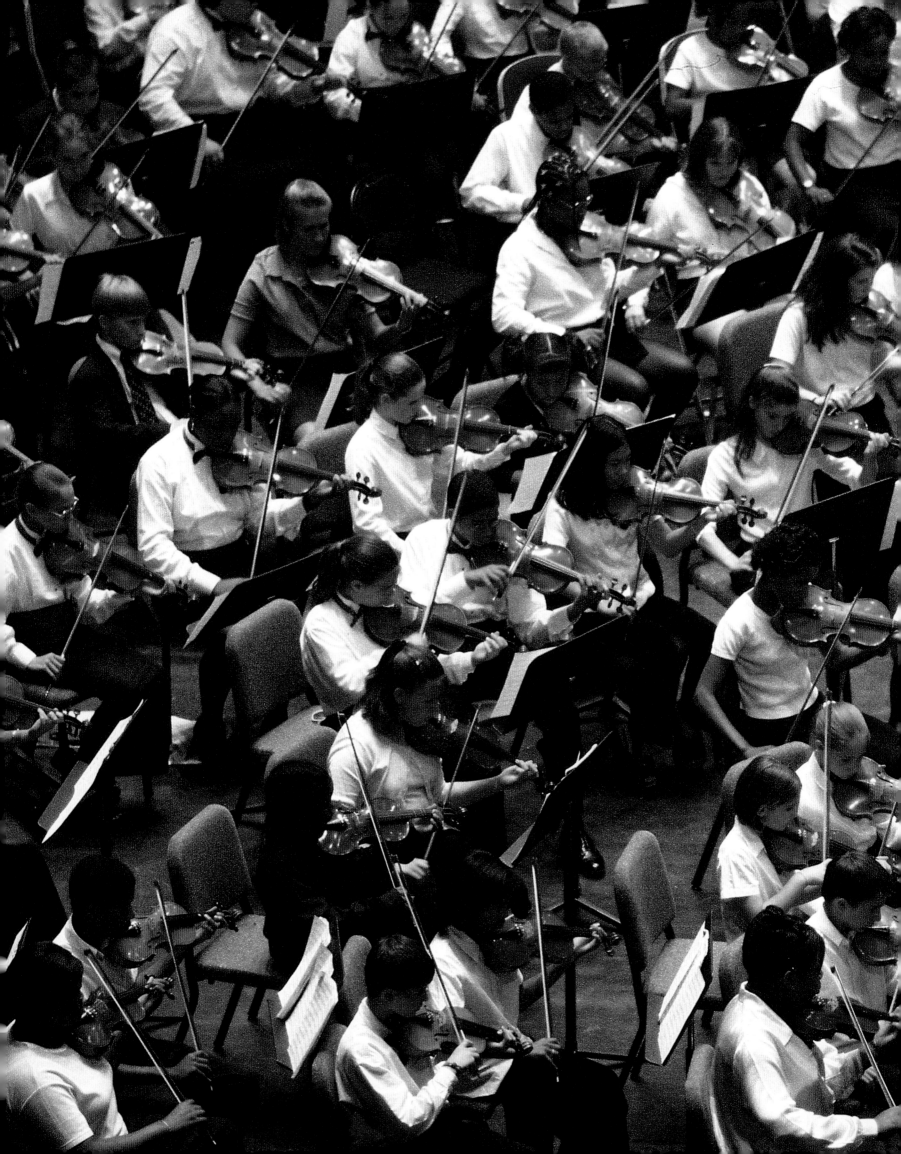

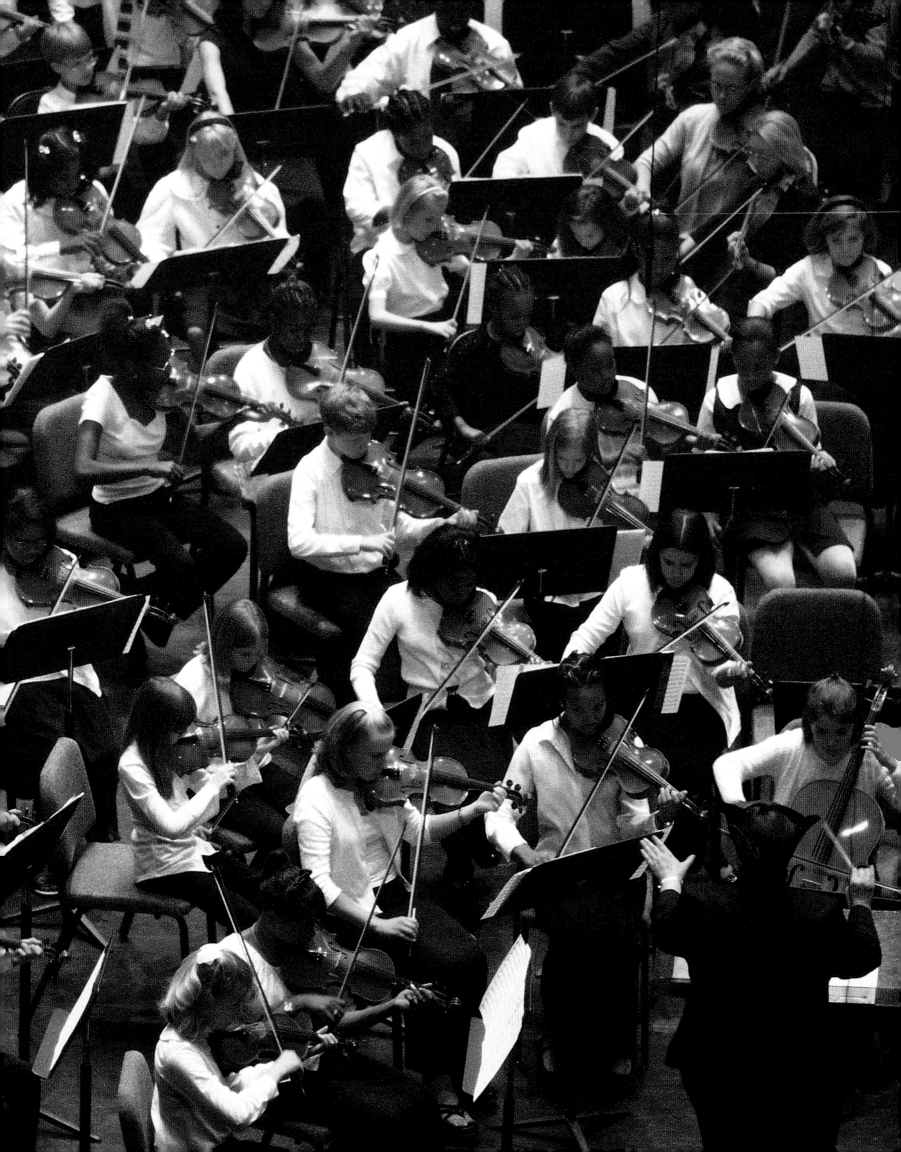

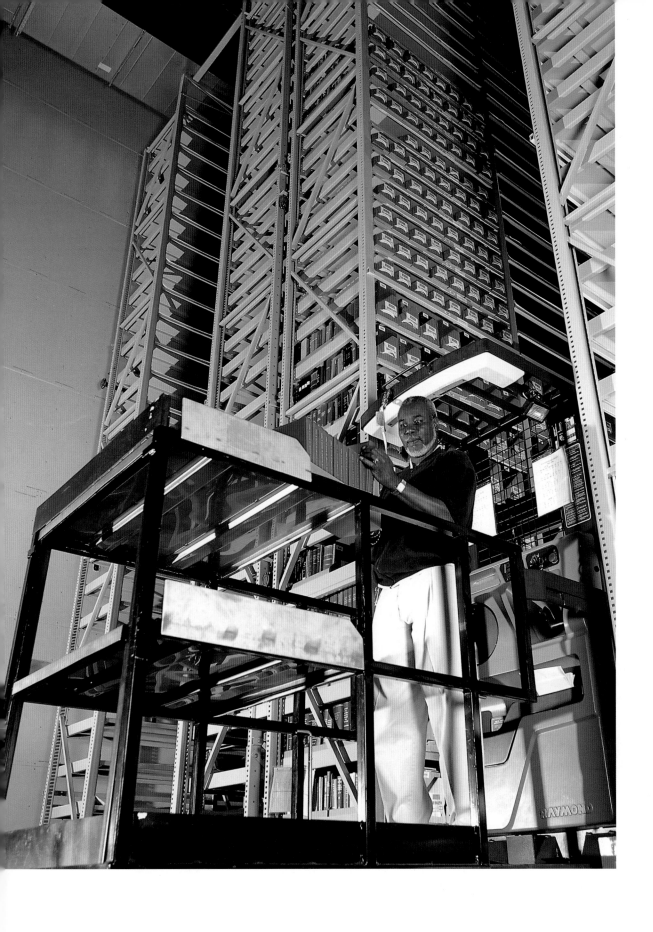

Massive shelves and a specialized cataloging and preservation system—
books are sorted by size, not topic—are hallmarks of USC's Library Annex
and Conservation Facility, an off-campus facility that serves as an overflow
for the main library's seldom-used books.

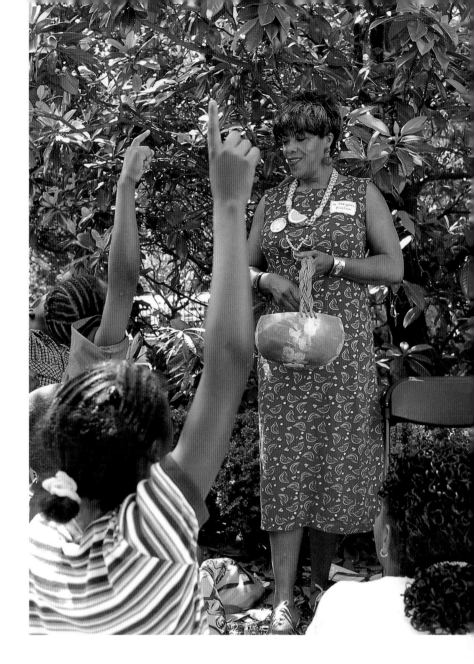

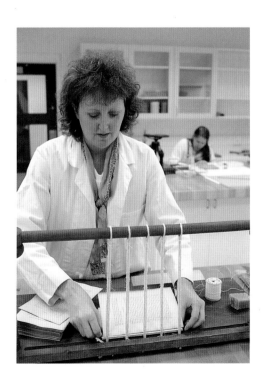

Acclaimed South Carolina author Pat Conroy chats with audience members after delivering a Writers Conference lecture. Though a graduate of The Citadel, Conroy also studied at USC under James Dickey, Carolina's late poet-in-residence. He was awarded the honorary degree of Doctor of Literature from USC in 1997.

A conservator at USC's library annex prepares a manuscript for rebinding, one of many book repairs performed at the facility to keep library volumes in usable condition.

A storyteller gets an enthusiastic response during the annual A(ugusta) Baker's Dozen storytelling event. Sponsored by USC and the Richland County Public Library, the two-day storytelling-fest draws thousands of students and honors the late Augusta Baker, a longtime storyteller-in-residence at USC and former children's librarian for the New York Public Library.

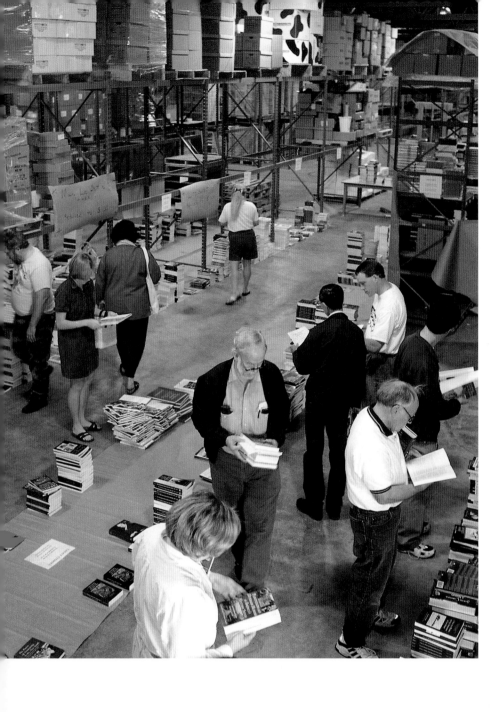

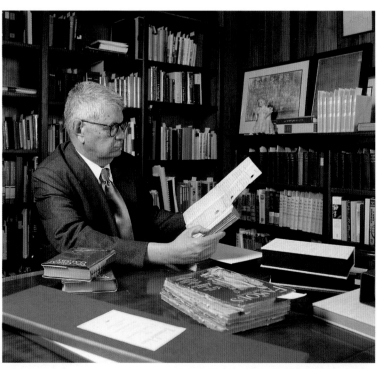

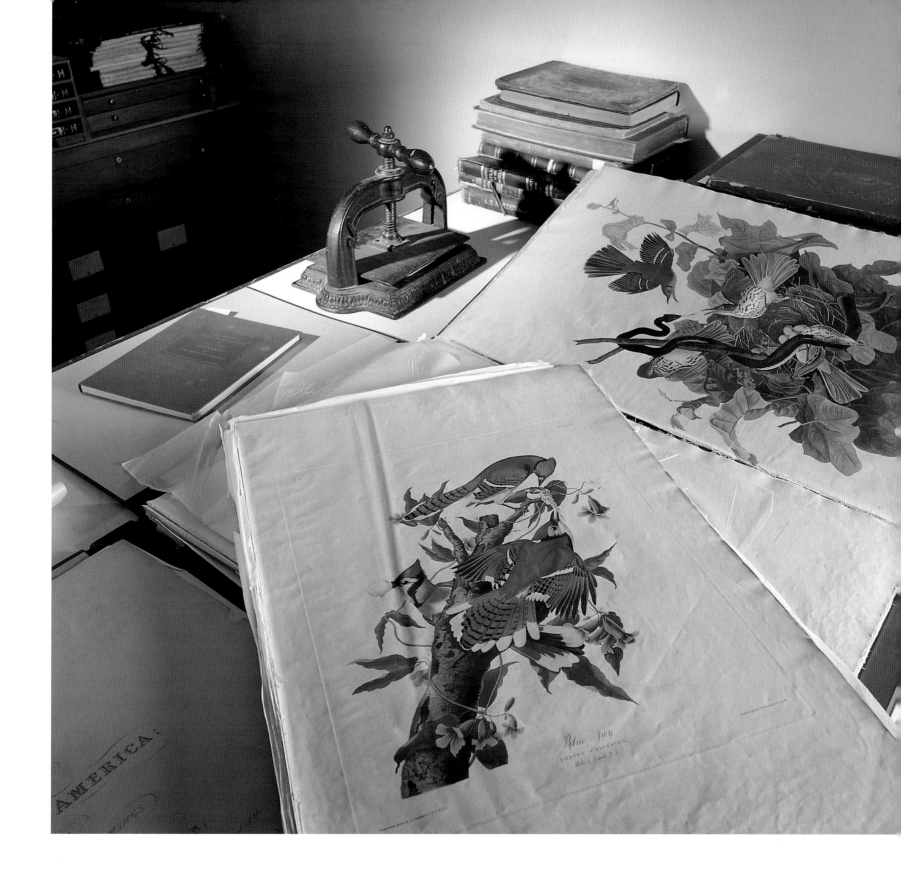

Left

Bargain-hunting book buyers check out discounted titles at a USC Press warehouse sale. The Press began publishing in 1944 and has earned a considerable reputation among the nation's university publishing houses.

Matthew J. Bruccoli, Emily Brown Jefferies Professor of English, peruses an original letter from the library's F. Scott Fitzgerald collection in the Fitzgerald Room. Thomas Cooper Library acquired the collection from Bruccoli, an acclaimed Fitzgerald scholar, and his wife, Arlyn.

Above

Soon after they were published in London between 1828 and 1838, plates from John James Audubon's *Birds of America* were purchased for South Carolina College by a special vote of the South Carolina legislature. The works are part of USC's Special Collections.

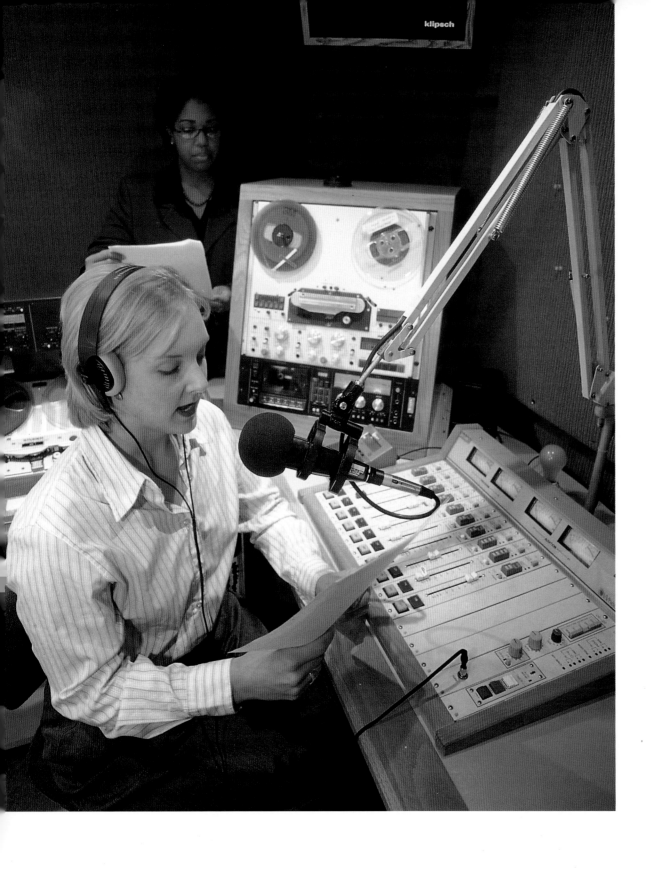

A USC journalism student is on the air at South Carolina Educational Radio, where broadcast journalism majors produce news stories as part of their senior semester. USC's College of Journalism and Mass Communications began in 1923 and has the state's only fully accredited journalism degree program.

Right
Bedecked in a Roman soldier's costume that was used in the MGM classic *Ben Hur*, history professor Ralph Mathisen makes a point with his sword during an ancient history lecture.

Graduate students in USC's public history program learn the craft of historic preservation, museum studies, and archival studies from professional staff at the Robert Mills House, a historic home maintained by the Columbia Historic Foundation.

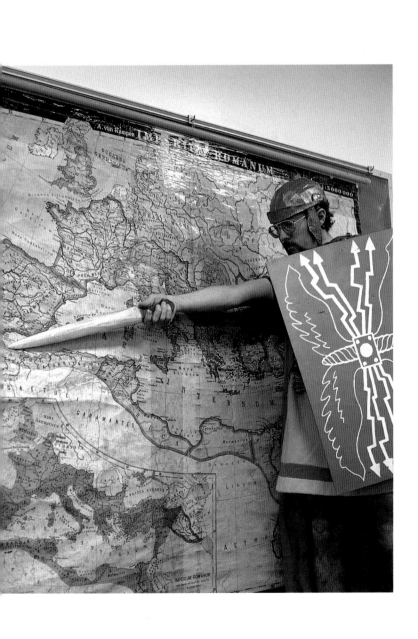
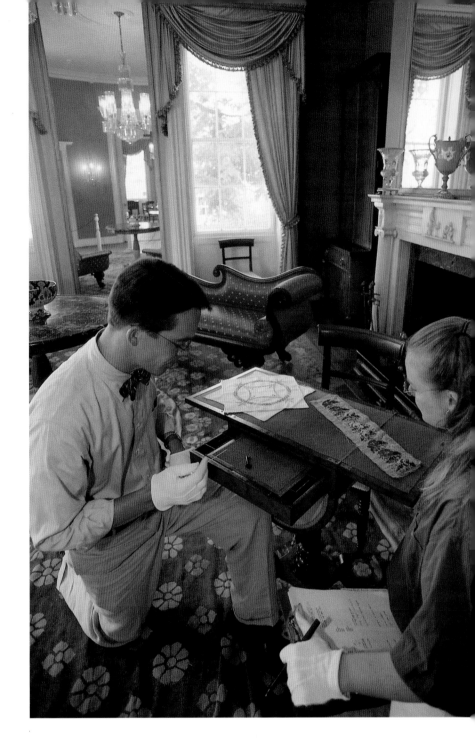

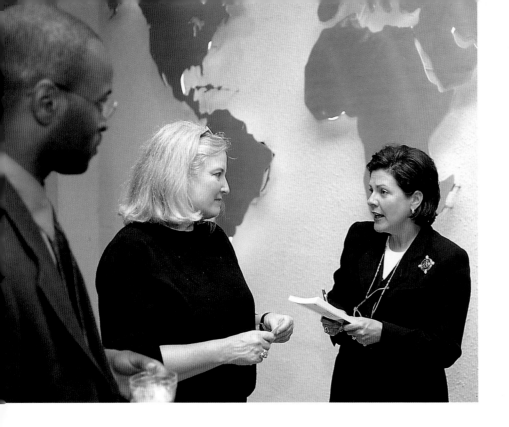

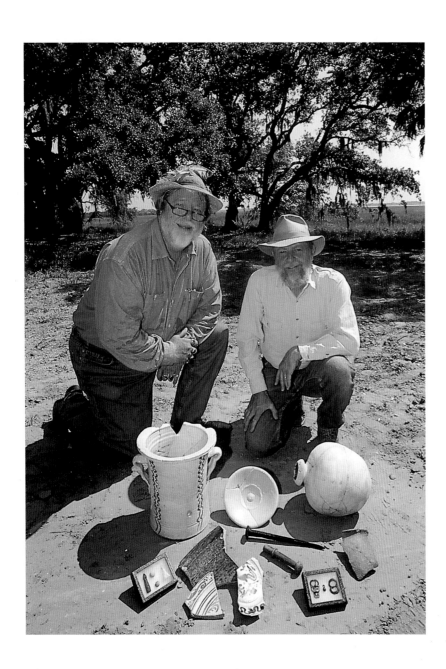

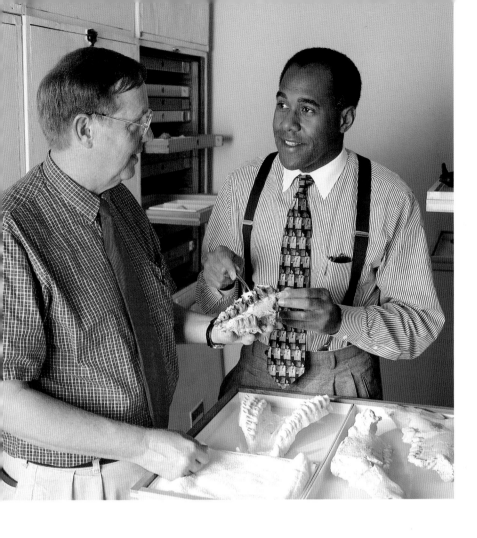

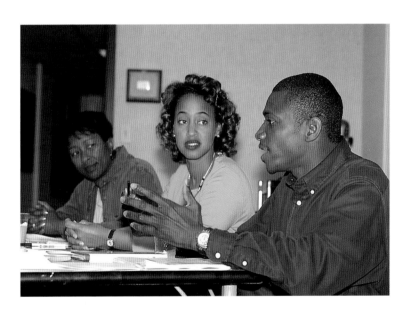

Award-winning fiction writer Josephine Humphries (center), whose coming-of-age novel *Rich in Love* is familiar to many USC students, talks with USC history professor Bobby Donaldson and fellow writer Dorthea Benton Frank following a program sponsored by the Institute for Southern Studies.

USC archaeologists Stan South (left) and Chester DePratter have unearthed an array of 16th-century artifacts in twenty-one years of excavations on Parris Island near Beaufort. Their diggings uncovered the site of Santa Elena, the capital of Spanish Florida from 1566 to 1587, and Charlesfort, France's earliest but short-lived (1562–1563) New World settlement.

Michael Howell, a geological sciences faculty member, and Ph.D. candidate James Knight examine rare fossils of brontotheres and rhinoceroses in their efforts to identify fossils from the South Carolina coastal plain. These studies represent a major focus of the department's Laboratory for Cenozoic Studies and will provide important insights into the history and evolution of life in South Carolina and the southeastern United States.

A teaching workshop in the African-American Professors Program is aimed at increasing the nation's cadre of African-American faculty, particularly in math, science, and business.

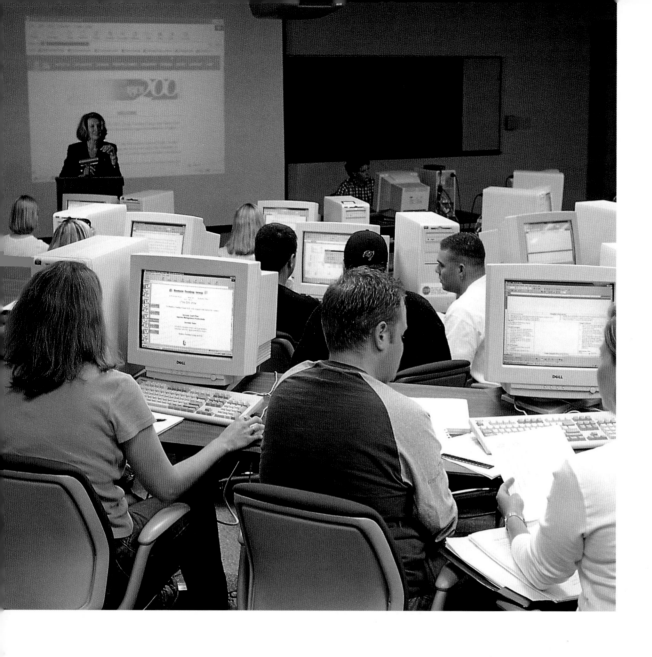

THE DARLA MOORE SCHOOL OF BUSINESS

Left

As computers have become an integral part of a business education, a computer lab in The Darla Moore School of Business enjoys little rest.

Students in the School of Business focus in eight major areas of study: accounting, finance, economics, insurance and risk management, real estate, management, management science, and marketing. The school was established in 1919 and now has more than 100 faculty members.

Above

The Darla Moore School of Business recognized the importance of an international perspective long before "global village" became a buzzword. Today, the school is recognized as a leader in international business, both at the graduate and undergraduate levels.

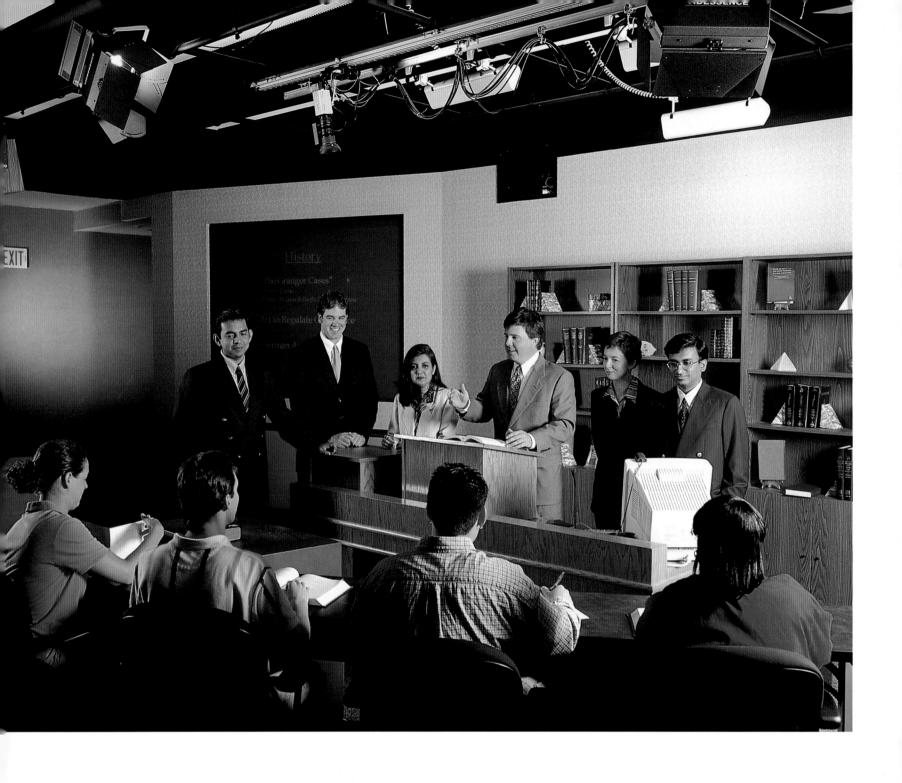

Students in USC's Master of International Business Studies (MIBS) program present a business plan to fellow students and professors, one of many they will make in the classroom and in professional internships abroad. MIBS recently celebrated its 25th anniversary and has consistently been ranked among the nation's top two international business programs by *U.S. News & World Report*.

Right

In special studio classrooms around campus, USC's distance education program videotapes professors' lectures for distribution by satellite or videotape around the state. About eighty courses are offered via live broadcast each semester, serving students who cannot attend traditional classes on campus.

Faced with a nonstop stream of new computer software programs and upgrades, USC staff stay up to speed through USC's Computer Services Division, which offers more than 30 hands-on workshops.

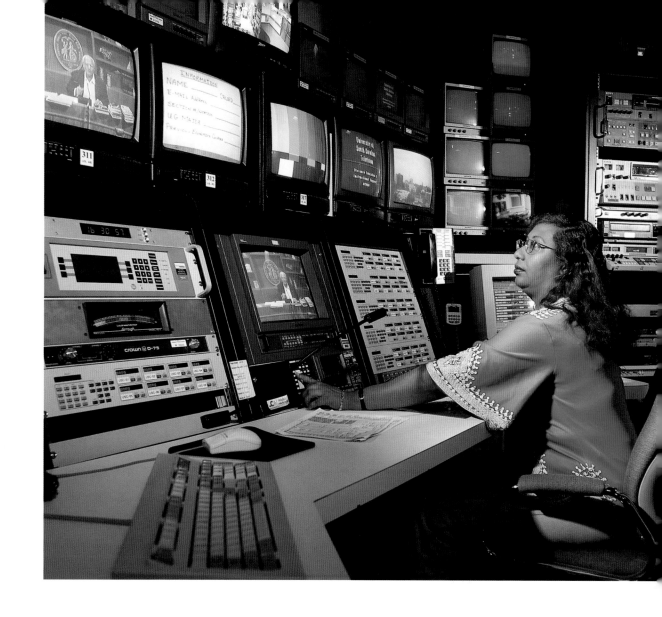

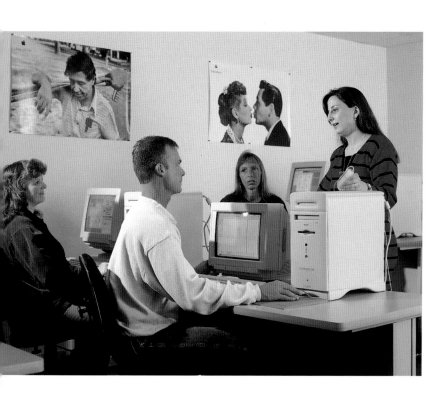

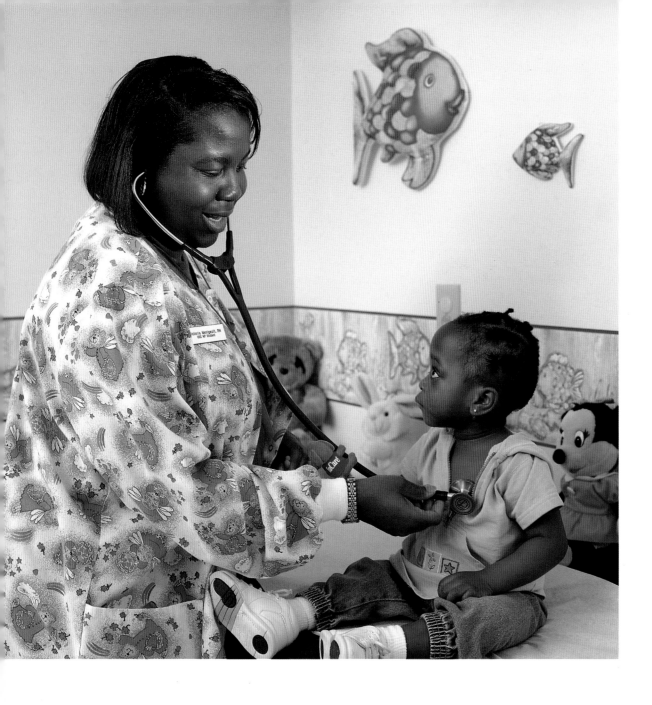

Operated by the College of Nursing, the Children and Family Healthcare Center offers clinical experiences for nurse-practitioner students in the graduate program. The College of Nursing also manages Primary Care Partners in the Thomson Student Health Center and the Women's Health Care Center.

Undergraduate nursing students use the Client Simulated Laboratory in the College of Nursing to learn basic nursing skills. The college has offered bachelor's degrees in nursing since 1962.

Right
A School of Public Health researcher uses a laser scanning confocal microscope to create a three-dimensional image of microbes found in deep-sea sediments.

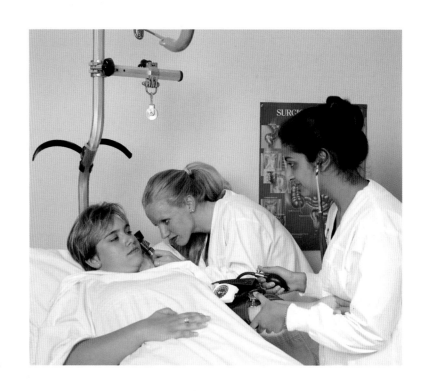

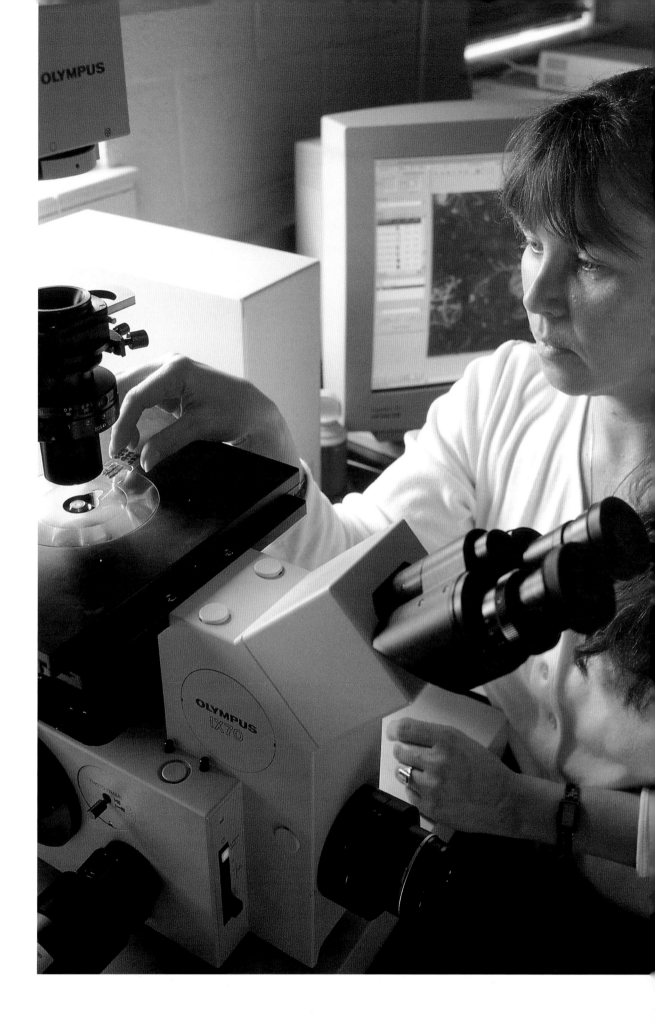

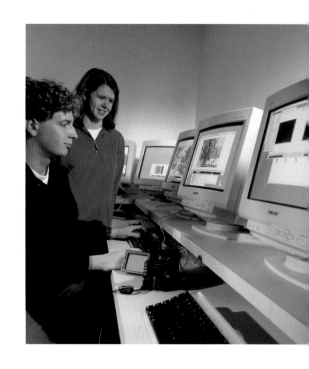

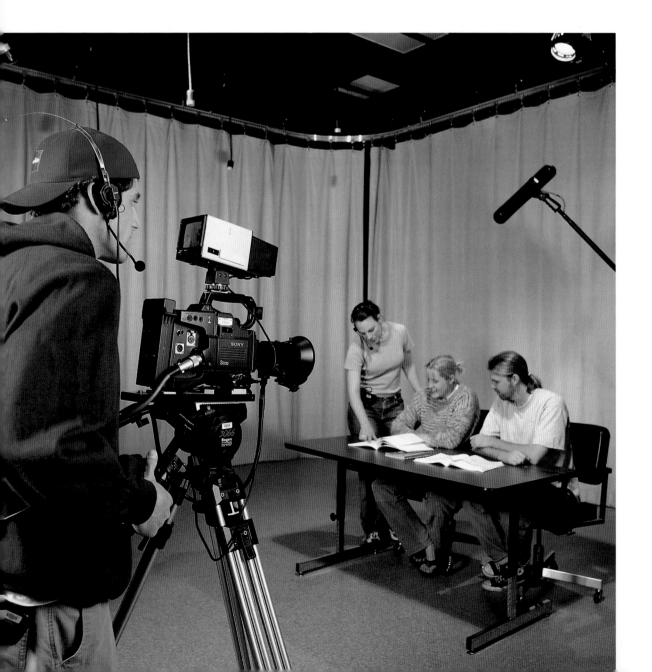

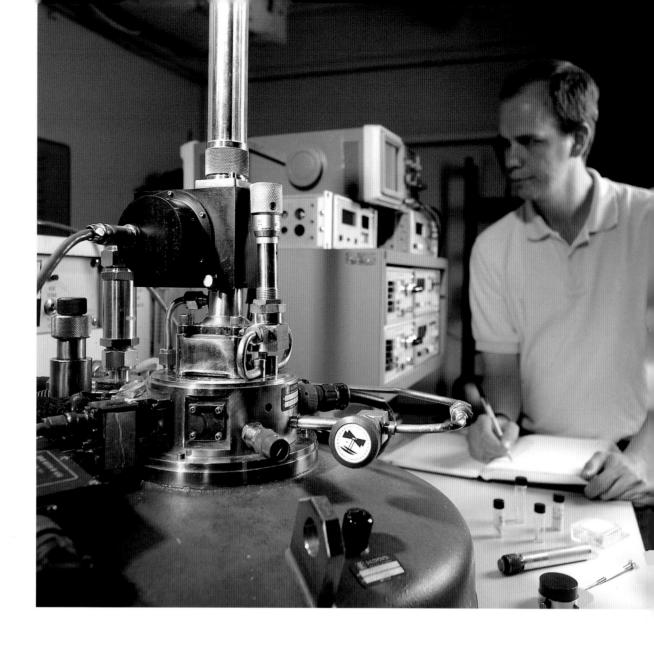

Left

Media arts students learn the basic techniques of producing and editing videos, including camera work, lighting, and studio recording.

With access to one of the best digital editing suites in the country, media arts students master the latest in computer video technology and technique.

Above

A doctoral student in physics controls a superconducting quantum interference device, which is used to study the electronic behavior of particles in an extremely cold and highly magnetized environment. One of the applications of the research is for development of faster computers.

Participants and researchers convene for a meeting of the Early Alliance Program, a federally funded research project in USC's Department of Psychology aimed at reducing school violence.

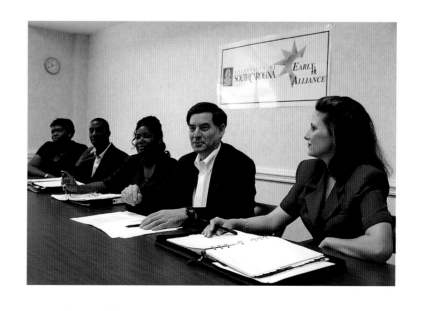

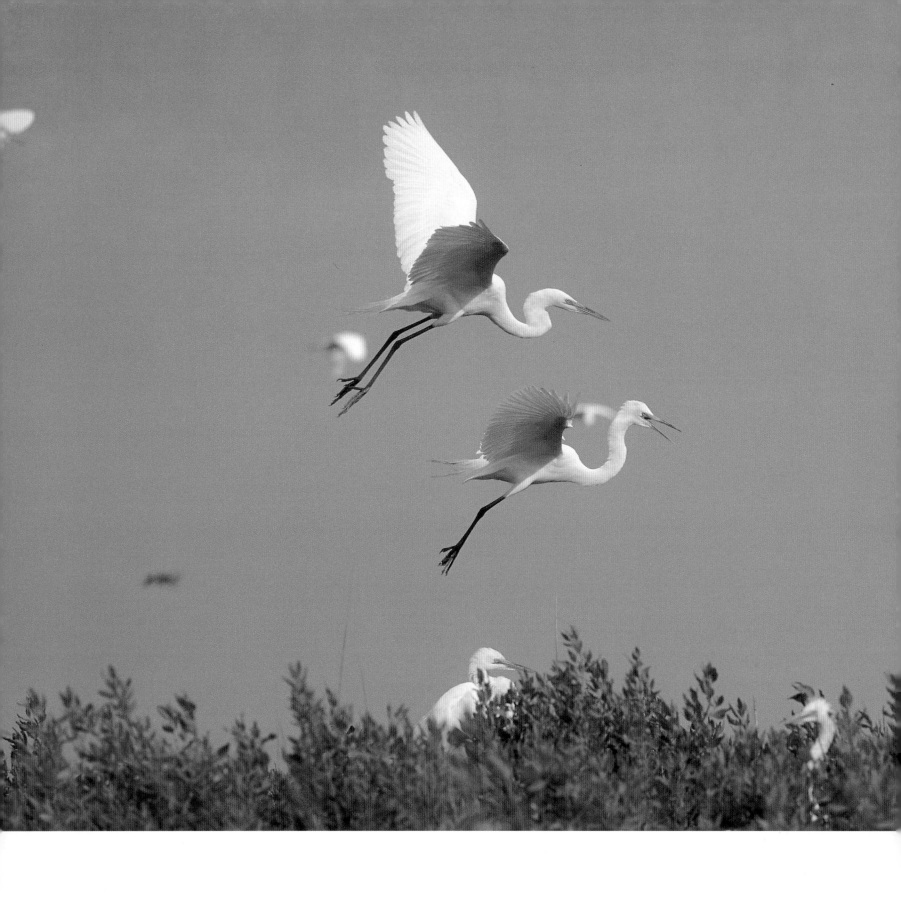

The Baruch Marine Field Laboratory, completely rebuilt after Hurricane Hugo's devastation in 1989, is the center of USC's long-term marine research on Hobcaw Barony near Georgetown's North Inlet.

USC scientists from the Baruch Marine Field Laboratory near Georgetown are engaged in a long-term study of juvenile saltwater fish, a project aimed at better understanding the nursery function of marine estuaries.

Egrets, herons, and ibises make their home on Pumpkinseed Island, a five-acre spit of sand and shrubs near USC's Baruch Marine Field Laboratory on the coast. The birds feed on fish, crabs, and shrimp and are most active from March through July.

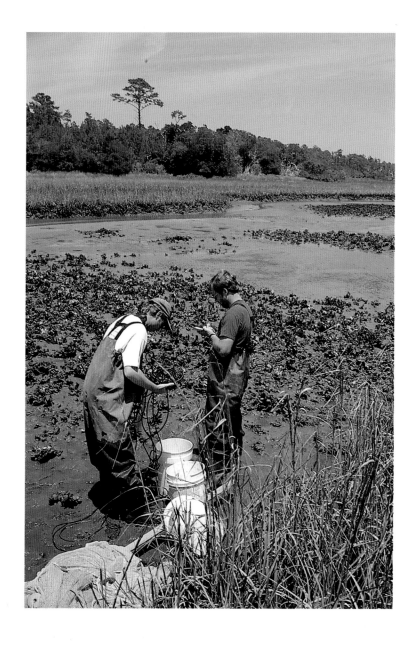

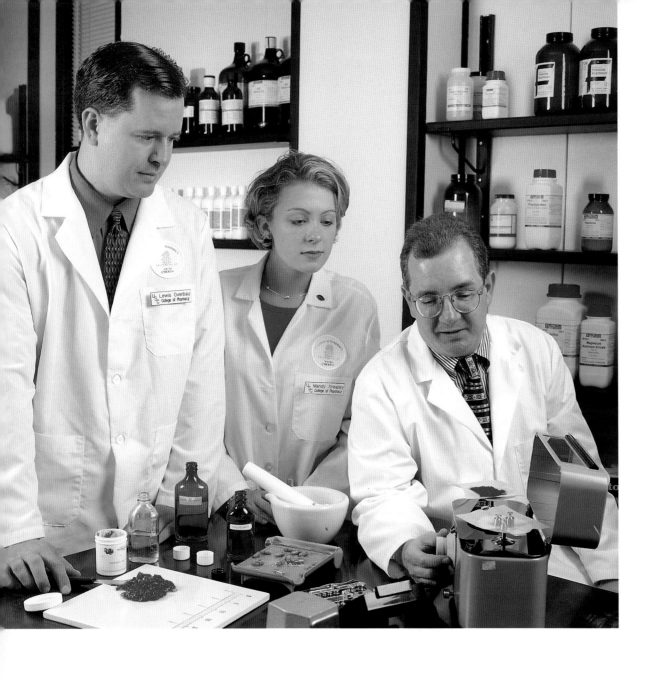

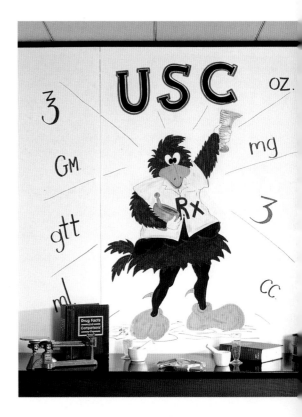

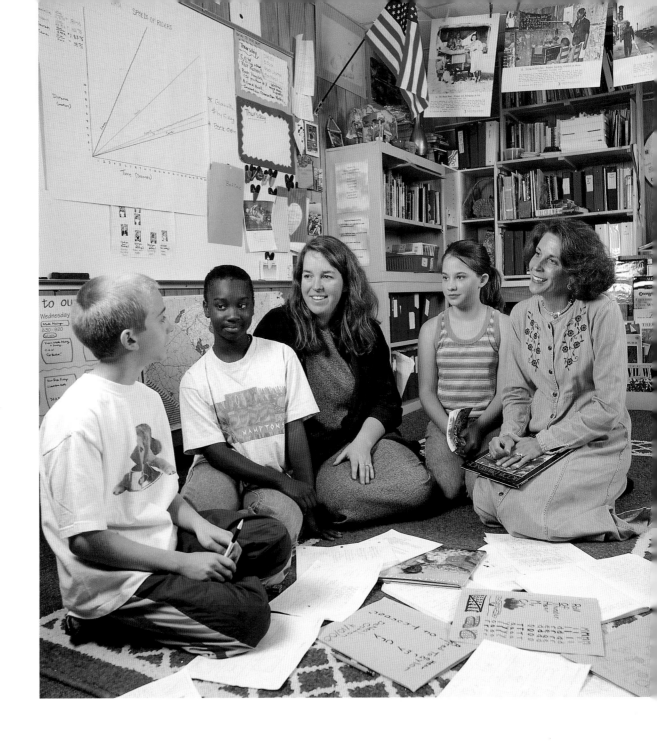

Left

Students in the College of Pharmacy complete six years of study and intern-
ships to earn a Pharm.D. degree, the most advanced professional degree
available in that field. Admission to the pharmacy program is quite com-
petitive, attracting five applicants for every available student slot.

The ubiquitous Cocky offers a prescription for pharmacy students: learn
these measurement and volume symbols!

Above

About 140 children in grades K through 5 attend the Center for Inquiry,
operated through a partnership between USC and Richland County School
District Two. Using an inquiry-based approach to instruction, classroom
teachers and University researchers from the College of Education work
side by side at the center to provide exemplary education for young
children.

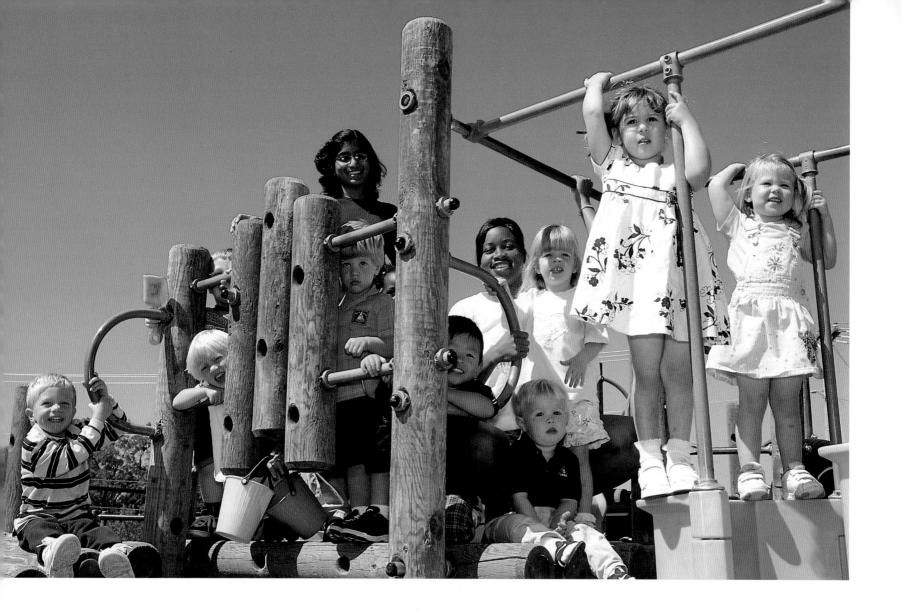

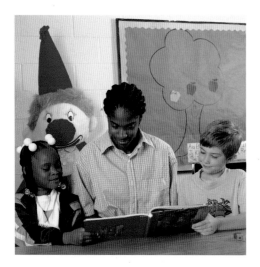

USC's Children's Center, located on Whaley Street, offers daycare to children of faculty, staff, and students.

To help underachieving first-graders improve their reading and math skills, USC's College of Education trains AmeriCorps members who are deployed in schools across South Carolina.

Right

More than 6,000 children participate in summer programs at USC each year, experiencing the worlds of art, drama, sports, music, computers, and other cultural and science-related topics. Summer programming for children is but one of many community education opportunities offered through USC's Division of Continuing Education.

Classes at USC Fort Jackson allow active duty military personnel and their family members to earn college credits and degrees. Every eight weeks, the campus has about 500 enrollments and offers 18 classes.

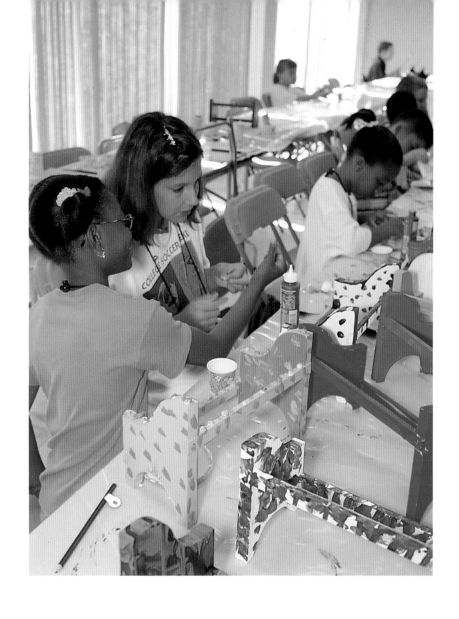

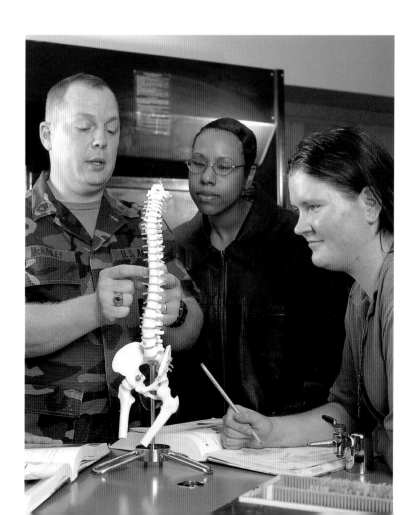

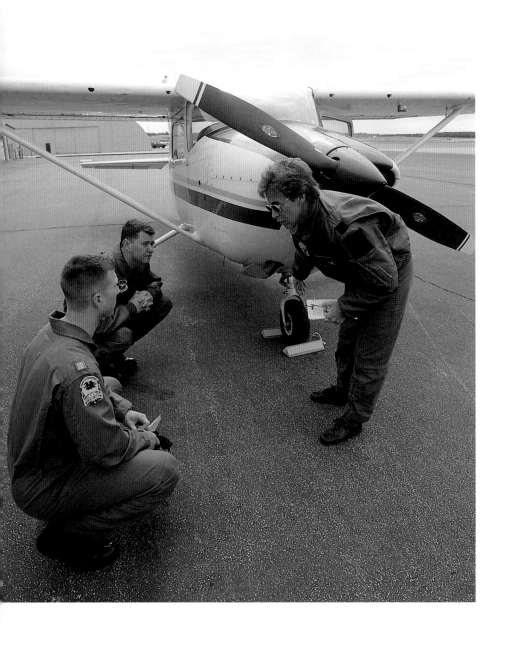

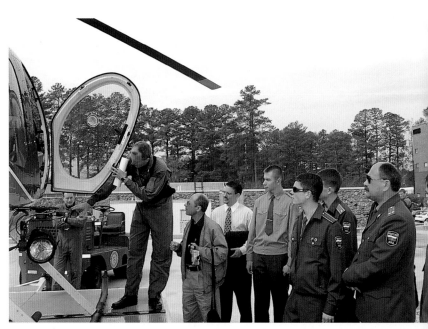

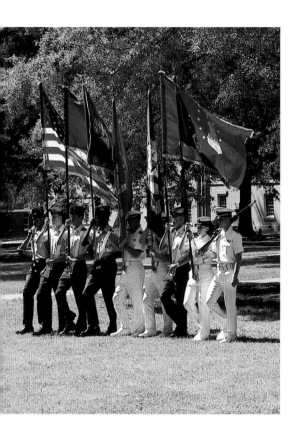

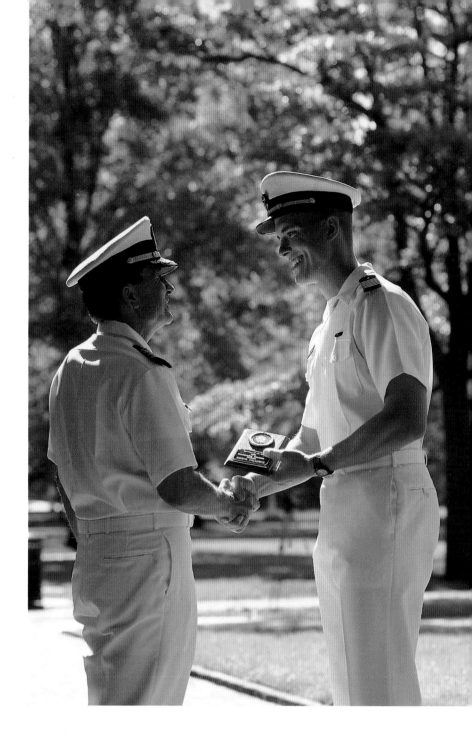

Air Force ROTC (Reserve Officer Training Corps) cadets from USC chat with a Civil Air Patrol officer at Owens Field near Columbia. Air Force ROTC cadets often get their first flight experience in the small prop planes flown in search-and-rescue missions by the Civil Air Patrol.

Cadets from Russia's Volgograd Law Institute, visiting USC as part of an exchange program with the College of Criminal Justice, tour the South Carolina Law Enforcement Division's headquarters. A contingent of USC criminal justice students visited the Russian institute several weeks later.

An ROTC color guard marches during a special awards-day event for members of USC's ROTC programs in Air Force, Army, Marines, and Navy.

A Naval ROTC graduate receives a service award from his commanding officer. The United States Navy began USC's first ROTC program and counts among its graduates two skippers of the Navy's newest aircraft carriers.

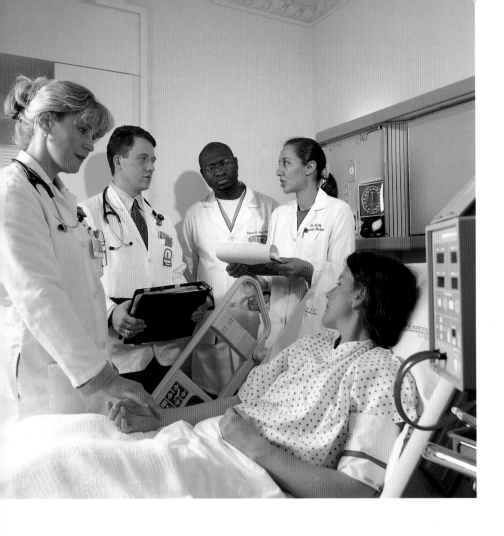

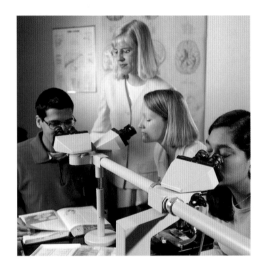

USC medical students practice bedside care during mock hospital rounds. As part of their medical training, School of Medicine students rotate through several types of internships, from rural family practice settings to large hospital wards.

To understand the function and structure of body tissues, first-year medical students view a histological slide in the School of Medicine's microscopy teaching lab.

Second-year students at USC's School of Medicine don white lab jackets in the Pledge of Commitment Ceremony, an annual event that marks the beginning of the students' hospital training. USC's medical school prides itself on the number of graduates who practice primary medicine in the state's medically underserved areas.

Medical students learn some 10,000 medical terms in their first year of study—about half of them come from the gross (large structure) anatomy course, which involves dissection of human cadavers.

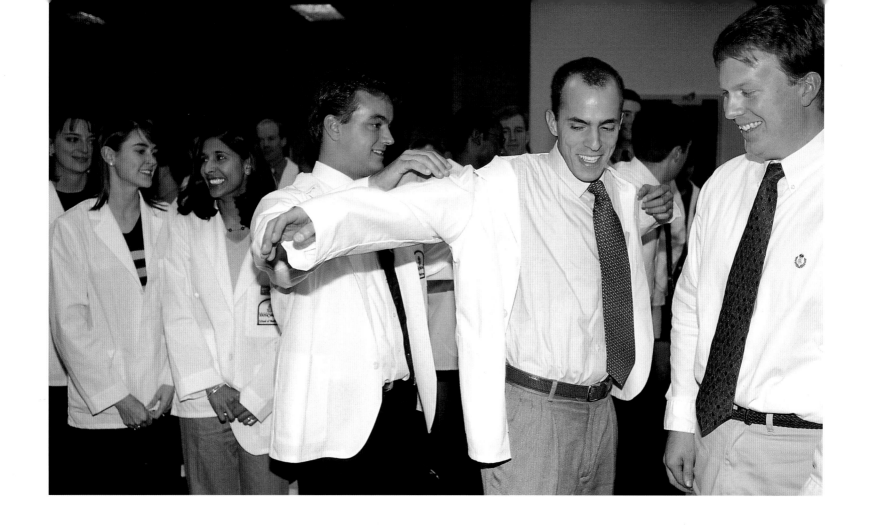

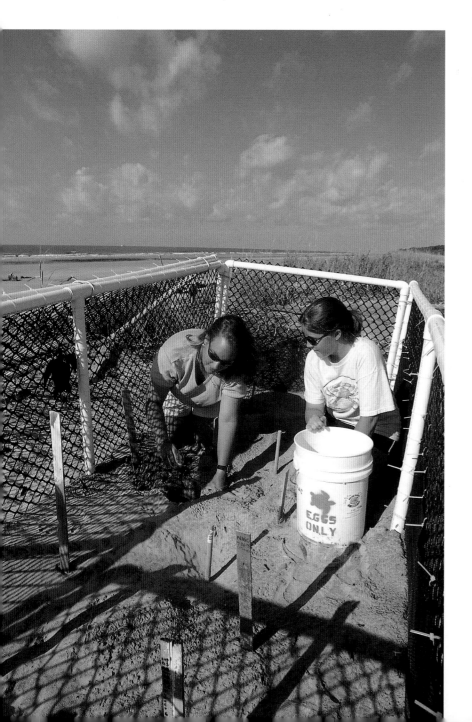

Since 1982, USC researchers and a small army of volunteers have rescued tens of thousands of loggerhead sea turtle eggs from destruction by natural predators and high tides. The eggs are protected by wire cages, thereby ensuring a larger supply of turtle hatchlings.

Pritchard's Island includes 100 acres of maritime forest, some of which is lost to the sea in the constant ebb and flow of the island's shoreline. USC researchers use the island as a field laboratory for studying the effects of coastal erosion.

Right
With 1,000 acres of salt marsh and two-and-a-half miles of Atlantic shoreline, Pritchard's Island is a microcosm of the delicate marine ecosystem on America's east coast. The island is home of the Center for Coastal Ecology, part of USC Beaufort's continuing education program.

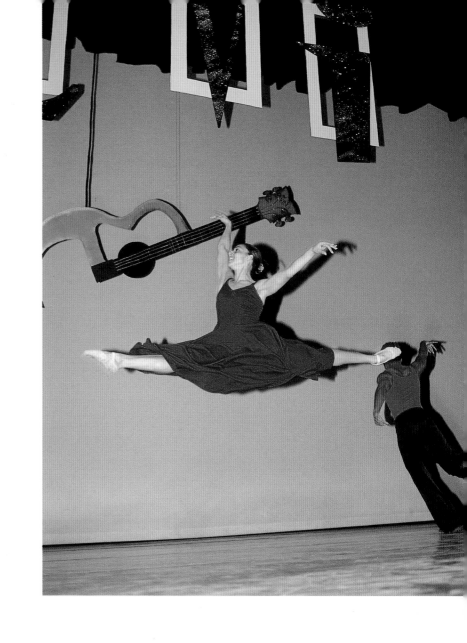

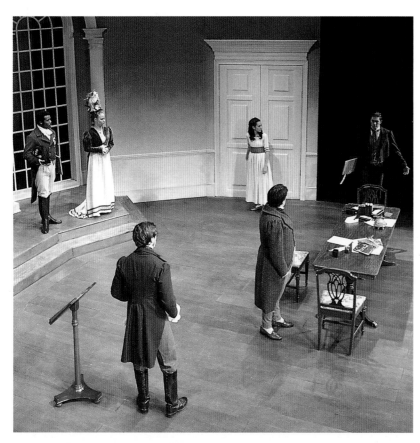

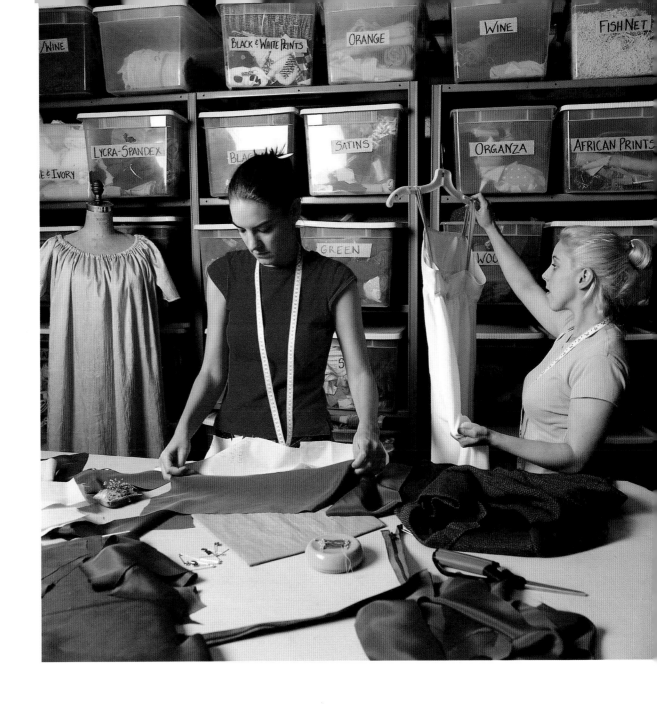

Student actors from Theatre South Carolina, USC's student theatre troupe, perform in *Arcadia,* a Tom Stoppard comedy that made its Columbia premiere at USC's Drayton Hall. Student dramas are staged at Drayton Hall and Longstreet Theatre each fall and spring semester.

Performers from the USC Dance Company present "Tribute to Elvis," one of several dance performances by the forty-member troupe.

Student costume makers test their tailoring skills in preparation for a USC theatre production. Students participate not only in costume design and production but also in set construction, lighting, and other technical aspects of staging a play.

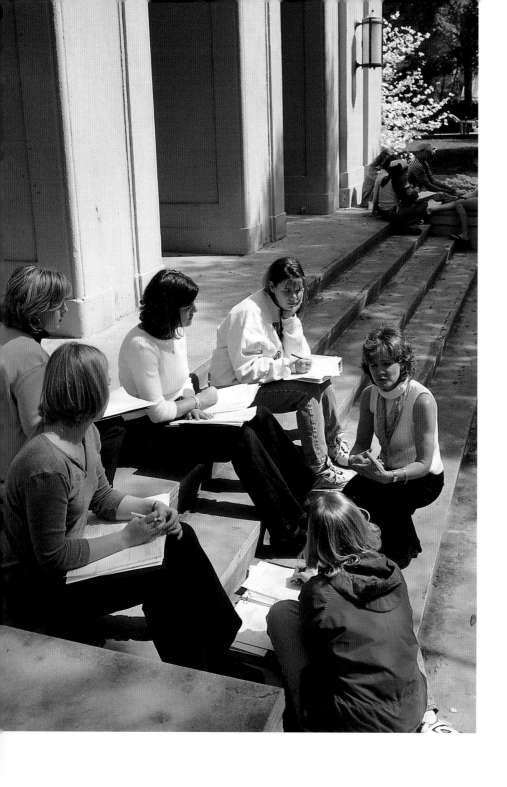

Students enjoy a discussion on the quiet, cool steps at Wardlaw, home of the College of Education, where learning takes place not only within the confines of a classroom.

President John M. Palms congratulates a new graduate in the hooding ceremony for doctoral candidates. For more than 500 students with disabilities attending USC, the University offers an array of services to help students achieve academic success and strives to make campus buildings accessible for all.

Smiles abound at every Carolina graduation, a day of pomp and circumstance that takes place in May, August, and December. USC annually awards more than 7,000 degrees on its eight campuses, ranging from associate's, bachelor's, and master's to doctoral, law, and medical degrees.

USC's first Rhodes Scholar since the early 1980s, 1999 graduate Caroline Parler (left) chats with Susie VanHuss, executive director of USC's Office of Foundations. Parler's many scholarly and extracurricular achievements are a source of pride for the entire Carolina family.

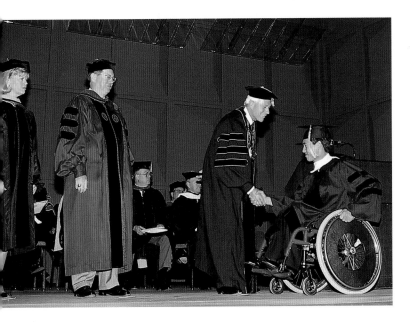

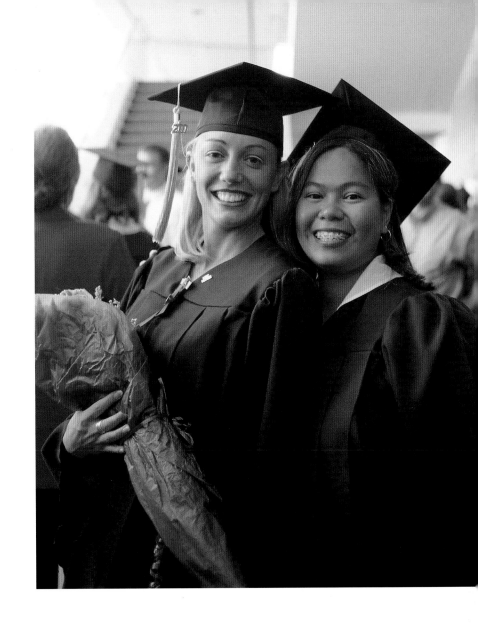

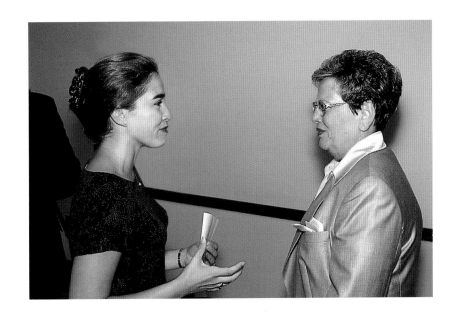

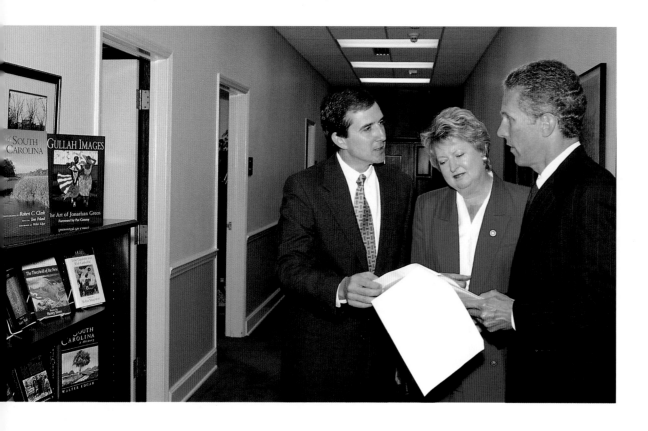

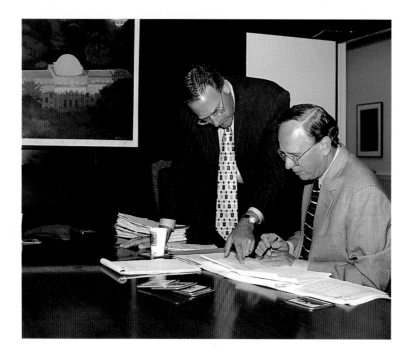

Walter H. Parham, USC's general counsel; Jane M. Jameson, vice president
for human resources; and J. Lyles Glenn, vice president and chief operat-
ing officer for the University, confer outside a conference room in the
Osborne Administration Building.

Dennis Pruitt (left), vice president for student and alumni services, dis-
cusses University budget issues with John L. Finan, vice president for busi-
ness and finance. USC Columbia's annual budget exceeds $500 million;
about 40 percent comes from state appropriations.

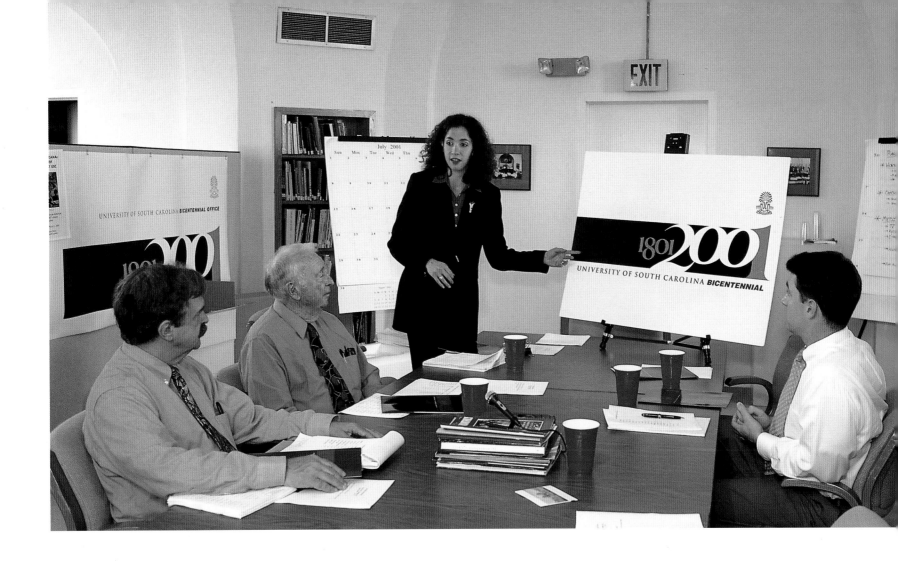

Chief planners for USC's bicentennial celebration in 2001—all USC alumni—include, from left, Thorne Compton, chair of the Bicentennial Executive Committee; Othniel Wienges, chair of the Bicentennial Commission; Sally McKay, executive director of the Bicentennial Office; and Harry Lesesne, associate director and historian of the Bicentennial Office.

As provost and executive vice president for academic affairs, Jerome D. Odom (left) is responsible for making important decisions with President Palms regarding curriculum, faculty, and other academic concerns.

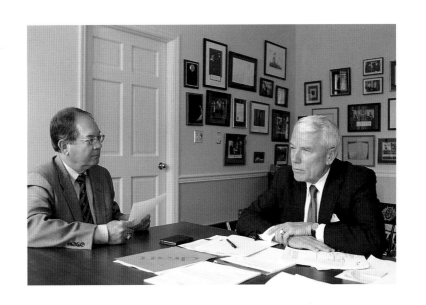

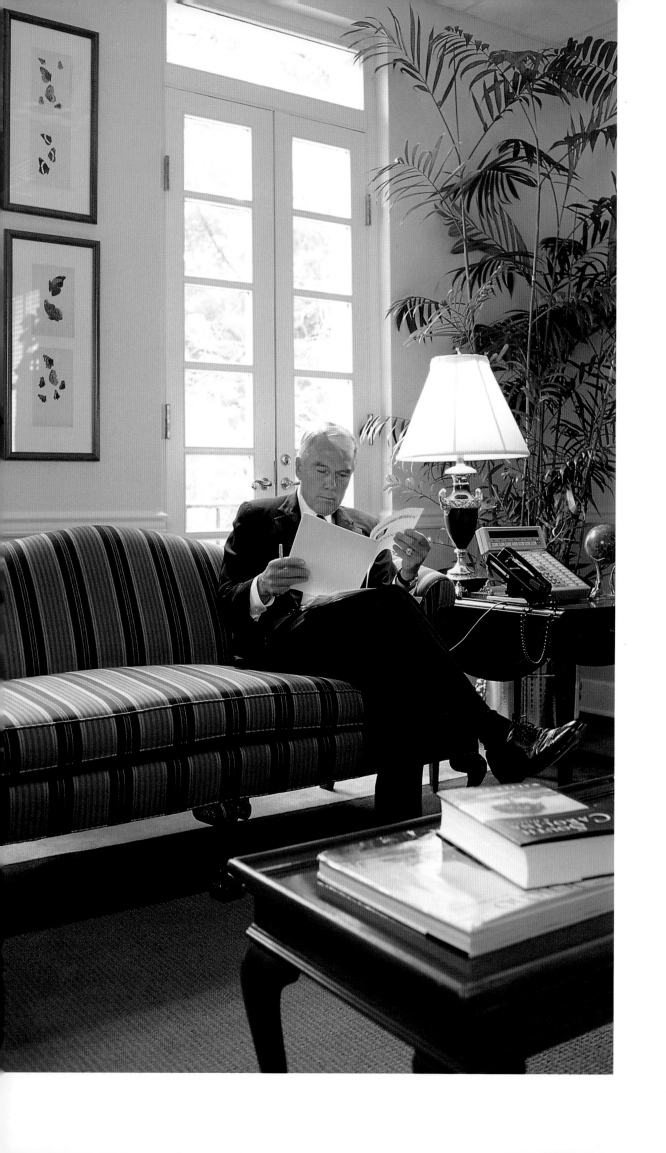

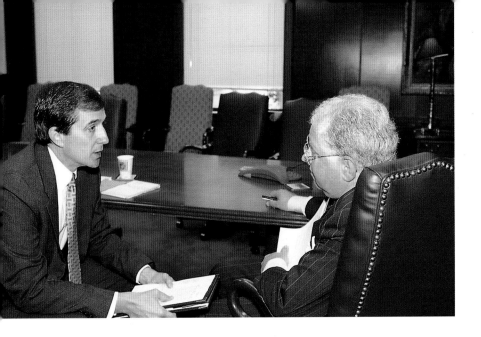

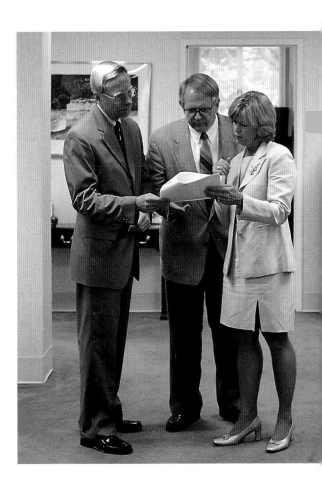

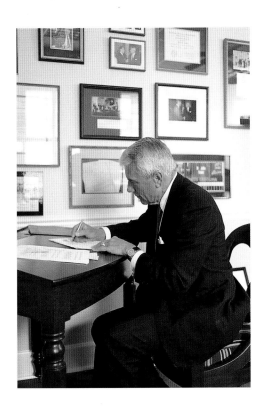

President Palms uses a desk built in 1844—one of ten such tables that formed a circle when placed end to end—for signing correspondence and documents. Carolina's Board of Trustees used the desks for more than a hundred years, until 1952. In 1993, the Board of Trustees restored and refurbished the desks; one is still used in the Board of Trustees office.

USC's general counsel, Walter H. Parham (left), and Thomas L. Stepp, University secretary and treasurer, compare notes before an Administrative Council meeting in the Osborne Administration Building.

Left

John M. Palms joined Carolina as USC's 26th president in March 1991 and has guided the University through a dramatic building program and highly successful Bicentennial Campaign. A Phi Beta Kappa graduate of The Citadel, Palms has been a strong advocate for USC's quest to be of such excellence as to warrant membership in the Association of American Universities, which includes 62 of the finest universities in North America.

All three associate provosts, Donald J. Greiner (left), John N. Olsgaard, and Marcia G. Welsh, carry faculty responsibilities in addition to their administrative posts. Greiner, an English professor, is dean of undergraduate affairs; Olsgaard, a library and information science faculty member, oversees academic budgets; and Welsh, a School of Medicine professor, is dean of the Graduate School.

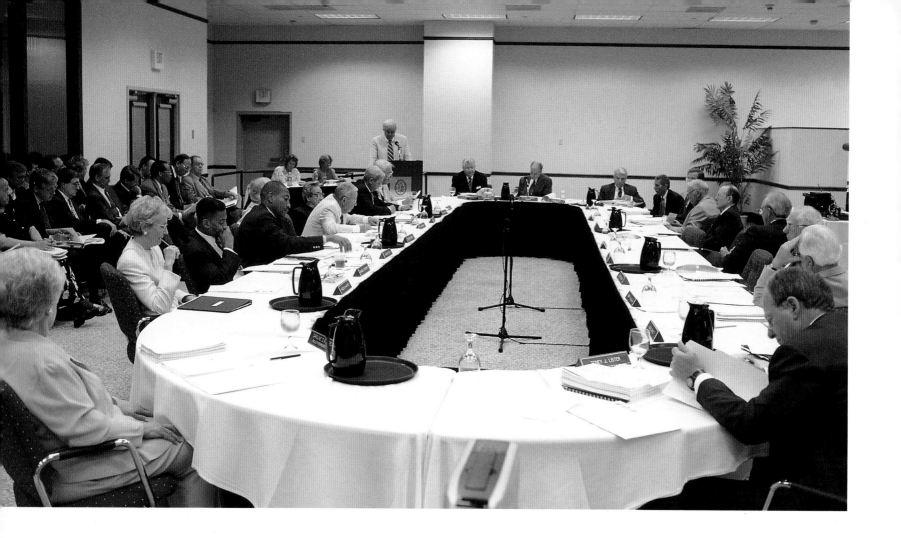

University trustees gather for six full meetings and numerous committee meetings every year. Elected by the General Assembly from sixteen judicial circuits and with two trustees appointed by the governor, the Board of Trustees provides oversight and accountability, sets policy, and approves the University's annual budget.

Two of the newest members of USC's Board of Trustees are former Gamecock basketball standout Alex English (left) and businesswoman Darla Moore (center) shown here at a University boards retreat with fellow board member Miles Loadholt. Both are USC alumni and were named to the board by Governor James H. Hodges.

Right

Athletic director Michael B. McGee (left); William Hubbard, chair of the Board of Trustees; and President Palms confer before a trustees meeting.

Governor Hodges, a 1982 graduate of USC's School of Law, addresses members of Carolina's Board of Trustees and University foundations at the Carolina Plaza.

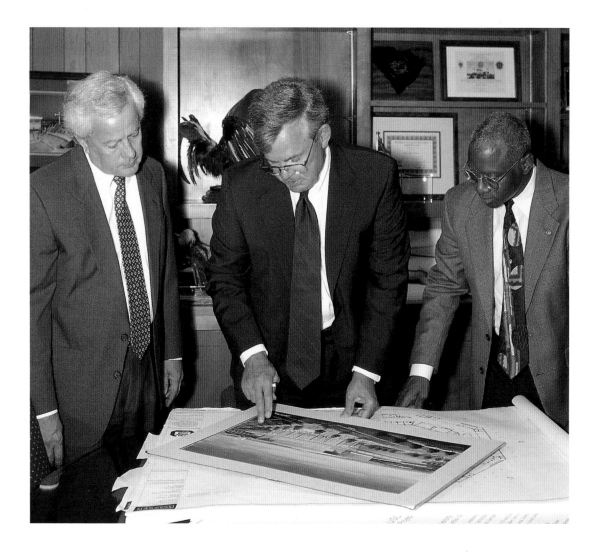

Right

Models, architectural renderings, and blueprints adorn a table in an office of the Boudreaux Group, the architectural firm commissioned to design USC's Strom Thurmond Fitness and Wellness Center. Located at one of the state's busiest intersections—Blossom at Assembly Street—the new wellness center will become an impressive and attractive landmark for the University, city, and state.

(Left to right) Lexington County Council member Johnny W. Jeffcoat, athletics director Mike McGee, and Paul Livingston of the Richland County Council review an architectural rendering of the USC Basketball Arena. Partnerships and cooperative efforts between the University and state and local governments benefit the state in many ways. The USC Basketball Arena is a product of the University's partnership with state government, Richland and Lexington Counties, and the City of Columbia.

(Left to right) John N. Hardee, commissioner of the South Carolina Department of Transportation; Scott Garvin, a principal with the Boudreaux Group, Inc.; and Robert Coble, mayor of the City of Columbia, join Jotaka Eaddy, student body president, and Jerry T. Brewer, director of student life, in examining models for the University's Strom Thurmond Fitness and Wellness Center. The wellness center will be a state-of-the-art recreational facility for USC students, faculty, and staff.

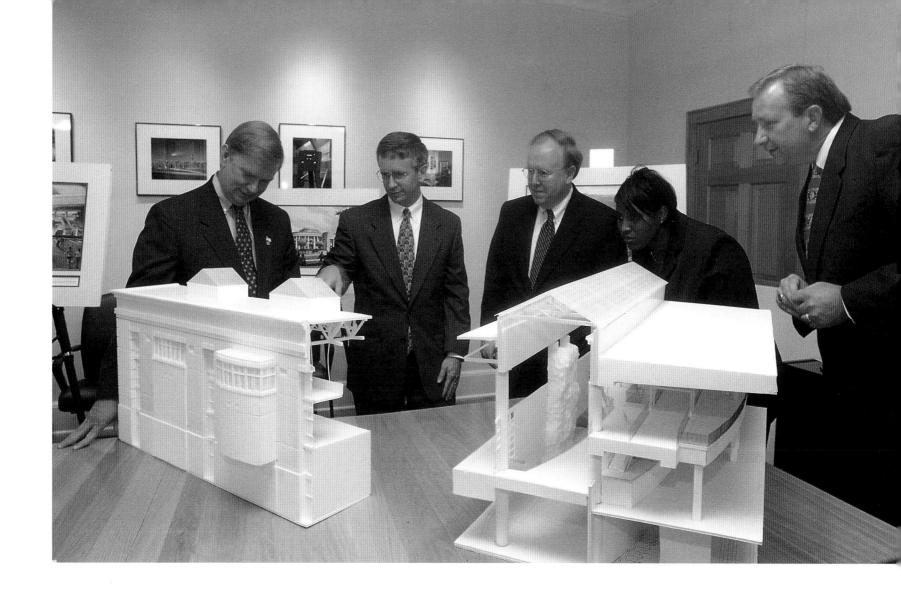

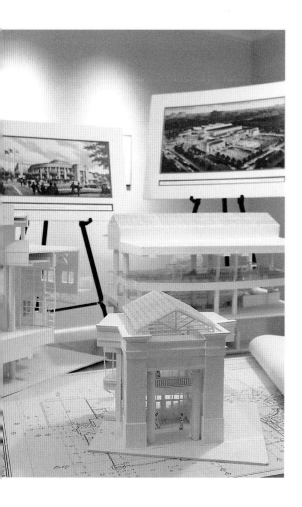

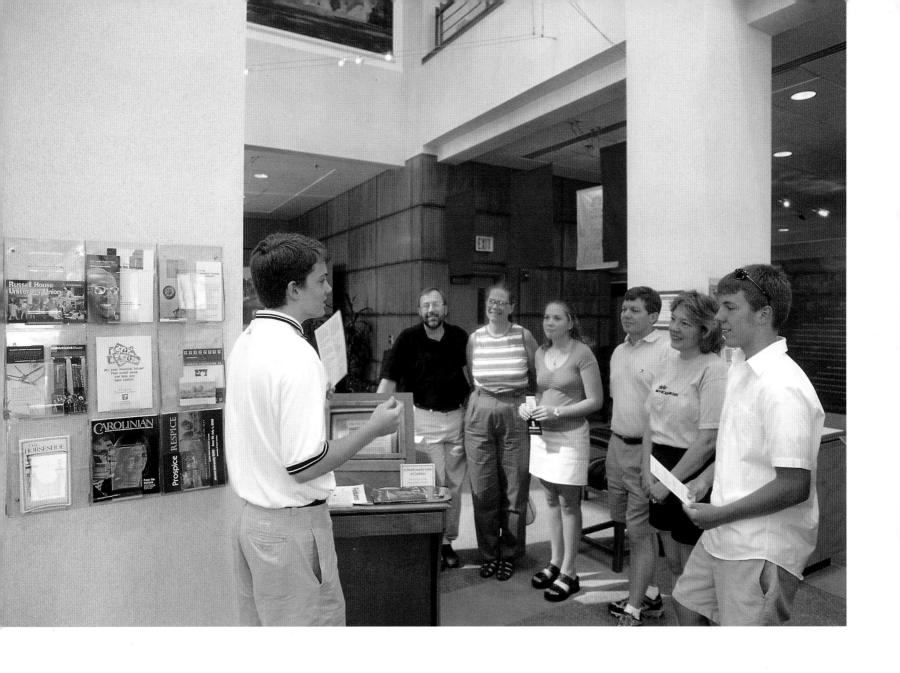

More than 10,000 visitors a year—many of them prospective students and their parents—come to USC's Visitor Center in the Carolina Plaza to learn more about the University. Most of them take walking tours of the campus, led by volunteer student guides who are well versed in USC's history and mission.

Student Government representatives get a taste of debate, lawmaking, and compromise during a Student Senate meeting.

Flags from around the globe drape the Russell House Student Union Building, celebrating USC's annual International Festival. Students from more than 100 countries attend Carolina.

Held every fall and spring, career fairs at USC draw more than 1,000 students and more than 100 companies. The University's Career Center coordinates the fairs, which connect employers with students looking for internship, co-op, part-time, and full-time positions.

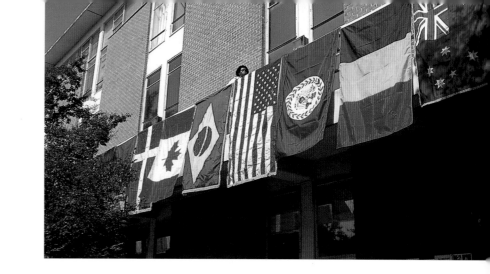

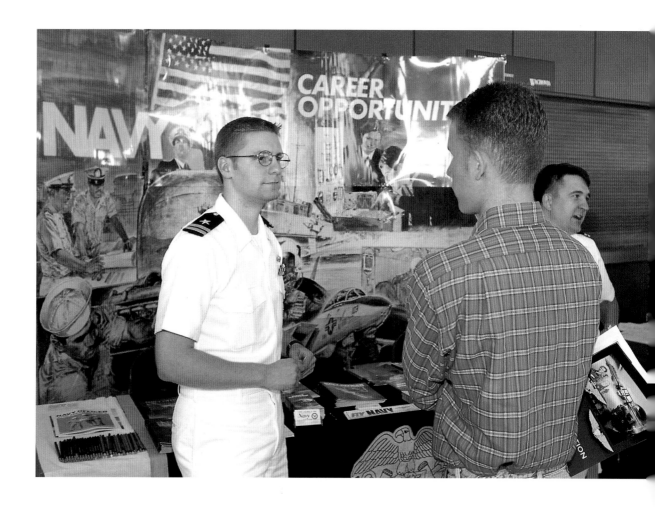

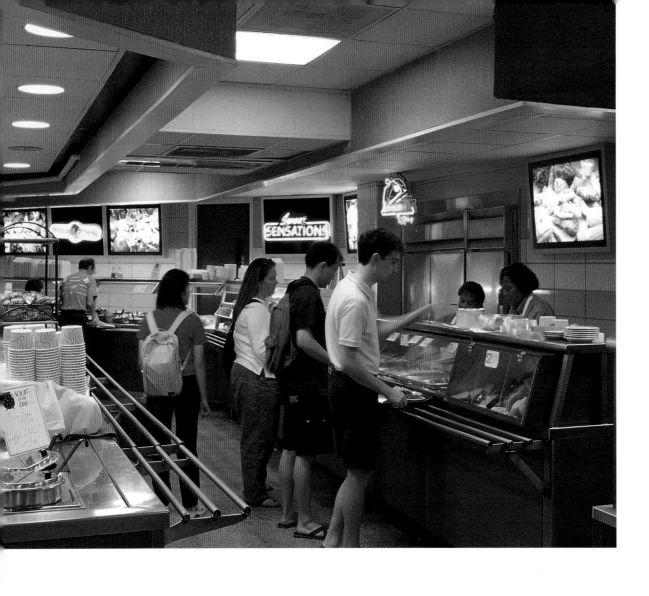

Serving 5,000 people for breakfast, lunch, and dinner, the Grand Market-place in Russell House offers something for nearly every appetite: Chinese stir-fry, a full salad bar, hot entrées, a deli, and a dessert bar. Operated seven days a week by Sodexho Marriott Services, the facility is the largest eatery on campus.

Located on the ground floor of Russell House, the University Bookstore has plenty of books, of course, but also offers an array of Gamecock cloth-ing and other garnet-and-black memorabilia.

Right
First-year Honors College students relax in their room in Maxcy College residence hall. Built in the 1930s, Maxcy was completely renovated sev-eral years ago and now houses all on-campus Honors College freshmen.

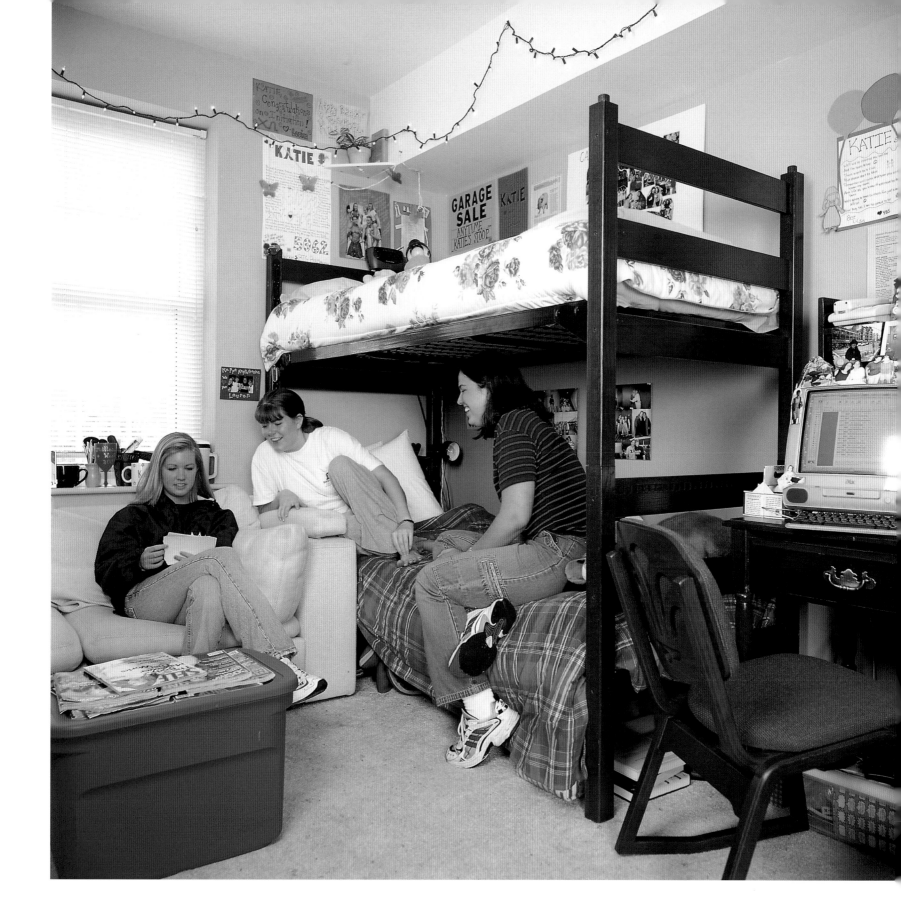

USC's ubiquitous symbol—the fighting Gamecock—makes a newly painted appearance on Greene Street in front of Russell House. The nickname "Gamecocks" originated with *The State* newspaper's description of the Carolina football team in 1903, and the official emblem was designed in the 1960s. The mascot Cocky was born in 1980.

Right
USC students stay on their feet for twenty-eight hours in a dance marathon aimed at raising money for the Palmetto Richland Children's Hospital. In 1999 and 2000, the effort raised a cumulative total of nearly $125,000.

Likenesses of Cocky appear everywhere, even on Halloween pumpkins.

Overleaf
A view from the south end zone of Williams-Brice Stadium as the Carolina Marching Band entertains a near-capacity crowd. The first phase of the stadium was built in 1935, when it was called Carolina Stadium. Renovations in the 1970s were partly funded by a gift from the estate of the late Martha Williams Brice of Sumter. The stadium was renamed as a memorial to Mrs. Brice; her husband, Thomas H. Brice, a 1926 law school graduate; and her parents, Mr. and Mrs. O. L. Williams.

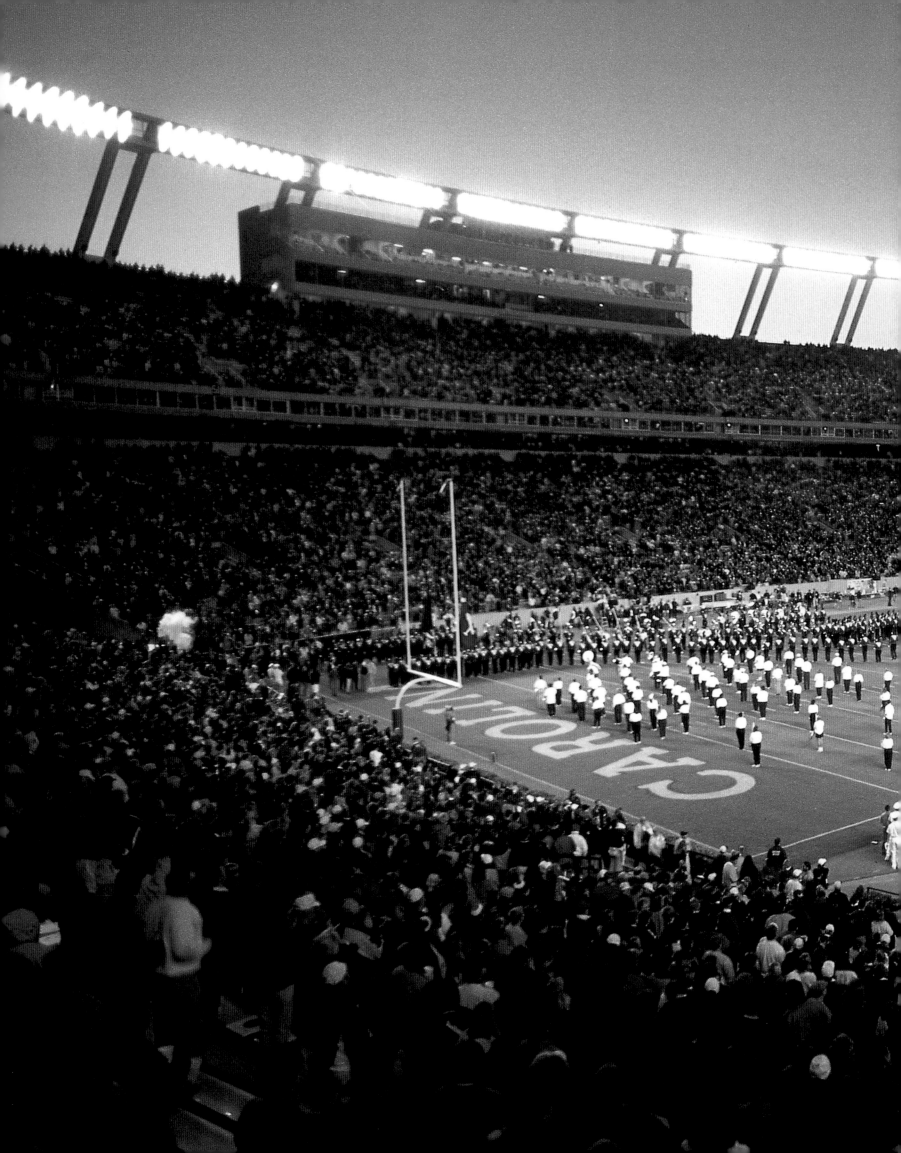

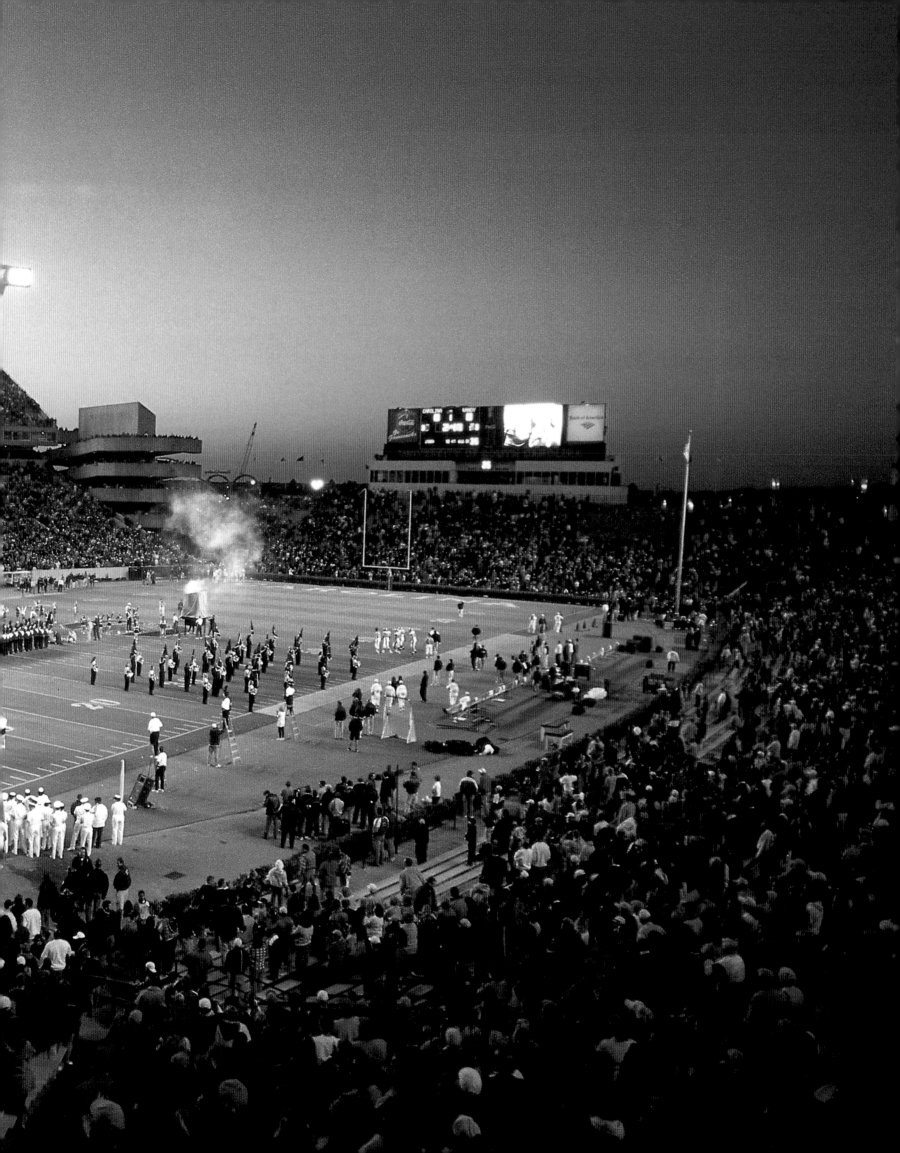

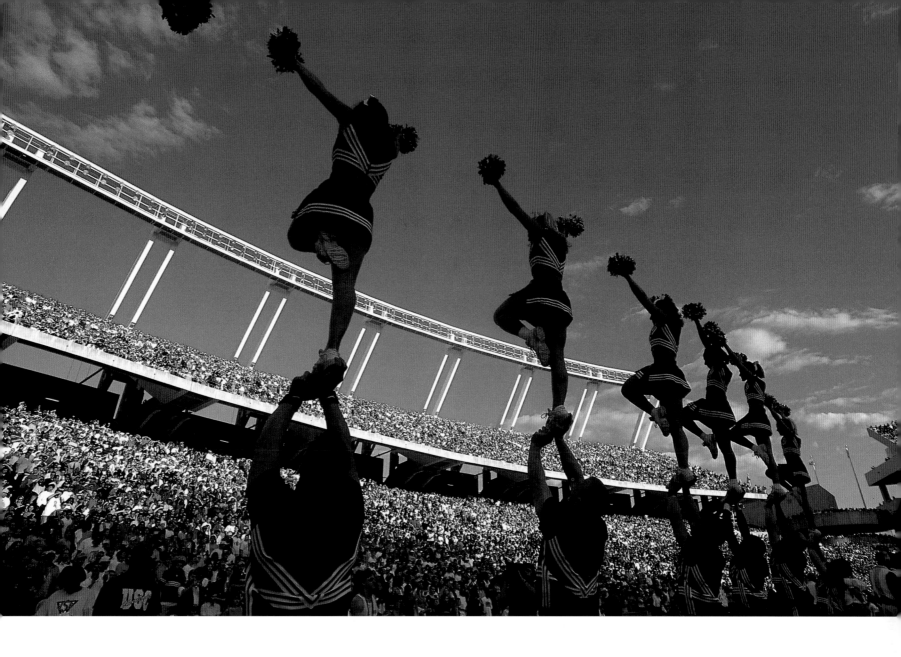

Left
A unique view of Williams-Brice Stadium through the windows of The Zone, the stadium's posh end-zone facility that is often used for catered gatherings.

This three-foot-high, sixty-pound trophy goes to the winner of the annual Carolina-Clemson football game and is returned to the field for the next year's game. The trophy was first presented by Spartanburg-based Spartan Foods (now Advantica Restaurant Group) some twenty years ago and has been traded back and forth by the victors ever since.

Above
Life is busy for Carolina cheerleaders: the sixteen-member varsity squad and twenty-four-member junior varsity squad pump up the crowds at football, volleyball, and men's and women's basketball games, and make special community appearances.

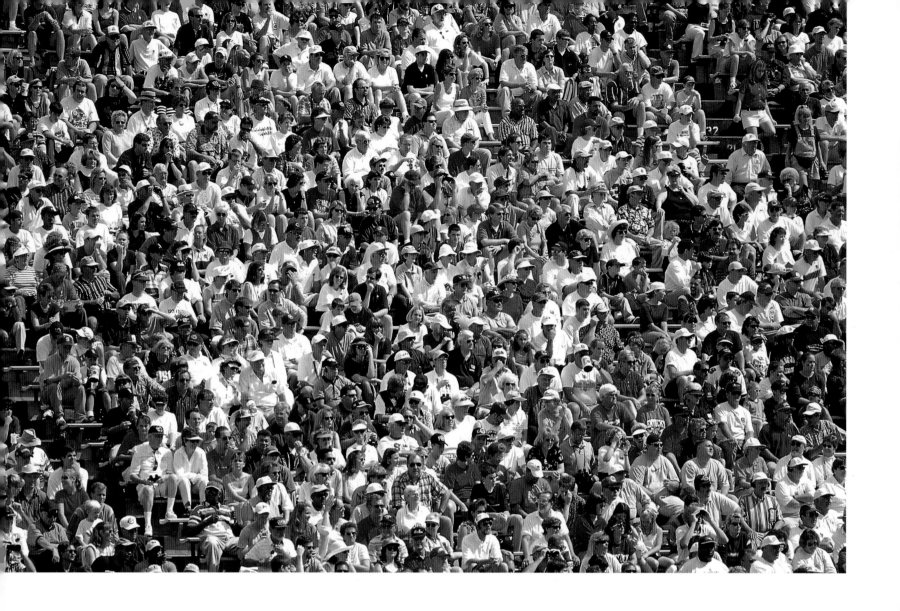

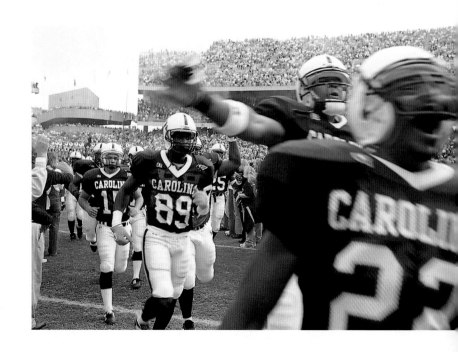

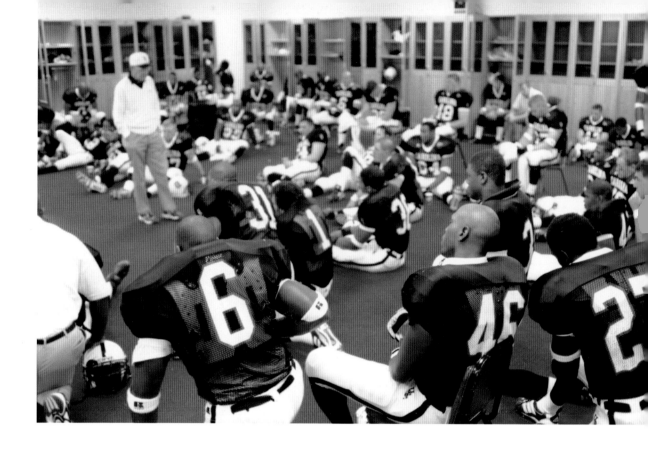

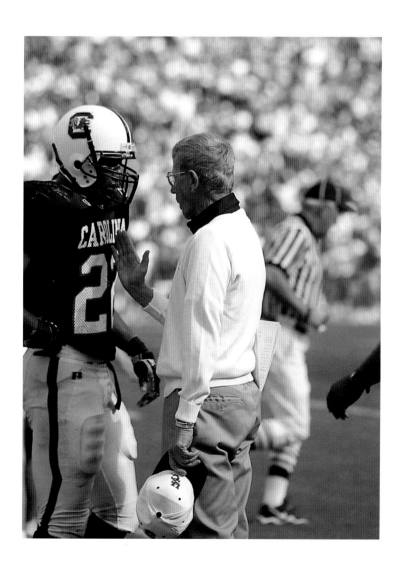

Win, lose, or draw, Gamecock fans give USC one of the nation's best football attendance records in the nation. Look closely and you'll see two lone University of Kentucky fans amid a sea of Gamecock faithful.

With the dramatic *2001* theme music creating an acoustical backdrop, Gamecock football players charge onto the field at Williams-Brice Stadium.

Head football coach Lou Holtz was an assistant coach at USC in the 1960s. He later coached at William and Mary, North Carolina State, Arkansas, and Minnesota, and at Notre Dame, where he won a national championship before returning to USC in 1999.

With his inimitable talent for player motivation, head football coach Lou Holtz delivers a pregame pep talk just before his team takes on the Clemson Tigers.

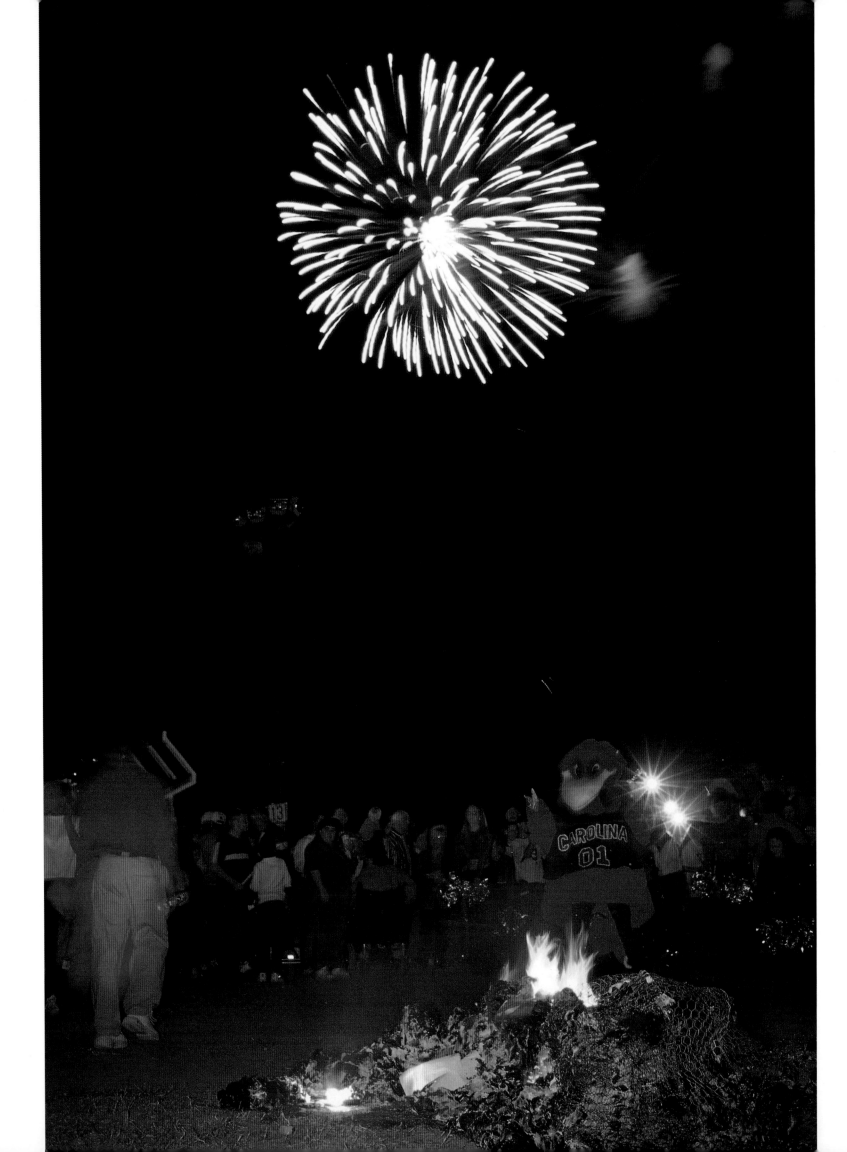

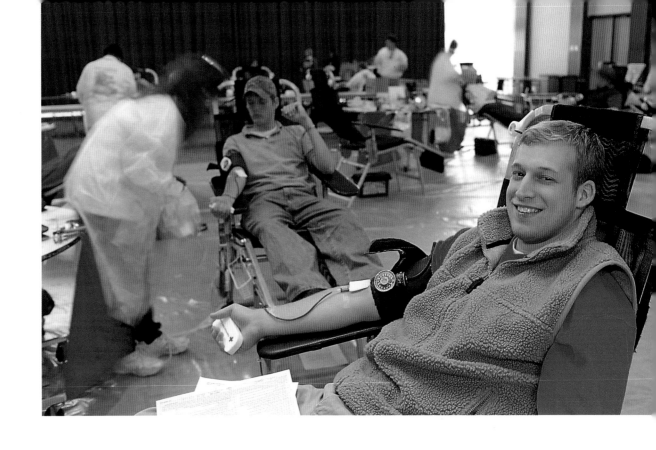

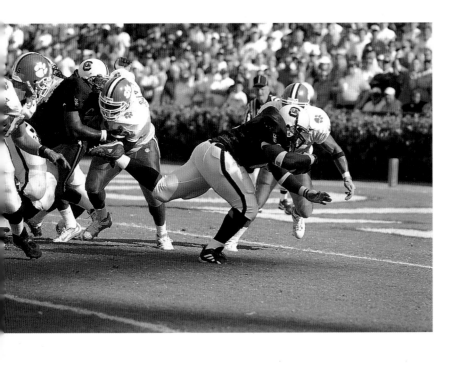

A USC student proves that his blood really does run garnet as he contributes to the annual Carolina-Clemson blood drive. The friendly competition takes place just before the two in-state rivals clash in football; in 1999 it netted nearly 4,000 pints of blood for hospitals and other healthcare agencies.

The final regular game of the season is traditionally the Carolina-Clemson game. For years, the event took place on Big Thursday during the South Carolina State Fair. While that custom has ended, competition for the winner's year-long bragging rights continues.

Left
Fireworks blaze, a paper tiger disintegrates into a heap of glowing embers, and Cocky shines with competitive spirit at the annual Tiger Burn pep rally before the USC-Clemson football game.

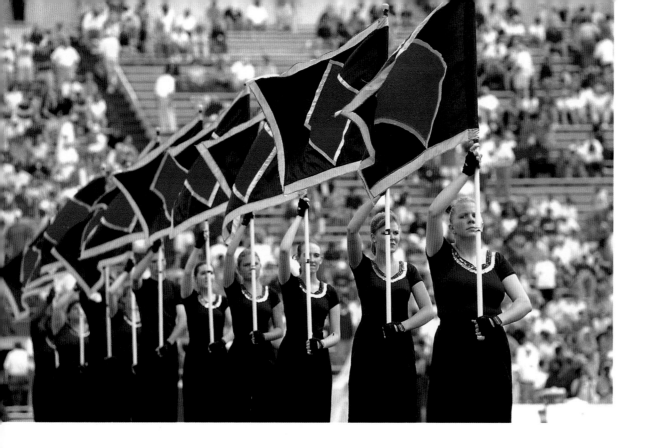

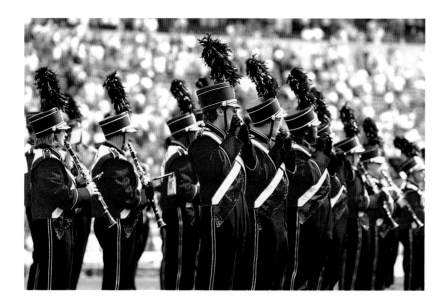

Their movements carefully choreographed and synchronized with the Carolina Marching Band, the twenty-four-member flag corps puts on a flag-waving exhibition at every home football halftime show.

Bedecked in garnet-and-black uniforms, some 300 student members of the band take the field for football pregame and halftime shows at Williams-Brice Stadium. The band performs four new shows every fall, choreographed and rehearsed during thrice-weekly practice sessions.

Air Force ROTC cadets present the American flag before football fans at Williams-Brice Stadium. USC has ROTC cadets from the major branches of service—Air Force, Army, Marines, and Navy—seeking commissions as second lieutenants or Navy ensigns after graduation.

Right
With brass instruments gleaming under the stadium lights, members of the Carolina Marching Band align themselves in perfect formation in preparation for their halftime performance.

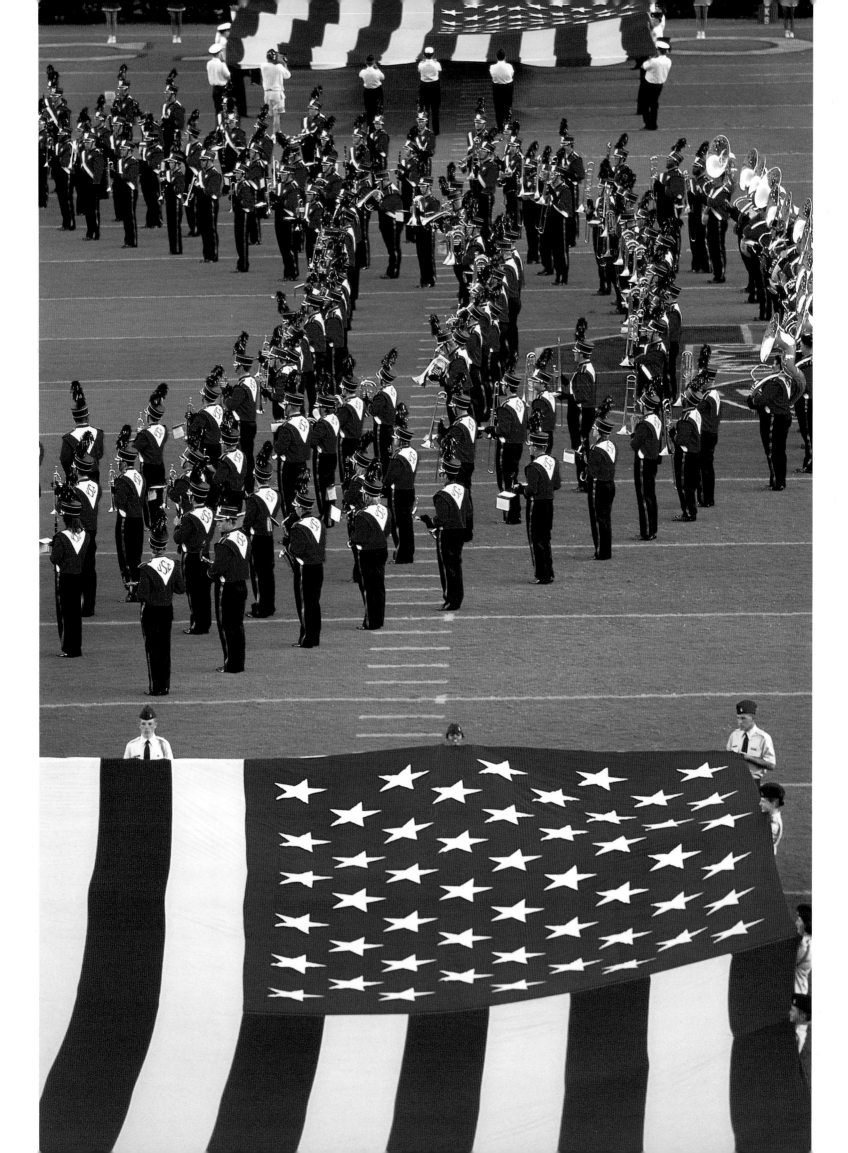

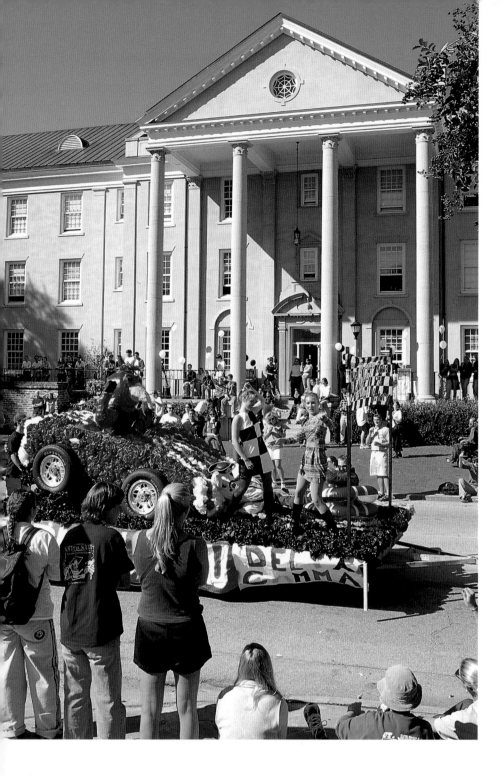

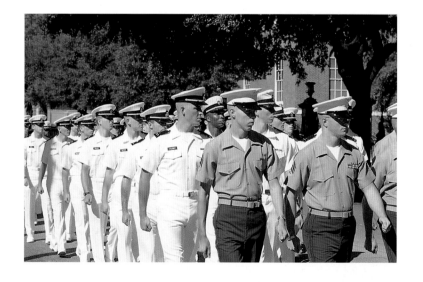

Sorority sisters from Delta Gamma, one of thirty-one Greek organizations on campus, cheer a papier-mâché Cocky to victory as the Homecoming parade—replete with floats, the Carolina Marching Band, and the real Cocky—makes its way up Greene Street.

A Homecoming pageant contestant gets a peck on the cheek from Cocky during the talent portion of the competition. The crowning of Homecoming kings and queens is based on several criteria, including grade point average and community service.

Thursdays are drill day for cadets in USC's ROTC programs. Navy and Marine cadets like these were in the first ROTC unit on campus more than half a century ago.

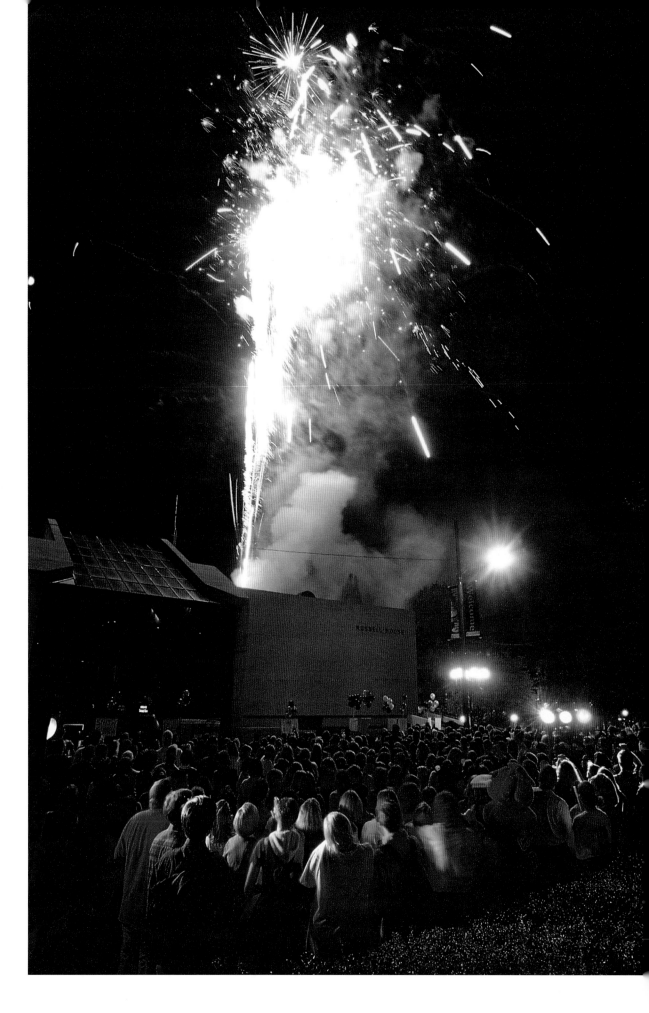

Colorful fireworks light up the sky above Russell House as part of the annual kickoff for Homecoming, a festive weekend that brings many of USC's 190,000 alumni back to campus.

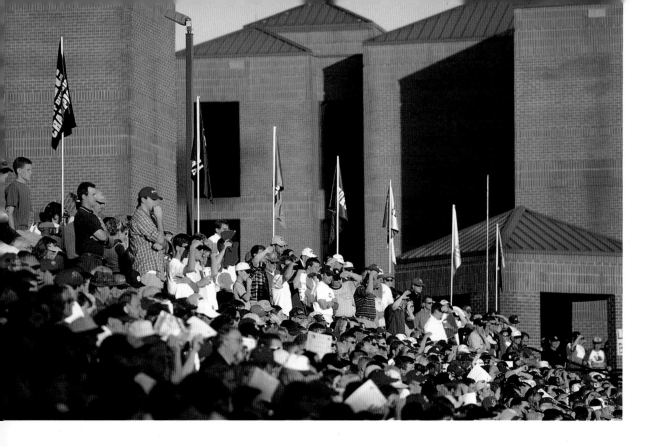

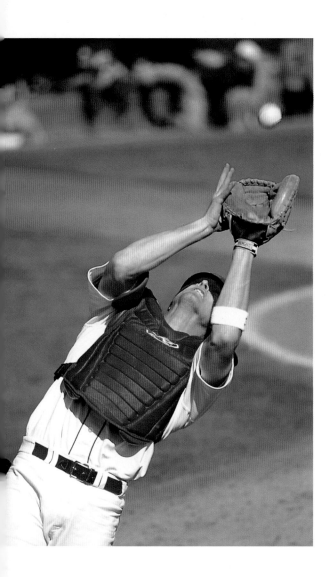

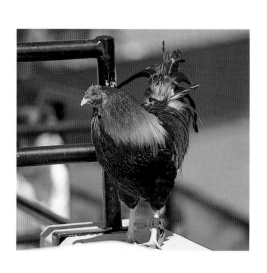

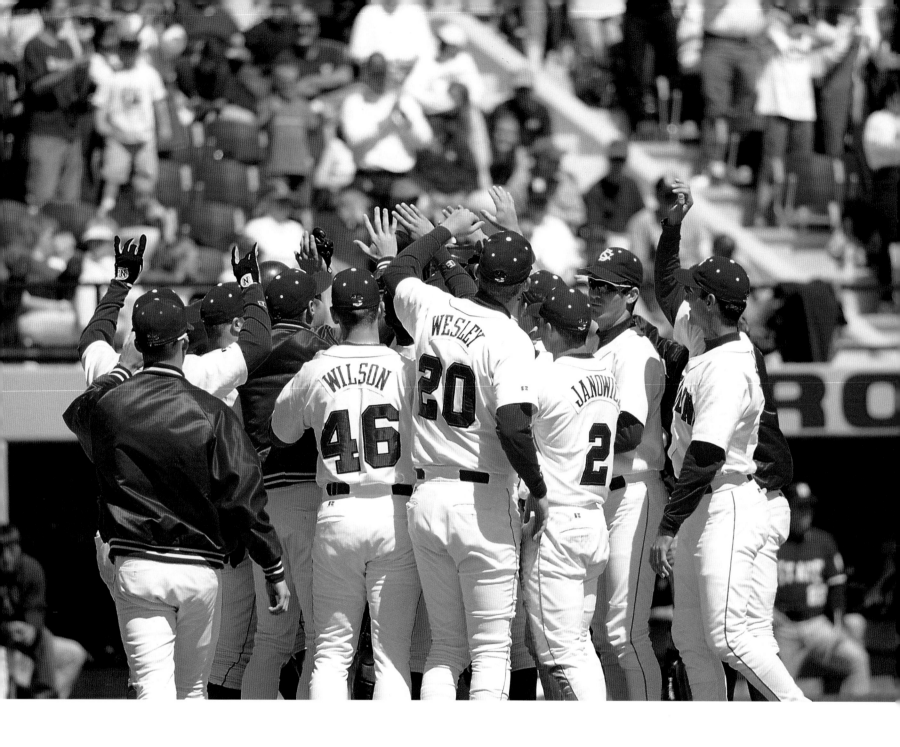

Left

Only a few spots of orange are visible in a sea of garnet as fans from USC and Clemson watch their teams play baseball at Sarge Frye Field. The field is named for legendary Carolina groundskeeper Weldon B. Frye, who tended athletic fields for more than forty years. Gamecock baseball has been around far longer—organized play began in 1892.

Despite the late afternoon sun in his eyes, a USC baseball catcher closes in on a foul-tipped ball to get one out closer to a Gamecock win.

With a tether on his left leg to keep him from getting too carried away, this colorful rooster cheers on the Gamecock baseball team to another win in their spectacular 2000 season.

Gamecock baseball players had plenty to celebrate during their 2000 season—winning their second-straight SEC Eastern Division Championship, winning the SEC Championship, earning a number one national ranking, making a trip to the NCAA regionals, and setting an SEC record for consecutive wins.

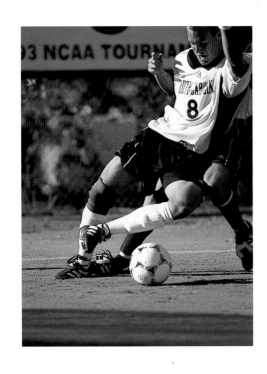

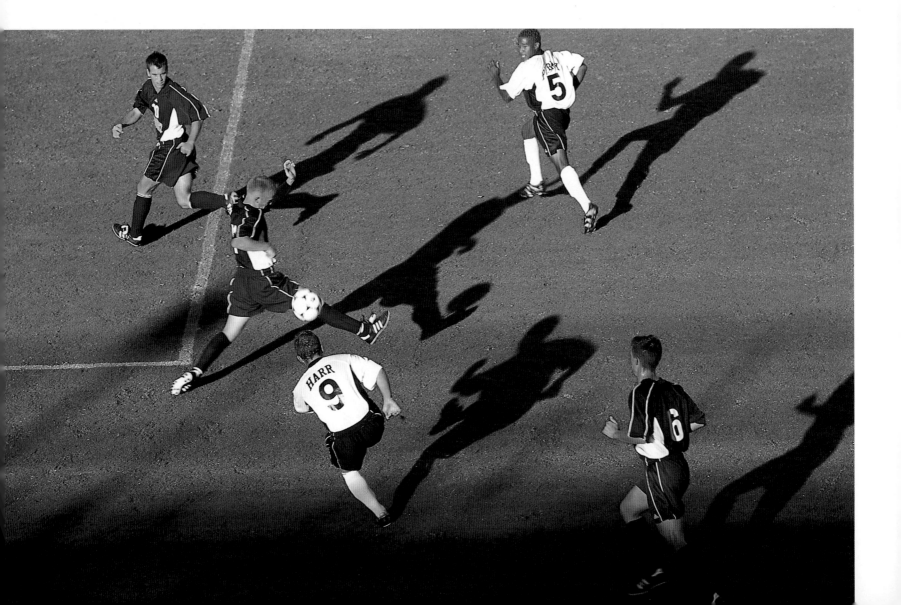

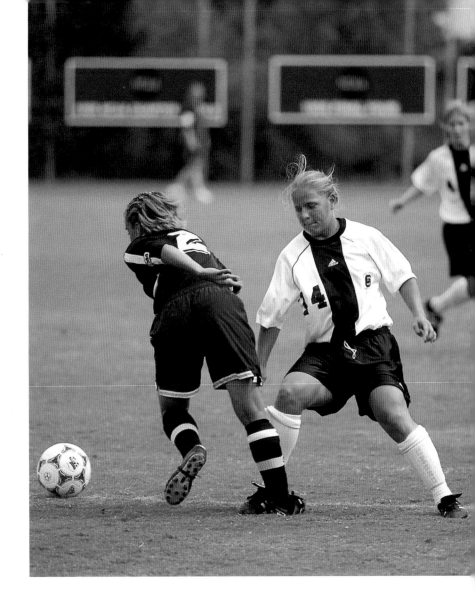

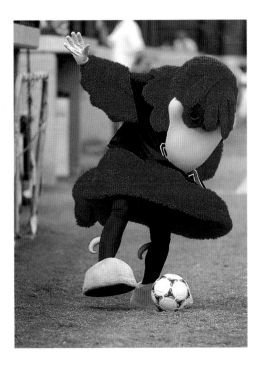

Left

Maintaining his balance while keeping the ball from the opposition, this soccer player employs some phenomenal moves on the field at the Eugene Stone III Stadium, a.k.a. the Graveyard.

Men's soccer notched its 24th season in 2000, making it one of the oldest programs in the South. Mark Berson has coached the team every year and is among the top ten winningest coaches in NCAA Division I play.

A soccer star hopeful gets her T-shirt signed by a Carolina soccer star. USC's women's soccer team posted more wins in 1999 than any season since the program began in 1995. Twelve team members were on the SEC Academic Honor Roll.

Cocky shows up to cheer at nearly every sport, so why not try to play, too? Well, there is the problem of those big yellow feet.

USC's women's soccer program began its sixth season in NCAA competition in 2000. The team plays in about twenty games during the fall, with home matches at Eugene Stone III Soccer Stadium.

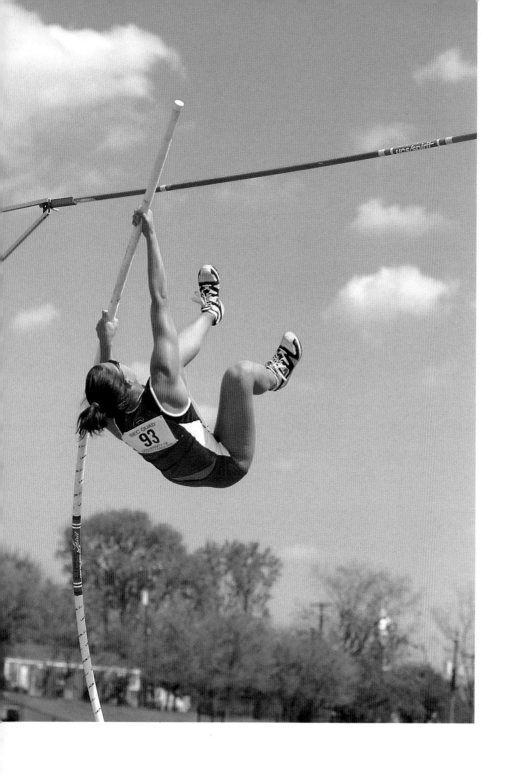

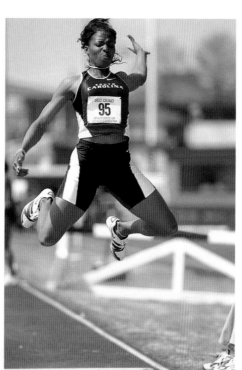

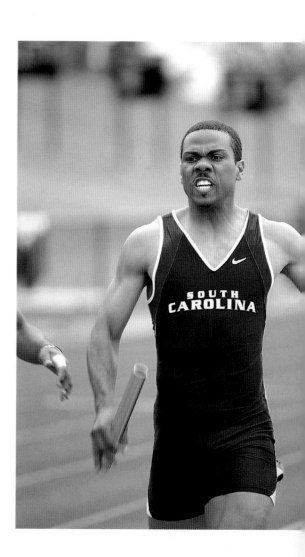

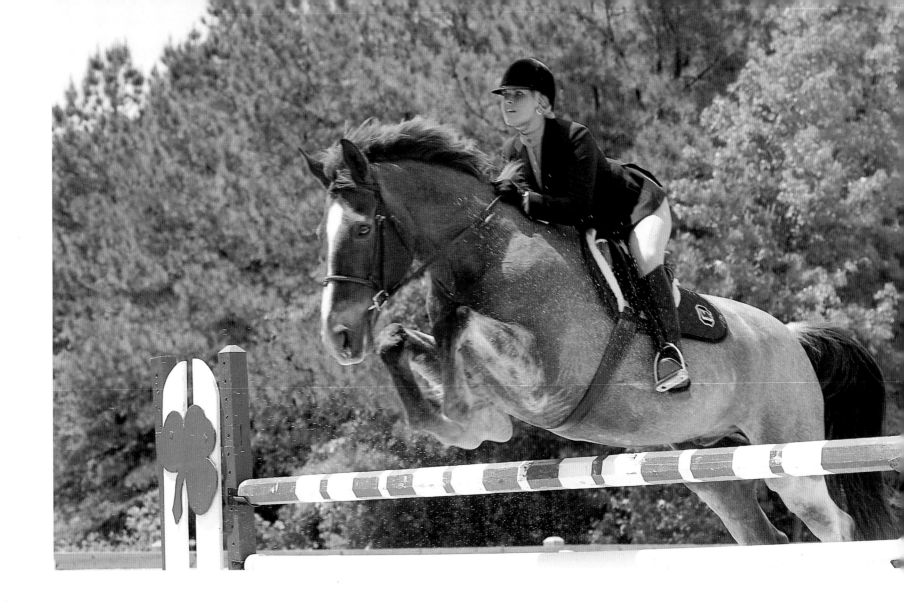

Women's track and field athletes continue to soar to new heights, capturing the outdoor SEC title in 1999 and vying in 2000 for their fifth-straight top ten NCAA finish in outdoor events.

A member of USC's women's track and field team is temporarily airborne in long jump competition. In 1999, in addition to capturing the SEC outdoor title, the team placed second in the NCAA indoor meet, the highest-ever finish by a USC women's team.

The men's track and field team, led by outstanding individual and team talent, has placed in the top ten in NCAA indoor events for the past four years.

Above

Equestrian is Carolina's newest women's varsity sport, with riders competing in English club jumping and Western show. In-state rival Clemson University and SEC members Auburn, Georgia, and Alabama are among USC's equestrian competitors.

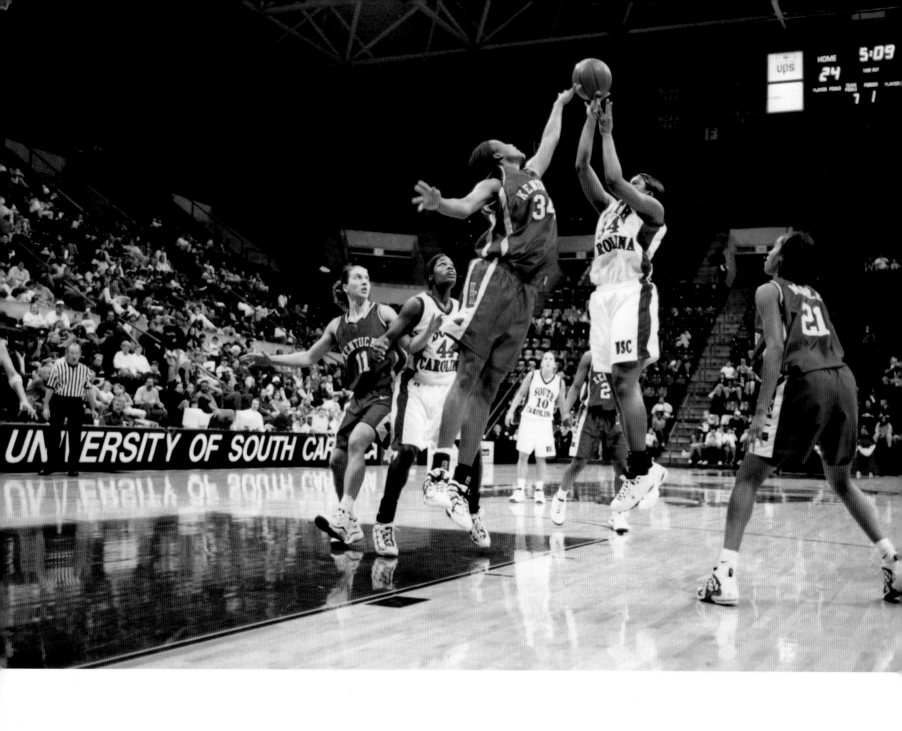

Right

Susan Walvius, head women's basketball coach, discusses strategy on the sidelines while keeping a watchful eye on the court. Women's basketball at USC gained varsity status in 1974 when it became part of the athletics department under Helen Timmermans, the University's first associate director of athletics for women.

Carolina's women's golf team has made seven NCAA postseason appearances and, with the men's golf team, uses the 5,996-yard links at the University Club as its home course.

The Lady Gamecocks are competitive on the court and in the classroom; four team members were named to the SEC Academic Honor Roll in the most recent season.

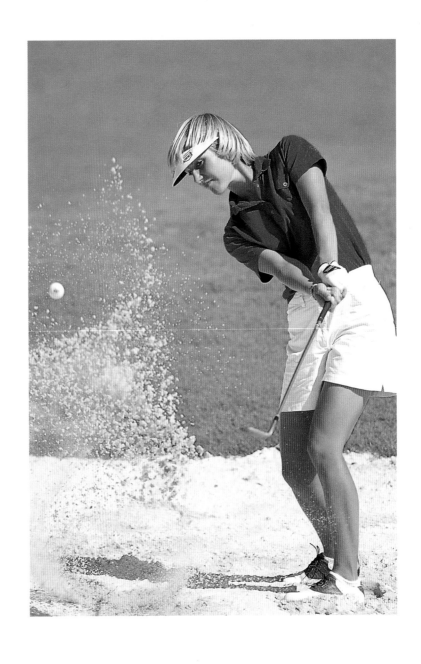

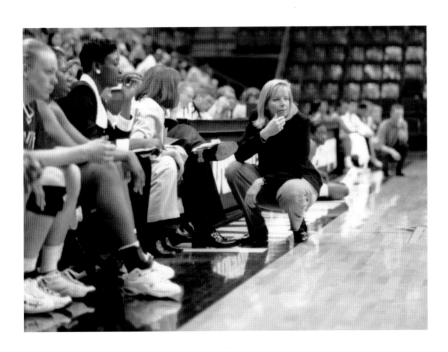

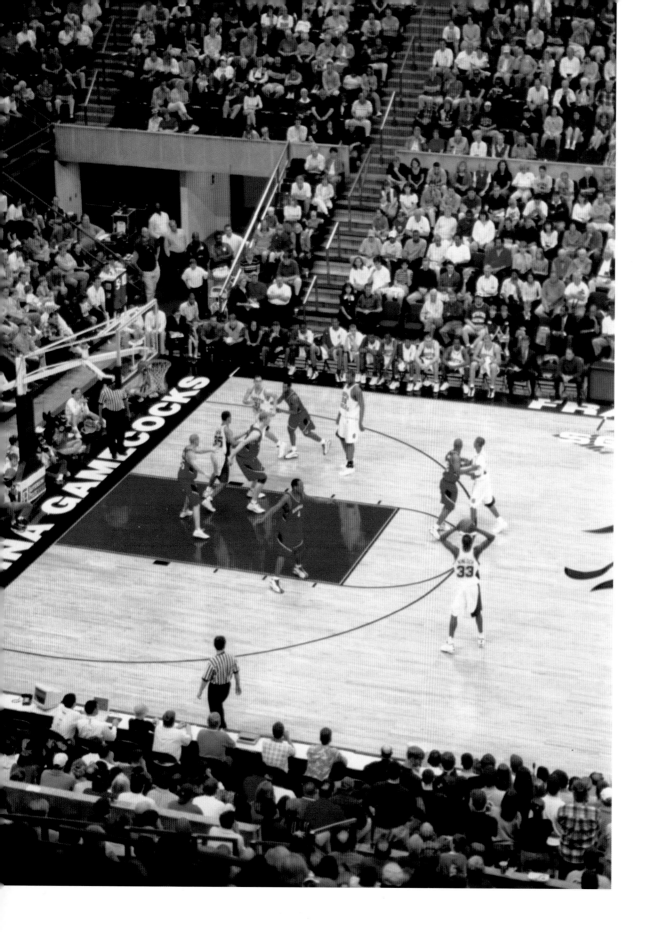

USC's basketball teams have played at the Carolina Coliseum since 1968 but will move to a new location with the completion of a new and larger 18,000-seat arena to be built in the Congaree Vista.

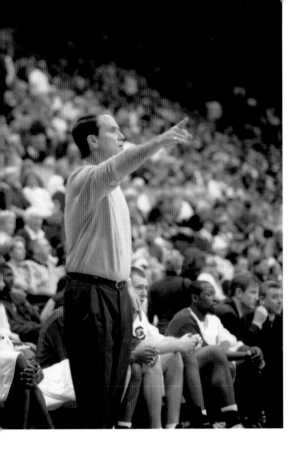

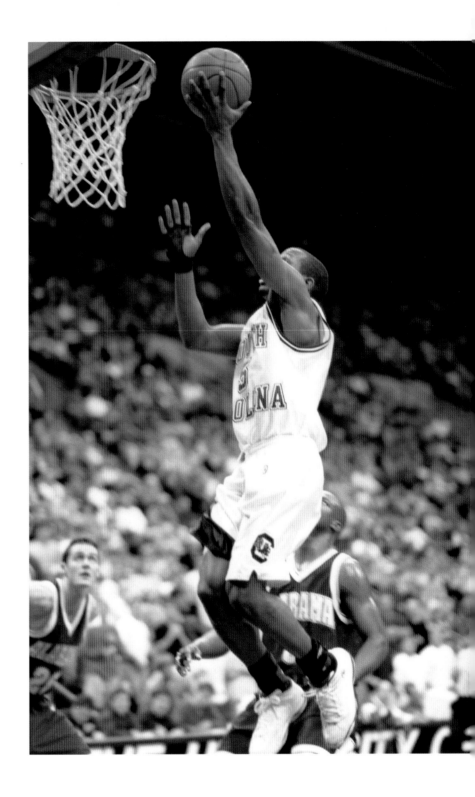

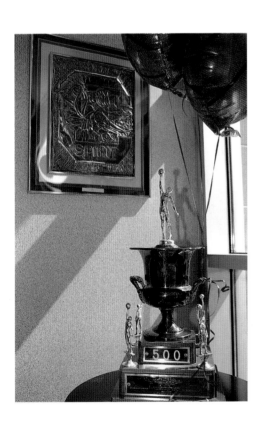

Head men's basketball coach Eddie Fogler directs a play from the home court sidelines in Carolina Coliseum's Frank McGuire Arena. Fogler has coached the Carolina team since the 1993–94 season.

The USC men's basketball team captured the University's first SEC championship in any sport in 1996–97, the same year Coach Eddie Fogler was named NCAA Coach of the Year. The team's home court is named the Frank McGuire Arena, in honor of USC's longtime basketball coach who brought national acclaim to the program in the early 1970s.

A trophy memorializing Coach Frank McGuire's 500th win is on display in the athletics practice facility beside the Carolina Coliseum.

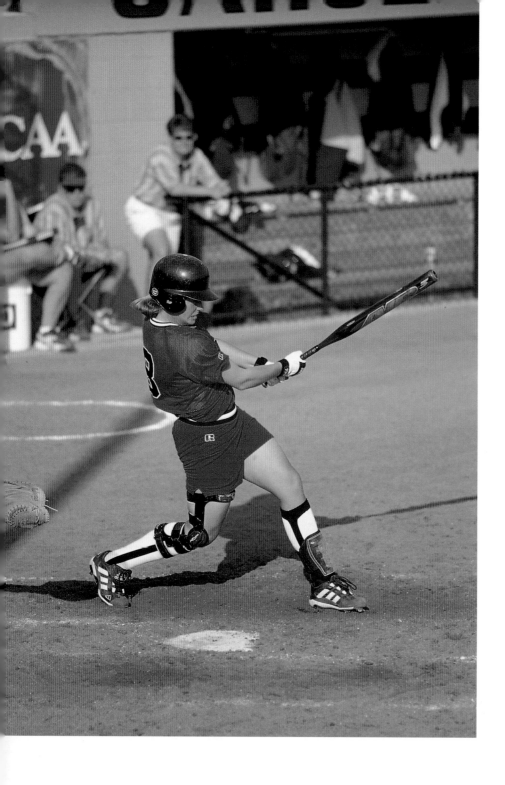
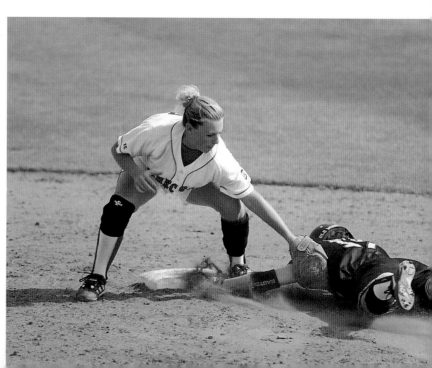

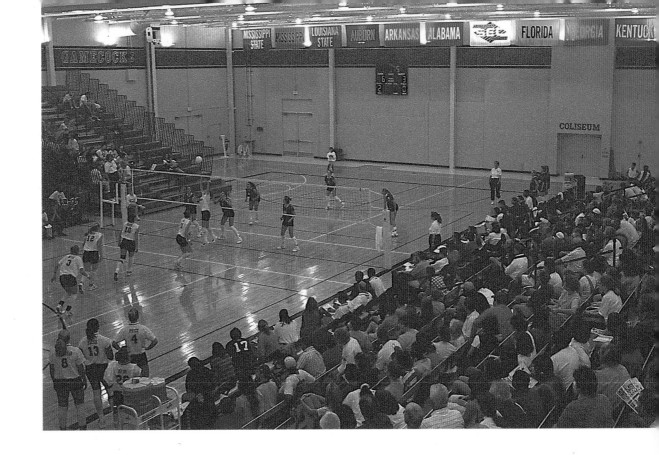

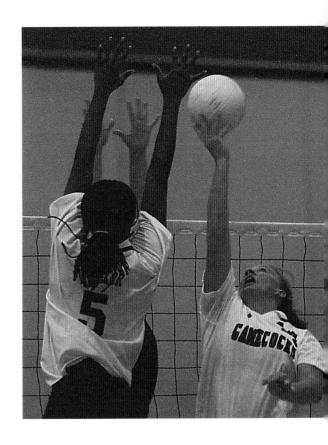

Above

Competing in the NCAA tournament in three of their past five seasons, USC's women's volleyball squad has often tasted success since women's volleyball became a Division I–level sport in the early 1970s.

Two members of the women's volleyball team go up against a competitor during a conference game at the Volleyball Competition Facility. Women's volleyball began competing at the club level in 1967 and became a varsity sport in 1978.

Left

Women's softball teams have knocked in 900 wins—highest in the Southeastern Conference—competed nine times in NCAA regionals, and made three trips to the College World Series.

The women's softball team made a strong finish in 1999, winning the SEC tournament and competing in postseason play.

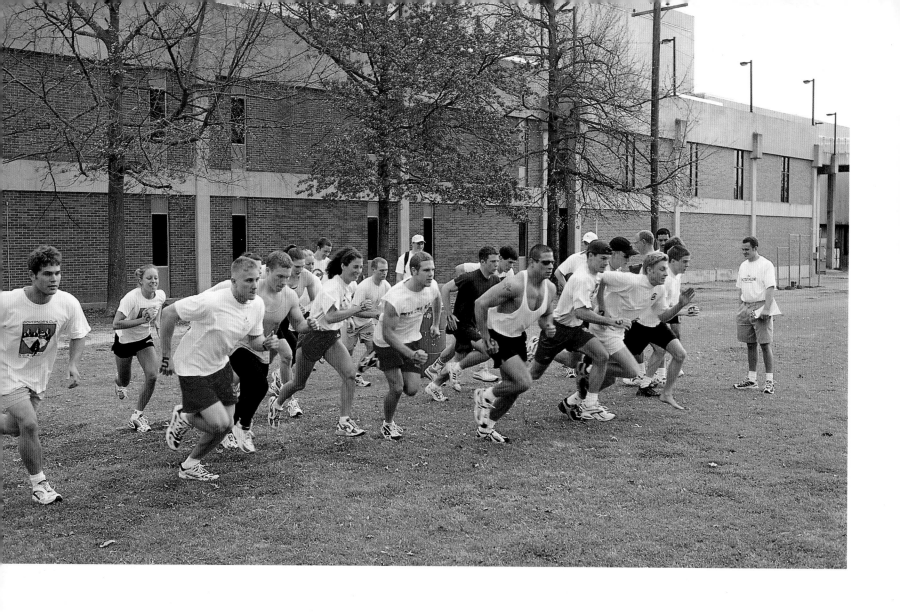

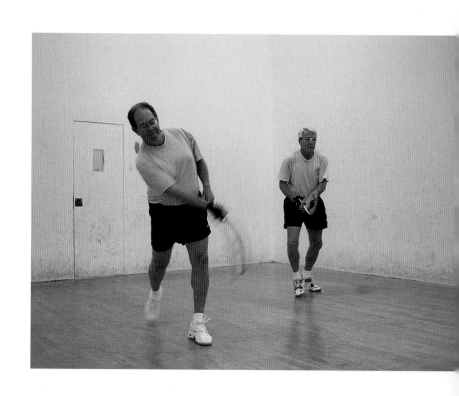

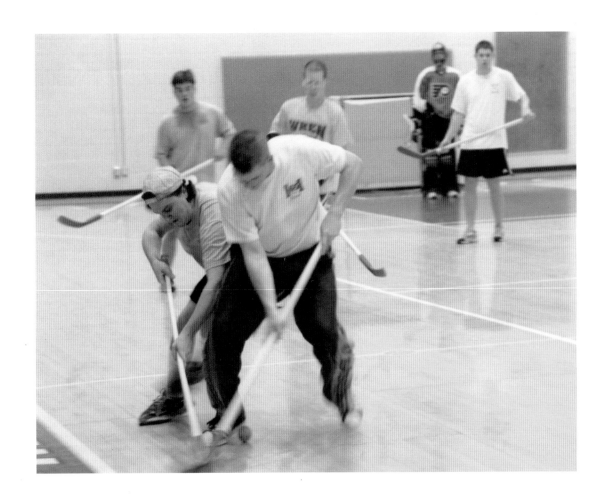

Left

Students charge off on a one-mile run, the first event in USC's first-ever octathlon. The fitness-promoting event attracted students from across campus who swam, ran, and negotiated an obstacle course in a non-competitive test of physical and mental stamina.

President Palms and Provost Odom enjoy a collegial working relationship, but a game of racquetball brings out their competitive nature at the Sol Blatt Physical Education Center.

Above

A lively floor hockey game at the Blatt Center is one of thirty-five intramural sports available for students.

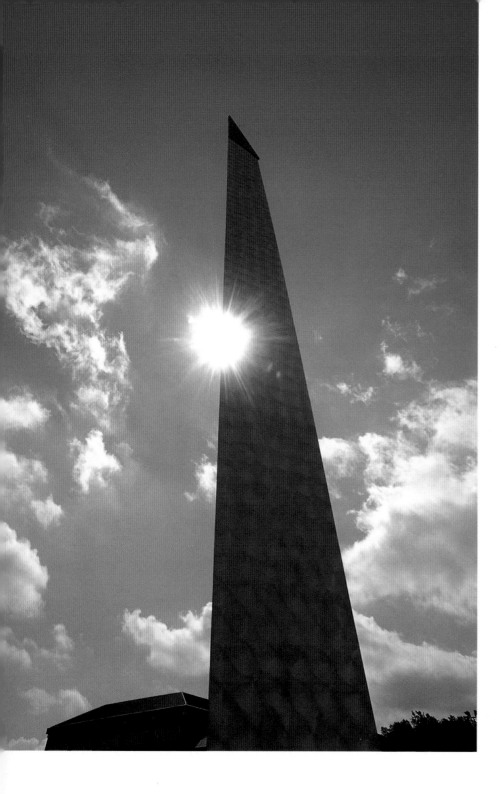

An Egyptian obelisk, part of a massive sundial, stands guard in front of USC Aiken's Ruth Patrick Science Education Center, a hands-on science and math learning center for K through 12 students. The center attracts more than 60,000 visitors yearly.

The DuPont Planetarium in the Ruth Patrick Science Education Center takes students on intergalactic journeys every week.

Right

The Pickens-Salley House, built in 1828–29, was once the home of South Carolina governor Francis Pickens and later the home of Aiken suffragist Eulalie Salley. Moved twice from its original foundation in Edgefield, the historic house is now the administrative headquarters for USC Aiken's chancellor and its development and alumni office.

The USC Aiken campus includes thirteen academic buildings on 453 acres, offering bachelor's and master's degrees and serving more than 3,000 undergraduate students. One of two senior campuses within the University, USC Aiken was founded in 1961.

Right

USC Beaufort's Arts Building on Carteret Street in downtown Beaufort was originally the town's first African Methodist Episcopal Church. USC Beaufort was established in 1959 and includes other historic structures on its campus.

Originally the Beaufort Elementary School and later donated to USC Beaufort, the remodeled Performing Arts Center includes classrooms, offices, and a 472-seat auditorium often used for community events. In the summer of 2000, 28 of the fiberglass cow sculptures made famous in Chicago found their way to Beaufort as "Cows on Vacation"—one pastured here.

Architects and historic preservationists from around the state sightsee at USC Beaufort's ongoing renovation of the old Beaufort College Building. Beaufort College was established as a liberal arts institution for the sons of Sea Island cotton planters; the building later became part of USC Beaufort.

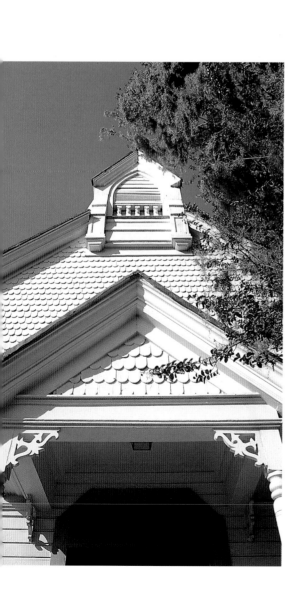
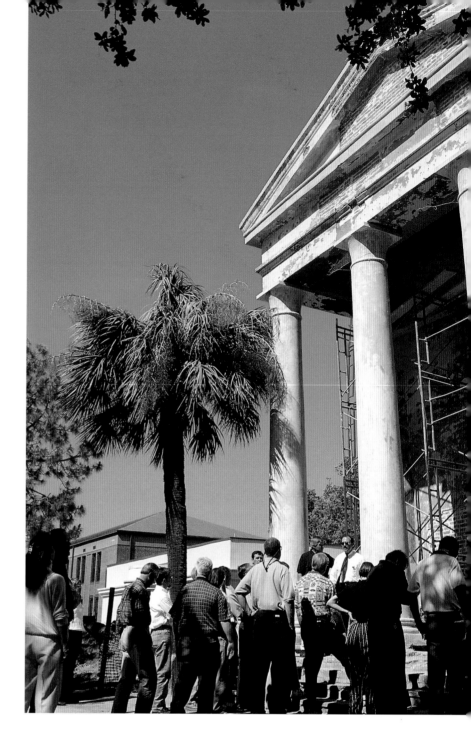

Named in honor of a longtime member of USC's Board of Trustees, the James Bradley Arts and Sciences Building at USC Lancaster features state-of-the-art labs, classrooms, and a 450-seat auditorium.

Right
USC Lancaster students are introduced to fiber art in a special class that links art and English studies.

Fourth-graders from all nine elementary schools in Lancaster County take advantage of swimming lessons at USC Lancaster's natatorium.

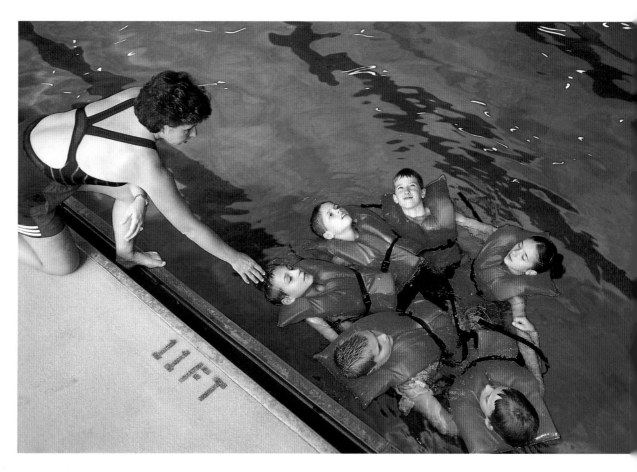

Right
USC Salkehatchie's main classroom building in Walterboro was built in 1926 and is listed on the National Register of Historic Places. USC Salkehatchie, established in 1965, serves Allendale, Bamberg, Barnwell, Colleton, and Hampton Counties.

USC Salkehatchie's original classroom building was first the home of the Allendale Elementary School. The campus has 200 acres, seventeen buildings, and a student enrollment of about 1,000.

Known simply as the Hut, USC Salkehatchie's beloved log structure was built in 1935 by the federal Works Progress Administration. It is now a rustic gathering spot for campus and community events.

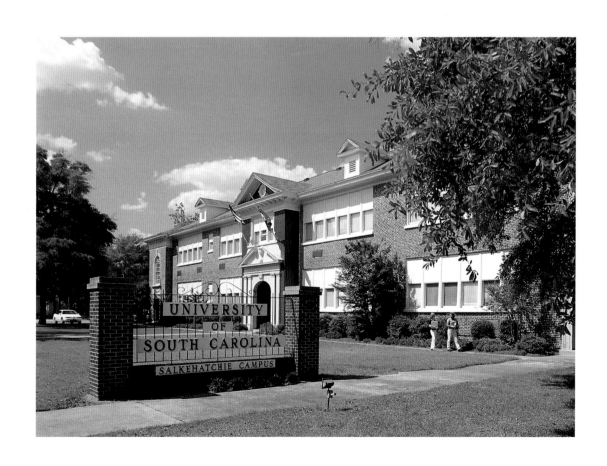

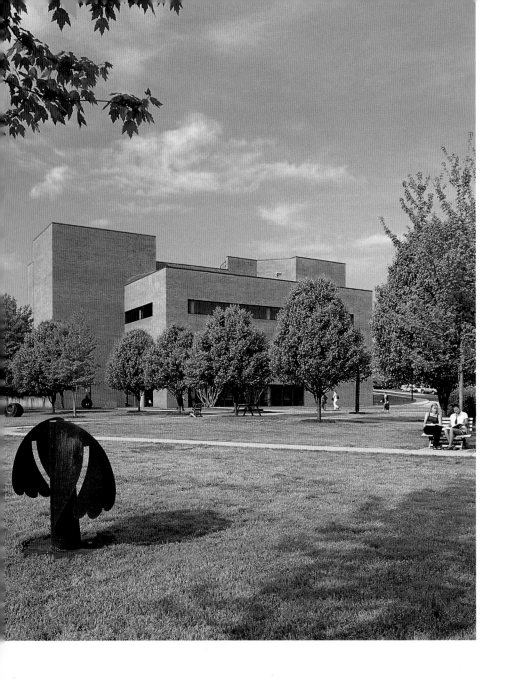

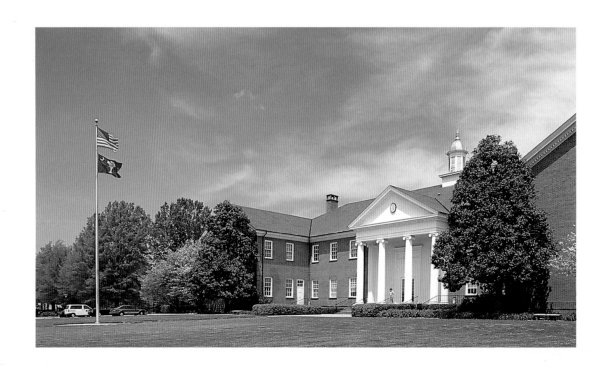

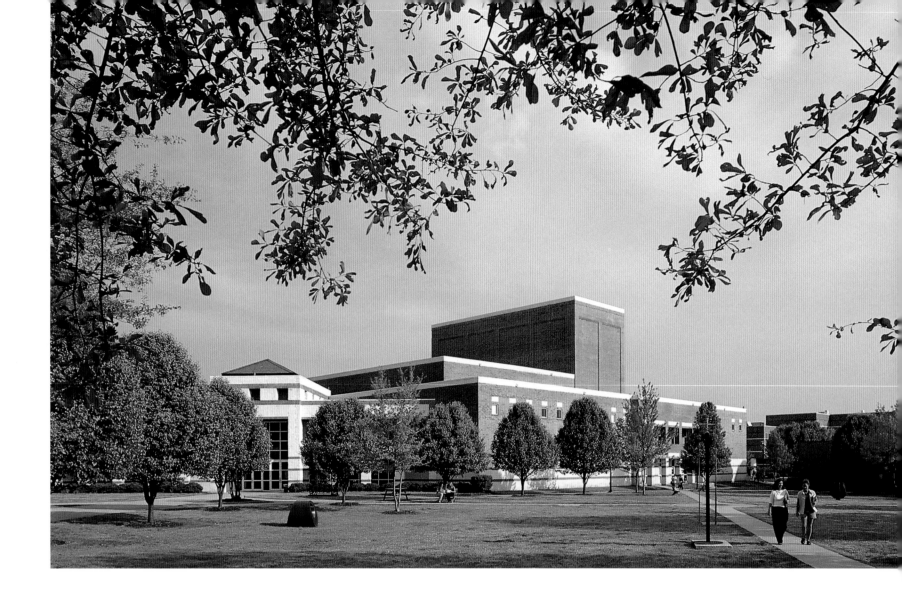

Left

USC Spartanburg's Horace C. Smith Building houses science classrooms and teaching professors noted for their ability to inspire and challenge their students.

Built in 1969, the Administration Building was USC Spartanburg's first structure and provides a familiar centerpiece to the 300-acre campus. The institution is one of two senior campuses within the University.

Above

USC Spartanburg's Humanities and Performing Arts Center provides a modern venue for visual art exhibitions as well as stage events.

Musical and theatrical presentations draw the community to USC Spartanburg's scenic campus, located near Interstates 85, 285 and 26 in the busy upstate.

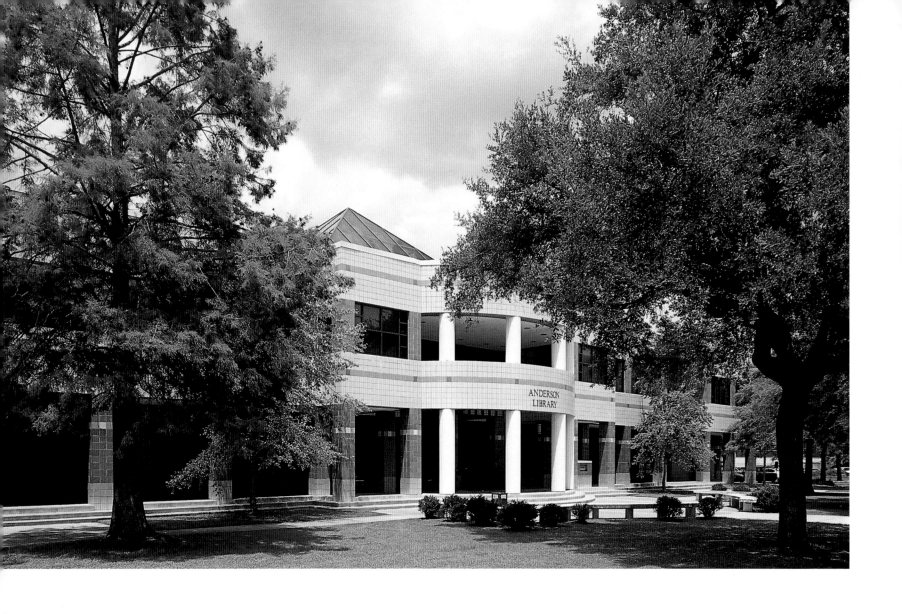

Right
Opened in 1966, USC Sumter began as a branch campus of Clemson University but changed its affiliation to Carolina in 1973. The campus has grown from an original student body of 97 to nearly 1,300 and also offers instruction for military personnel at nearby Shaw Air Force Base.

USC Sumter's Anderson Library is named for Jack C. Anderson, dean emeritus of the campus, and was completed in 1994. The library includes computer labs and an art gallery, and is electronically connected to other University library facilities.

A pole in USC Sumter's Peace Garden proclaims "May Peace Prevail on Earth" in four different languages. The garden, designed by USC Sumter alumnus and grounds supervisor Goliath Brunson Jr., blooms year round and offers a spot for quiet meditation.

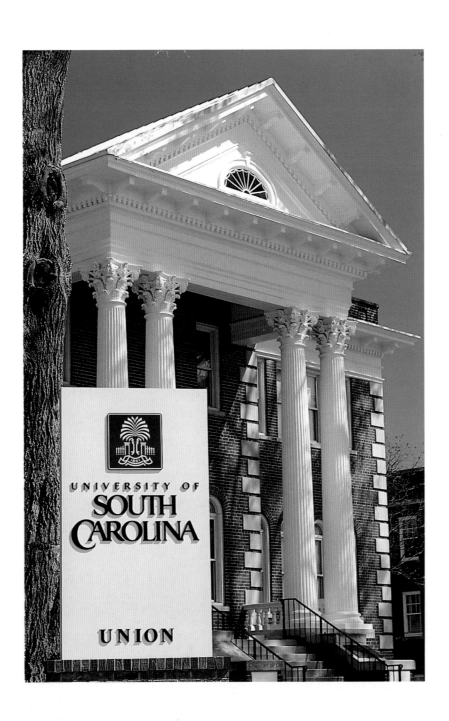

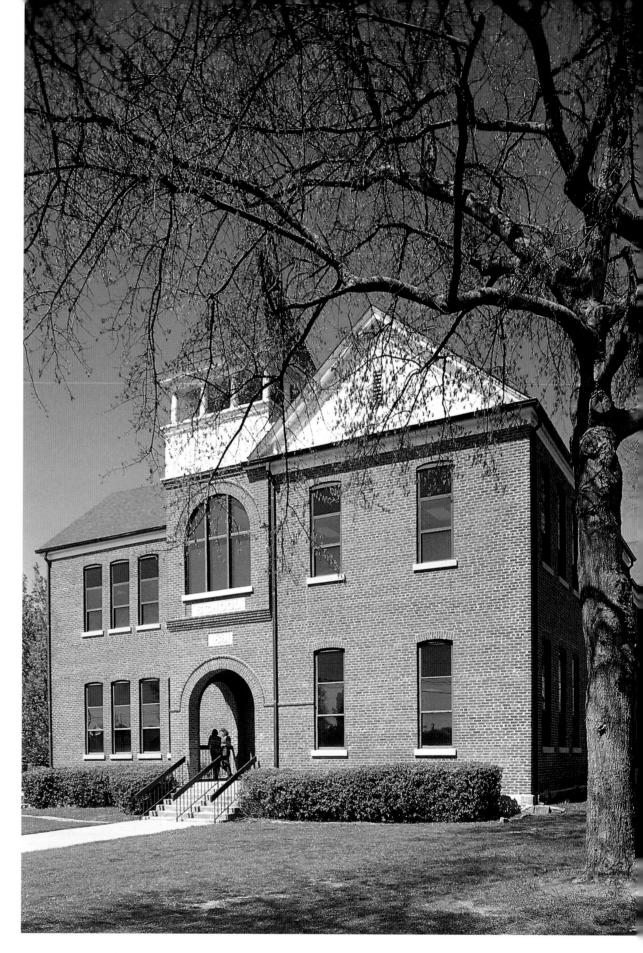

Left

USC Union's Main Building started out in 1909 as Union County's first public high school. On the National Register of Historic Places, the facility was restored in the early 1990s.

The weather vane–adorned cupola atop USC Union's Central Building offers a visually pleasing feature for the home of the campus's administrative offices and library.

Above

USC Union's Central Building was built in 1891 as one of the town's first centralized elementary schools. It became part of USC Union when the campus was established in 1965.

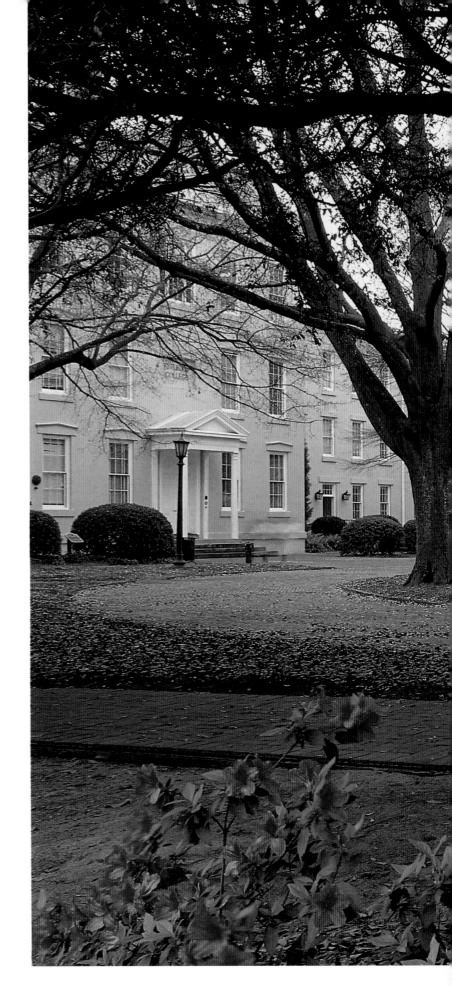

On the Columbia campus, a solitary dogwood in full bloom is juxtaposed against a clear blue sky on the historic Horseshoe.

Nothing could be finer than a quiet spring morning on the Horseshoe to conjure up memories of Carolina. "You are told a lot about your education," wrote the Russian novelist Fyodor Dostoyevsky, "but some beautiful, sacred memory . . . is perhaps the best education of all."

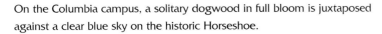

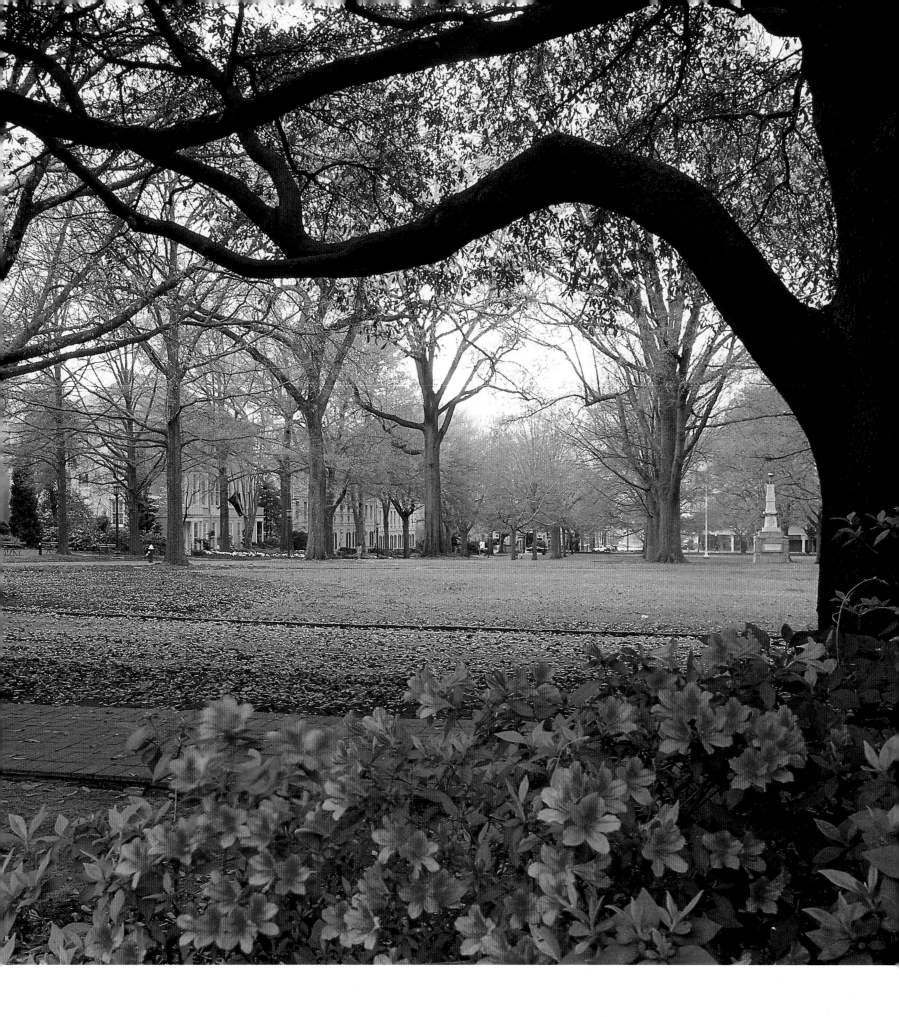

PUBLISHER'S NOTE

University of South Carolina: A Portrait is the result of the collaborative efforts of many throughout the University of South Carolina community. The volume was commissioned by the Press with the support of the Office of the President and the University Educational Foundation. President John Palms and Provost Jerome Odom gave unwavering support, and Foundations Executive Director Susie VanHuss orchestrated funding. Vice President J. Lyles Glenn was actively involved with the project from its inception, and his staunch support and wise counsel were critical to the success of the book. Director of Presidential Communication and Research Pete Mackey and University Publications Director Lawrence Pearce served as valuable advisors, and Mackey worked closely with President Palms to prepare the foreword to the volume. Athletic Director Michael McGee and Assistant Athletic Director Kerry Tharp offered considerable help and made possible the photographs of USC sports. The USC Bicentennial Commission endorsed the project, and Bicentennial Executive Director Sally McKay and Executive Committee Chair Thorne Compton were helpful consultants. At the USC Press, Assistant Director Linda Fogle provided able direction for the project; Designer Pat Callahan worked magic to transform the photographs and text into this volume; and Managing Editor Barbara Brannon helped shape the text. All members of the Press staff were involved in some phase of the book's preparation. Scores of unnamed administrators, faculty, staff, and friends of the University have provided assistance to Robert Clark, Chris Horn, and the Press by suggesting images, coordinating photograph sessions, and providing information about their programs. The University of South Carolina Press extends sincere thanks to all who helped in the creation of *University of South Carolina: A Portrait* and takes pride and pleasure in publishing this photographic celebration.

AUTHORS' ACKNOWLEDGMENTS

I am indebted to a number of people for their valuable help during the preparation of this book. First and always, I am grateful to my wife, Ruth, for her love, support, and encouragement. At the USC Press, I wish to thank Director Catherine Fry for her support and direction; Assistant Director Linda Fogle, who oversaw the entire project and handled all logistics for the photo shoots; and Pat Callahan, book designer extraordinaire, whose skills make my images look so good on the printed page. Thanks go to student assistant John Smoak for his assistance, encouragement, and patience on numerous photo sessions, and to Emily O'Connor for her assistance with the photo shoots. Special thanks go to the USC Athletic Department, especially Michael McGee, Kerry Tharp, and Brian Binnette for allowing access to numerous athletic events; to Barbara Riddle at the President's House; to Clint Cook for his help in scheduling photo sessions; and to Kenneth Ormand for his special encouragement. Finally I give sincere thanks to administrators, staff, and students at the University of South Carolina for their assistance with and participation in the photo sessions and events. All helped to make this project a wonderful experience.

R. C. C.

Many faculty and staff members throughout the University of South Carolina assisted me in gathering textual details for these photographs. Without their help, the task would have been long and tedious—because of their support, this book project was a pleasure.

C. H.

INDEX